CHINESE LANDSCAPE PAINTING

IN MOUNTAINS
ONE SEES
HUMAN-HEARTEDNESS
IN WATER, WISDOM

FROM A RUBBING OF THE EPITAPH OF YÜAN MENG-HUI
OF THE NORTHERN WEI PERIOD, DATED 520 A.D.

辟 仁 若 山 在 智 如 水

CHINESE LANDSCAPE PAINTING

SHERMAN E. LEE

Icon Editions
Harper & Row, Publishers
New York, Hagerstown, San Francisco, London

Printed by arrangement with Case Western Reserve University.

Clothbound copies of this edition may be purchased from the Press of Case Western Reserve University, Cleveland, Ohio 44106.

CHINESE LANDSCAPE PAINTING, REVISED EDITION. All rights reserved by the Cleveland Museum of Art, University Circle, Cleveland, Ohio. Printed in the United States of America. No part of this book may be used or reproduced in any manner whatsoever without written permission except in the case of brief quotations embodied in critical articles and reviews. For information address Harper & Row, Publishers, Inc., 49 East 33rd Street, New York, N.Y. 10016. Published simultaneously in Canada by Fitzhenry & Whiteside Limited, Toronto.

STANDARD BOOK NUMBER: 06-430010-2

79 80 12 11 10 9 8 7 6 5

PREFACE

This second edition of *Chinese Landscape Painting* attempts to correct the errors of the out-of-print first edition and to present a more attractive and useful appearance, particularly in quality of reproduction. While the first edition was a book-catalogue of a loan exhibition held at Cleveland in 1954, the second has been modified to include American and Canadian-owned pictures not then available as well as supplementing these with a few pictures owned abroad where nothing of their type or flavor can be seen here. This book is, then, an introduction to be used in conjunction with original works of art reasonably available for direct observation.

The author is indebted to many colleagues. More specifically, to the owners for their permission to reproduce their excellent paintings; to Dr. Richard Edwards and Dr. Wen Fong who made many of the original translations in 1954, and to Mr. Wai-kam Ho who has revised some of these and added others; to Dr. Osvald Siren and Mr. Walter Hochstadter for their photographs of the Chinese landscape; to Mr. Richard Godfrey, The Cleveland Museum of Art photographer, for many of the excellent new photographs; to Nancy Wu Stafstrom, Gretel Chapman, and Louise G. Schroeder for the onerous duties of manuscript preparation; to Dr. Merald E. Wrolstad for editing and design; and to the Trustees of The Cleveland Museum of Art whose support of the Museum's new publications program makes this second edition possible.

Sherman E. Lee

CONTENTS

CHINESE LANDSCAPE PAINTING

INTRODUCTION

Landscape is the great subject of Chinese painting, and Westerners are properly amazed at the very early date of its first full expression. At that time in the ninth and tenth centuries there was nothing in Europe that could be remotely considered a developed landscape art. And yet, if we go further back, to the Mediterranean world in Hellenistic times, we find that there was once a creative and forward-looking Occidental landscape art; and, even more, that the high state of that art, as seen in the frescoes of the *Odyssey* in the Vatican, predated a comparable stage in the history of Far-Eastern landscape painting. The preconditions for landscape include a non-anthropomorphic nature philosophy. In the Hellenistic and Roman world this was present in a philosophy for which Lucretius' *De Rerum Natura* was the prime literary expression. Christianity changed all this and landscape was buried in the West, not to reappear until a more sympathetic attitude to nature was evinced by the thinkers and doers of the post-Renaissance. The early pure

* Superior figures refer to books and articles listed in the Selected Bibliography which begins on page 157.
NOTE: Diacritical marks have been omitted from Chinese names and words in the text.

landscapes of Claude, Poussin, Rubens, and Ruisdael were seventeenth-century creations, but still dominated in number by the more acceptable category of figure painting. The development of landscape into a dominant category in Western painting occurred in the "materialistic" nineteenth century.

In China nothing occurred to seriously interrupt or reverse the steady growth of a generally accepted philosophy of nature that provided a perfect climate for great landscape painting. While the very first evocations of nature are magical, with a heavy overlay of an earlier animism, there is also present an idea of universal orientation. The magic mountain[131]* is not only an abode of strange spirits, but an axis from which the four directions emanate. This directional significance remains in early landscape painting. Ku K'ai-chih wrote in the fourth century, *How to Paint the Cloud Terrace Mountain*,[81] "Now, in the middle section to the east, I would draw. . . ." This orientation concept leads us away from the magical to the first of the two dominant Chinese philosophies which were all-important to a landscape art.

Confucianism originally, and as it developed, was not merely a system of ethics for humans, but was a rational world view of remarkable

consistency. While the *Analects (Lun Yu)* may regard nature with a human bias in the famous quotation, "The wise men find pleasure in water; the virtuous find pleasure in mountains," the almost contemporary *Conduct of Life (Chung Yung)*, a favorite compilation of later philosophers, assumes a more general and universal position: "Nature is vast, deep, high, intelligent, infinite and eternal." In this view nature's principles exist for their own sake with no ulterior or fathomable motives. Since the natural order or principle *(Li)* pervades all things, all things are worthy subjects of attention. Further, since we can observe the fallibility of man, the apparent infallibility of nature makes it *the* subject in which *Li* can be shown in its purest form. The first full pictorial expression of this rational attitude will be seen in the Northern Sung period; but it was ever present in the minds of earlier painters and critics. Thus the first and most important of the six pictorial canons listed by Hsieh Ho in the fifth century—"animation through spirit consonance,"[95]—refers as much to a rational correspondence of painting to principle as to mystic responsiveness to the Taoist way of the universe.[81] In general, the result of Confucian thought on nature was oriented to both humanity and nature. The great tenth-century painter, Ching Hao, writes with both morality and principle in mind:

> Every tree grows according to its natural disposition. Pine trees may grow bent and crooked, but by nature they are never too crooked. . . . They are upright from the beginning. Even as saplings their soul is not lowly, but their form is noble and solitary. . . . Indeed the pine-trees of the forests are like the moral character of virtuous men which is like the breeze.[78]

The second controlling attitude, Taoism, was more immediately derived from magical attitudes. But in its purest form Taoism provided the intuitive and direct response to nature which was as necessary as rationality. When the seventeenth-century individualist painter, Shih-t'ao, equated the mountain with the wave (water, mysterious female), he was returning to ancient Taoist concepts as expressed in Tsung Ping (early fourth century).

> In this manner, one may represent in a picture the sublime beauty of the Sung and Hua mountains and the spirit of *Hsuan P'in* [Mysterious Female-Spirit of the Valley] which dwells therein.[81]

Tsung, in turn, was referring to the source of most Taoist thought, *The Tao-te-ching* (fourth century B.C.):

> The Valley Spirit never dies.
> It is named the Mysterious Female.
> And the Doorway of the Mysterious Female
> Is the base from which Heaven and Earth sprang.
> It is there within us all the while;
> Draw upon it as you will, it never runs dry.
> *The Way and Its Power,* tr. A. Waley

—where the valley is thought of as the low point, the gatherer of waters, and hence female. The Taoist intuition of nature was ever the mystic half of the Chinese landscape painter, even when it was later cloaked in the garb of Ch'an Buddhism, the only form of Buddhism that provided a drive for landscape painting. All of these viewpoints—magical, Confucian, and Taoist—make it clear that there is more than the merely literal to the Chinese term for landscape: *Shan-shui,* "mountain-water" picture.

But philosophers do not paint and artists do. In this the Chinese painter is no different from his Western counterpart, so well described by Focillon in *The Life of Forms in Art:*

> He is human; he is not a machine. Because he is a man I grant him everything. But his special privilege is to imagine, to recollect, to think, and to feel in *forms.*

4

Just so the Chinese. When Tsung Ping refers to the already quoted passage from the *Analects* he says, "But the lovers of landscapes are led into the Way by a sense of form."[81]

Chinese painting, then, is concerned with forms seen or imagined by the eyes of a Chinese, but still *forms*. And while it is true that a Westerner can never see a Chinese painting in a completely Chinese way, the reverse is equally true. Where the Chinese sees the very real quality of brushwork as related to calligraphy, he also imagines the accepted clichés of a "pure and noble spirit . . . above the ordinary crowd." Where the Westerner sees an original handling of the problem of space composition, he also imagines *his* clichés: the metaphysical significance of the empty silk or the "lovely and decorative" colors of the later Chinese professional painter-artisan. We are not Chinese nor ever can be, but we can discipline ourselves to understand something of that country's approach to her own painting. This can be done with integrity only if we, at the same time, maintain our "Westernness," especially in the sense of our objective knowledge of materials and technique and, above all, of style, of forms. Each Chinese painting exists. There it is before us. If to each successive generation of Chinese it was a different painting, how much more so for us. But now it is "our" painting. We can try to see what it was; we see what it is. Both visions are valid and both are taken for granted here.

To the Chinese the purest of the arts is calligraphy for it is pure brush and pure idea,[29] the two farthest extremes of material and ideal combined into an inseparable whole. To the Chinese the value judgment of a picture rests primarily on its brushwork as related to, and derived from, calligraphy. The nearest we Westerners can get to the essence of what a Chinese sees in Chinese painting is our concept of *touch*. Touch differentiates one artist from another and the artist from the non-artist. If we think of the difference between the touches of Rembrandt and of Bol, or between the touches of Vermeer and of Van Meegeren, then we are thinking of something not unlike the concept of brushwork in a Chinese painting. Look at the last picture in the book, the little page by Ch'ien Tu | 108, p. 133 |.* Study the circles used for foliage in the background. Note their fatness, as if they were filled with water. Look at the Wang Hui | 79, p. 99 | and note the precision and shape of each stroke as it falls on the paper in an almost measured cadence. Then turn to the freer examples such as the Wen Cheng-ming | 57, p. 76 | or the Kuo Hsi | 15, p. 23 |, and consider them as masterpieces of touch.

The second of the more obvious barriers is the Chinese use of type forms. Not that they did not go to nature, even in the form of sketching. We have enough literary evidence that they did. Again Ching Hao:

> Astonished by this curious spectacle [a gnarled and gigantic pine] I walked around and admired it. The next day I returned with my brushes and sketched some of the pine trees. After drawing several they seemed real to me.[81]

or Wang Li (fourteenth century):

> As long as I did not know the form of the Hua Mountain, how could I make a picture of it?[88]

But still the Chinese landscape is primarily a complex of brush symbols for nature.[18] Ruskin would not have liked it for it does what Claude and other mannerist or ideal painters did. They used types: type elms, type rivers, type forests, intended to be taken as an aesthetic and ideal

* Figures within vertical lines refer to illustrations, which appear in numerical order with the accompanying text. Reference material on the illustrations is included under the List of Illustrations which begins on page 135.

re-creation. One could not copy nature, one could only create a landscape painting.

Such an achievement for the Chinese could only be accomplished through brushwork. But how varied, rich, and complex that brushwork could be! We have more readily accepted the single brush stroke type of Chinese painting, the type of the Southern Sung period | 23, p. 33 |, and we have often identified this one of many styles with *the* style of Chinese painting. But there were other ways used at all times and just as deserving of our attention. Consider the method of Kuo Hsi (eleventh century) | 15, p. 23 |:

> Having drawn a picture, he would retouch here and add there; augment and adorn it. If once would have been sufficient, he would go back to it for the second time. If twice would have been enough he would go back to it the third time. . . . From beginning to end he worked as if he were guarding against a strong enemy.[52]

In order to help this understanding of touch, relationship to nature, and variety of technique, we have drawn to a limited extent on old and modern Occidental drawings and on photographs of the Chinese countryside, and have used these in juxtaposition with comparable Chinese landscapes. These secondary aids may assist in making the scrolls less strange. At the same time the visual comparisons will highlight the real differences of the Chinese eye from the Western eye, or of the real landscape from the painted one.

Chinese landscape painting is an aristocratic production from beginning to end. Painting came after writing. Literacy was the first prerequisite and the second was literary knowledge. How could one use a brush if one could not write, and write well? How else could one know of *Li* and the first requirement of good painting, "animation through spirit consonance?" The scholar was, therefore, the principal class from which the great painters came. Further, the scholars painted for scholars. The standard formats for painting, the hanging scroll, the handscroll, and the album, were portable. They could be hung at will or carried wherever the owner wished. With the possible exception of the hanging scroll, the formats were intimate, to be seen by only one person or a few friends at a time. If we wish to experience something of the private and exclusive joy of the scholar-painter-collector, we must think of books. And there we are again back to the word "literary" which is perhaps the best definition of the term for the creative painters from at least the twelfth century on: *wen jen hua*, gentleman's painting. But since only gentlemen were literary—the literary man's school. Sir Kenneth Clark[18] has compared this concept with that in England involving the appreciation of Claude. Claude's landscapes and their titles were full of just those classical ruins and allusions that were of interest to the literate man. In China this feeling of aristocratic exclusiveness extended to the appreciation of nature. This poem of Po Chu-i (772–846) perfectly expresses the literary man's feeling of being above and apart from the crowd:

> The snow has gone from Chung-nan; spring is
> almost come.
> Lovely in the distance its blue colors, against the
> brown of the streets.
> A thousand coaches, ten thousand horsemen
> pass down the Nine Roads.
> Turns his head and looks at the mountains—
> not one man.
> *More Translations from the Chinese,*
> —tr. A. Waley.

The idea of the literary man's school was further developed in the early seventeenth century by the application of the term "Southern School" to the literary style. Its opposite, the professional-artisan school, was then called

"Northern." While not all of the "Northern" School deserved the scorn of the critics, in general the literary school was the more creative one, especially in landscape and particularly after the fourteenth century. There is, statistically speaking, some justification for the geographic distinction even though it is generally understood as a qualitative description. In the landscape listings of Kuo Jo-hsu,[96] who wrote in the eleventh century, twenty-four of thirty-seven painters are from the North; but fifty-three of sixty Yuan or later painters in this book, for example, came from the South. In part it is because the literati were driven there, first by the Tartars and Mongols, and later, in the seventeenth century, by the Manchus. Also, the milder climate of the South with its accompanying rich vegetation made it a favorite residence for the economically self-sufficient, including the scholar-official and his patrons. The life of retirement or the retreat of the recluse was more feasible in the South. But even more than these objective reasons there remains an apparently natural affinity of the South for landscape. The earliest landscape included here | 1, p. 8 | is from the South. Buddhism's greatest triumphs were in the North and with them appeared the greatest efflorescence of a public and a figural art. The South remained the stronghold of Taoist thought, aristocratic painting, and of emerging landscape art.[102]

Landscape paintings made up a major part of the great Chinese collections from the Sung Dynasty on. While the fact that a painting comes from a famous collection does not automatically prove it good, such a provenance is at least a good character reference. The growth of the Chinese painting collections in this country, beginning with Boston, the Freer Gallery in Washington, and later with Kansas City, has now spread rather more widely than we imagine. And so one can now present a selection of landscape paintings not only of intrinsic interest, but also with accompanying pedigrees in the form of owners' seals and colophons that read rather like a book of the great collections: for example, there are fifteen paintings from the Imperial Ch'ien Lung collection (1736–1796); five paintings from the collection of the famous connoisseur, the Korean salt merchant An Ch'i (1683–ca. 1742); fourteen paintings formerly belonging to Liang Ch'ing-piao (1620–1691), perhaps the greatest connoisseur of all; and six paintings from the extensive, if uneven, holdings of Hsiang Yuan-pien (1525–1590). All the standard formats of landscape painting are well-represented. The numerical representations from the various periods are comparable, allowing for the greater surviving quantity of post-Yuan painting. Some of the great painters are missing but in general the assembled reproductions give an adequate and authentic view of Chinese landscape art.

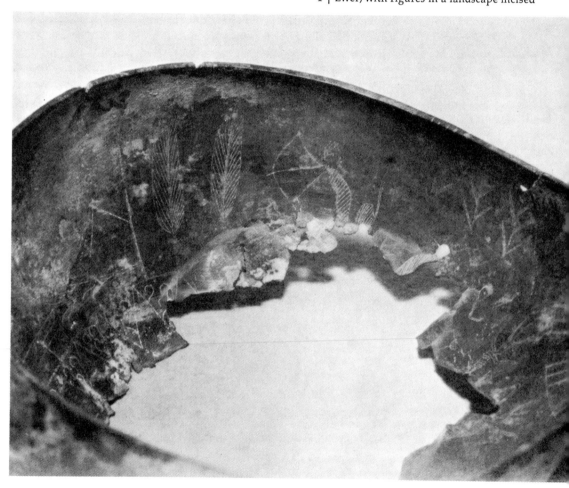

THE BEGINNINGS
OF LANDSCAPE

The earliest landscape representations in China take us back to at least the Late Chou period (fifth–third centuries B. C.). Most of these occur in cast metal; usually stylized trees or mountains on bronze mirrors and inlaid bronze vessels,[101] with one rare example in carved jade. But a unique example of even a semi-pictorial technique is to be found in the representation of trees incised on a thin-shelled bronze ewer | 1 | reputedly from Ch'ang Sha in South China. The striated and rather naturalistic technique has affinities with some slightly later stone reliefs from West China (Szechuan).[79] While the delicately but simply incised lines on the ewer differentiate four tree types and, perhaps, grasses, these elements are distinguished by symbolic over-simplifications which clearly reveal a lack of interest in landscape as such, other than as a magical setting for figures performing magical rites.

While the pictorial means for landscape representation at this time were comparatively meager, the literary means were much more varied and complex, and we find numerous poems in the *Book of Odes* and other sources which reveal the beginnings of a sensitive awareness of nature, but again as a setting, either for moral or narrative purposes or, as in the bronze ewer, for magical evocation.

Grandly lofty are the mountains, with their large masses reaching to the heavens. From those mountains was sent down a spirit, who produced the birth of Fu and Shan.*

The succeeding Han Dynasty (206 B.C.-A.D. 220) was a time of great development in figure and space representation with landscape remaining in a secondary position as a setting for the dominant figures. By this time two additional modes of landscape portrayal may be distinguished.[101] Again these are in media other than painting though the evidence is clear that the gap is due to the destruction of painted material. Stamped pottery tomb tiles, common enough as to material, sometimes use a mountain pattern as a base line for scenes of the chase or for magical bird-men, the spirits of the mountain and untamed nature. One unusual tile | 2 | presents the two mountain styles together on three friezes, one above the other. The uppermost, with the bird-man of Chinese origin, uses the continuous wave mountain range, a foreign import which can be traced to the Near East. The middle and lower friezes have figures of foreign origin,

* From the Ode "Sung Kao," tr. by Legge in M. Muller, *Sacred Books of the East*, V. III, p. 423.

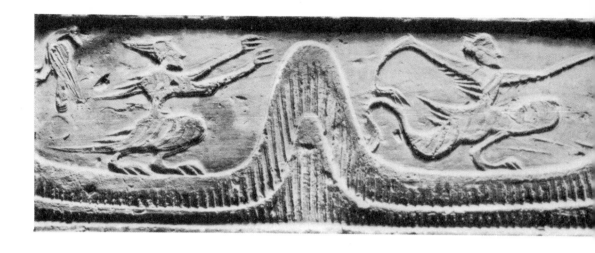

3 | Rural Landscape Scene, rubbing of a tomb tile

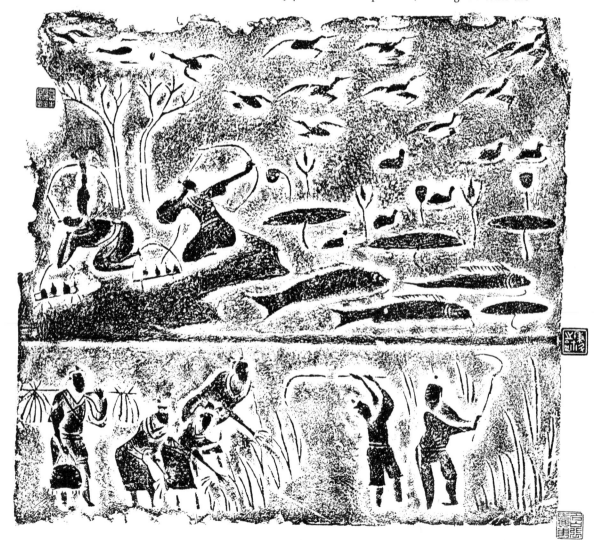

2 | Tomb Tile, with stamped designs (detail)

the hunt and chase motif imported from the Near East by way of the Steppes,[94] but the landscape base line is of native inspiration. It consists of linear and rhythmically undulating mountain symbols of a cloud-like nature. This form can be found as early as Late Chou, being used for clouds, mountains, or even as linear decoration out of which landscape elements sprout, a fine example of a decorative form preceding and giving origin to a natural one. Other stamped tiles | 3 | from West China show a surprisingly real and spacious setting for a hunting scene based on observation and possibly evolving from such earlier representations as the bronze basin.

The specifically Chinese linear and rhythmical landscape setting is further developed in the later Han Dynasty and is found on many stamped or molded and glazed pottery vessels | 4 |. By this time cliffs, mountains, rocks, and trees are clearly differentiated but without a sense of relative scale and without loss of the playful movement of the line. These, too, are settings for animals and figures of magic import.

4 | "Hill Jar," pottery cylinder on three feet

11

5 | Painted Tomb Tile (detail)

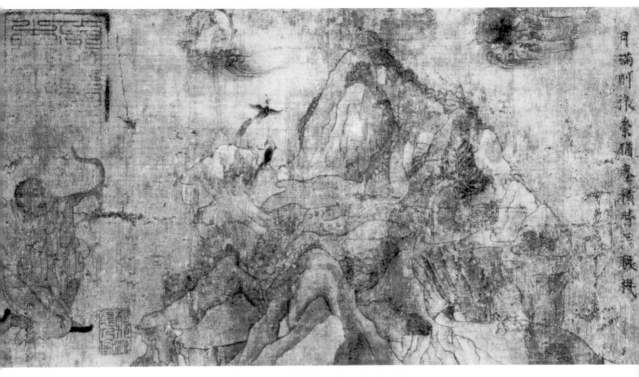

月滿則虧業棄擷臺牖壽之瓞栱

6 | *Mountain Landscape with a Hunter* by Ku K'ai-chih, handscroll (detail)

A pathetically few paintings remain from the Late Han or early Six Dynasties period (third-fourth centuries).[37] They are found on bronze mirrors, inside the lids of bronze boxes, or on lacquer bowls or boxes, and on white slip-coated tomb tiles. Of the few, even fewer show landscape elements and the example in Cleveland | 5 | is unique in its keenness of observation and its obviously experienced use of the brush as a descriptive rather than a decorative tool. Still the tree indicates a setting only. It is a prop saying "the scene is out-of-doors." Space is indicated not by landscape but by the figures, some in three-quarters view and one kneeling, placed above and hence beyond the adjacent standing man.

The succeeding few centuries have left us few major painted landscape monuments. From the late fourth or early fifth century we have the scroll by Ku K'ai-chih, in the British Museum | 6 |, which contains a sophisticated rendering of an incidental and archaic landscape.[94] Here the mountain exists as a "thing-in-itself," another symbolic element in the moralistic narrative: "He who aims high will often be brought low." Within itself, despite the arbitrary scale relationship with archer and his quarry, the development of natural forms, rocks, ledges, and foliage, shows a growing keenness of observation expressed in type brush forms. The numerous fifth- and sixth-century Buddhist frescoes in Northwest China

13

at Tun Huang |7| establish space control in a landscape as a setting for primarily narrative purposes. These space cells were the means of enclosing figures; the recession of successive mountain or rock ranges was developed as a setting for more expansive storytelling or more violent scenes of action.[94] The somewhat later painted banners from Tun Huang |8| show the landscape methods on a smaller scale. The votive picture sets forth, within the linear-rhythmical format, solid individual elements, ledges, trees, and cliffs. But it is retrogressive in its curiously naive use of an almost perfectly symmetrical landscape arrangement, as if nature herself were made up

of religious implements which could be arranged to conform with the iconic rectitude of the deity and donors.

Clearly the creation of a pure landscape art was beyond or beneath the interests of anthropomorphic Buddhism. Charming or interesting as all the "landscapes" from Tun Huang may be, they are essentially an echo of another, more sophisticated, and more serious interest in nature. This interest we can know only second-hand from a few Japanese incidental landscapes of the eighth century, but principally from literary materials of the period. These are largely works of poetry, philosophy, and art criticism, and they reflect the

7 | *Jataka Story: the Deer King* by unknown artist, cave fresco

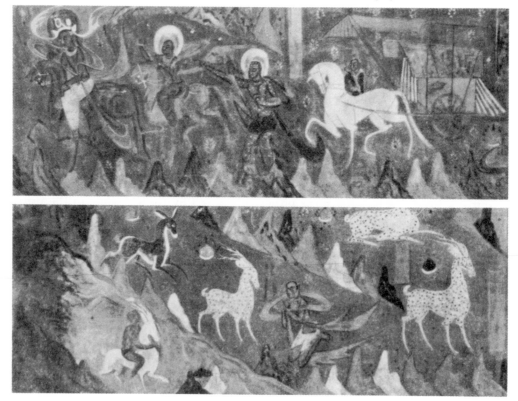

Taoist-influenced concern with the meaning of the Universe—especially in the manifestations of nature as a mysterious or magical power. Thus Tao-yun (ca. 400) writes:

High rises the Eastern Peak
Soaring up to the blue sky.
Among the rocks—an empty hollow
Secret, still, mysterious!
Uncarved and unhewn,
Screened by nature with a roof of clouds.
Times and Seasons, what things are you
Bringing to my life's ceaseless change?
I will lodge forever in this hollow
Where Springs and Autumns unheeded pass.
More Translations from the Chinese,
—tr. A. Waley.

We find the same concern with nature as a mysterious force in the *Introduction to Landscape Painting* by Tsung Ping (375—443)[81] with the usual mixture of such Taoist thought with the Confucian ideal of the sage who draws virtue from nature. Tsung, being a painter, is "led into the Way by a sense of form." Still, at this time landscape is realized more fully in verbal than in pictorial terms. We can see this not only in the sharp contrast between the grand description by Ku K'ai-chih of *How to Paint the Cloud Terrace Mountain*[81] and the relatively feeble pictorial accomplishment seen in the mountain section of his painting in the British Museum, but also in the

8 | *The Miracles of Avalokitesvara* by unknown artist, votive painting

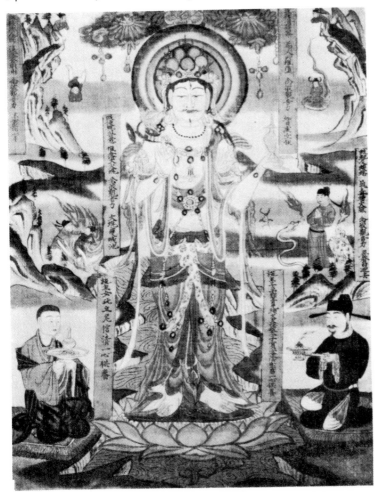

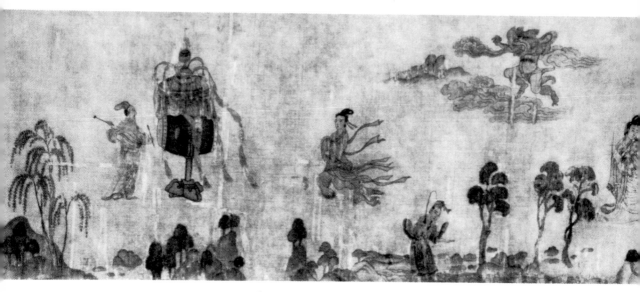

9 | *The Nymph of the Lo River* by Ku K'ai-chih, handscroll (one section)

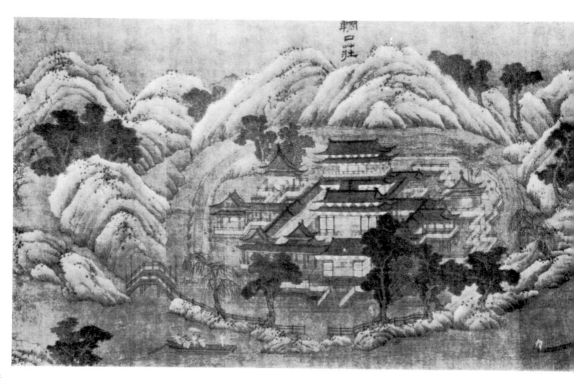

History of Painting written by Chang Yen-yuan in the ninth century. He disparages the landscape painting of previous times:

> There are still some famous pictures handed down from the Wei and Chin Dynasties, and I have had occasion to see them. The landscapes are filled with crowded peaks, their effect is like that of filigree ornaments or horn combs. Sometimes the water does not seem to flow, sometimes the figures are larger than the mountains. The views are generally enclosed by trees and stones which stand in a circle on the ground. They look like rows of lifted arms with outspread fingers.[88]

This is a good description of the landscape in the *Nymph of the Lo River* |9|. Final evidence for the lack of a real landscape art in the Six Dynasties period is contributed by the famous first canon of Hsieh Ho which demands *"ch'i-yun-sheng-tung"* (animation through spirit consonance) as the first and last requirement for great painting. However, the requirement seemingly does not apply to landscapes but to figures or sentient beings,[95] for Chang's *History* specifically excludes trees and stones from *ch'i yun.* We are still in a pre-landscape atmosphere.

The final preparations for a true landscape art are achievements of the T'ang Dynasty (618–907). Two other functions were added to the magical and supporting role of landscapes, both with motivations of a more direct and pragmatic nature in accordance with one aspect of T'ang culture. First, landscape

10 | *Wang Chuan Villa* by Wang Wei, handscroll (detail)

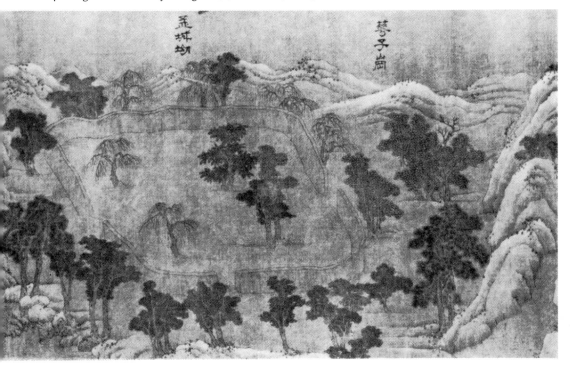

17

became a means of aiding sophisticated decoration. We know copies of courtly palace scenes in park-like settings, painted in green, blue, and gold.[76] Then there were large scale wall decorations now lost, but attested to by the *retardataire* eleventh-century tomb murals of the foreign Liao Dynasty in Manchuria,[63] as well as by literary evidence. The specifically symbolic use of the Seasons or Directions was evidently continued in these wall landscapes as well as the secondary aesthetic position for landscape painting implied by the mere fact of its use as architectural decoration.

Second, we have a topographical and descriptive approach which owes much of its drive to the same interests that produced maps and gazetteers. Indeed the earliest "pure" landscape painter, revered as the traditional father of the accepted landscape tradition, Wang Wei (698–759), would seem to have been such a descriptive painter to judge by his most famous scroll, now known to us only through painted or engraved-on-stone copies of a much later date | 10 |.[53] The organization is additive and consists of a series of space cells enclosing the principal points of interest, largely architectural, on the artist-scholar-official's estate. The ground plane is tilted in an early map-like fashion, and each cell or point of interest is carefully labeled. Nearly all of the painted copies indicate the original to have been in the green and blue decorative style associated with the courtly palace paintings of the period and which we also find in the Tun Huang fragment | 8 |. Still, tradition credits Wang with the origin of monochrome landscape painting, and other works—one, a possibly original or, at worst, near-original small winter landscape formerly in the Palace Collection[87]—show a more developed landscape style. But in the last analysis it is still closer to what had gone before than to the

18

full style which was soon to develop. Such an inference can be supported quantitatively by statements of later writers such as Wang Shih-chen (1526–1593) that "generally speaking, the landscape painters before the Five Dynasties (907–960) were few;"[88] or by the really small number of pure landscape titles to be found in records of collections up to the eleventh century. Even after the florescence of landscape painting, in the early twelfth-century catalog of Emperor Hui Tsung, religious subjects were placed ahead of landscape.

The beautiful *Emperor Ming Huang's Journey to Shu* | 11 | is one of our documents to sum up the position of landscape painting at this point. A work of the tenth or eleventh century, it is a rather conservative statement of earlier principles with an overlay of up-to-date details. The richly-colored horsemen give a sure hint as to the courtly-colored style of the painting. As we shall see, there are elements of the Northern Sung monumental landscape style present, especially in the treatment of the rocks and distant mountains. In these we sense a new, endlessly expanded world after the cramped quarters of the past. However, gold and what was once considerable color is to be found throughout the landscape as well as a rather careful descriptive handling of the principal tree. Meaningfully, the tree is placed in the immediate foreground as a space indicator for the frieze of figures, a typically T'ang or even late Six Dynasties device. All of the parts of the picture are carefully separated, whether details or the more general sub-divisions of composition on the surface of the silk, or in the suggested recessions of space. The *Journay to Shu* may well be one of our best portable keys to the more conservative side of landscape wall painting; and yet there are so many fundamentally new elements that we must now consider their foundation and evolution.

11 | *Emperor Ming Huang's Journey to Shu* by unknown artist, hanging scroll

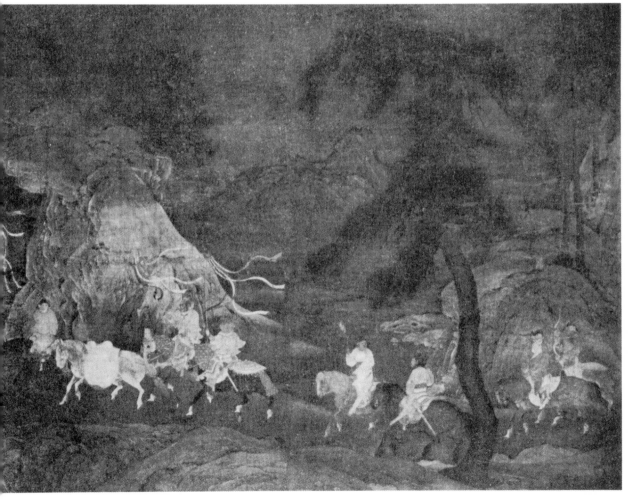

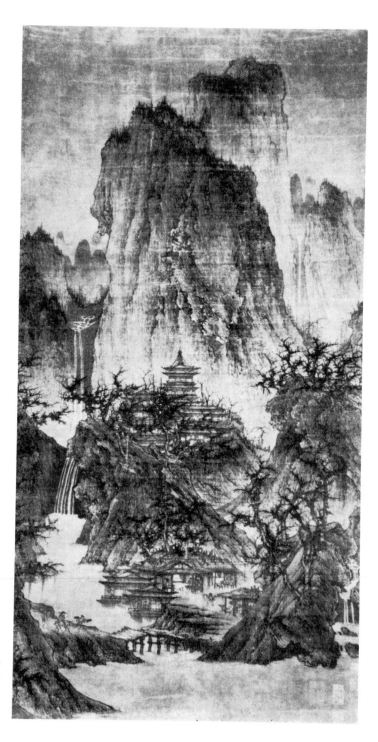

12 | *Buddhist Temple in the Hill after Rain* attributed to Li Ch'eng, hanging scroll

THE SUNG DYNASTY

With *Buddhist Temple in the Hills after Rain* | 12 |—probably an eleventh-century work close to the style of Li Ch'eng and the *Buddhist Monastery by Streams and Mountains* by, or very close to, the monk-painter Chu-jan | 13 | —landscape had become the subject of the painting and, as the title implies, its *raison d'être*. The qualifying phrase, "after rain," applies to the natural prospect. The temple happens to be there. If we examine these pictures objectively, we find centralized compositions with a relatively equal emphasis on their various parts. The fore and middle grounds are united, but clearly separated in space from the distant mountain masses whose bases are lightened so as to silhouette and separate nearer details. The recessions in space are accomplished by a careful and clear series of flat rock or mountain planes placed parallel to the picture plane. Representationally, the forms of nature are translated into brush-terms but not yet at the expense of the natural form. There is a tremendous effort to grasp the real-

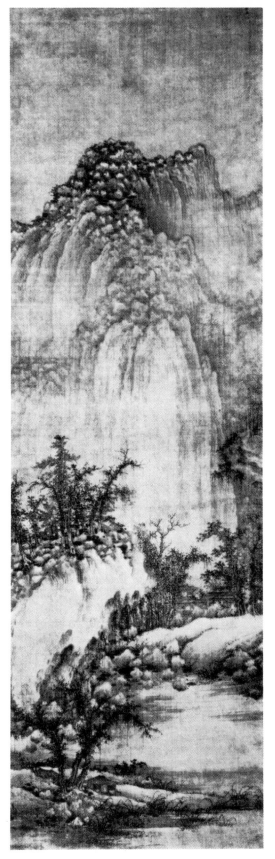

13 | *Buddhist Monastery by Stream and Mountains*
attributed to Chu-jan, hanging scroll

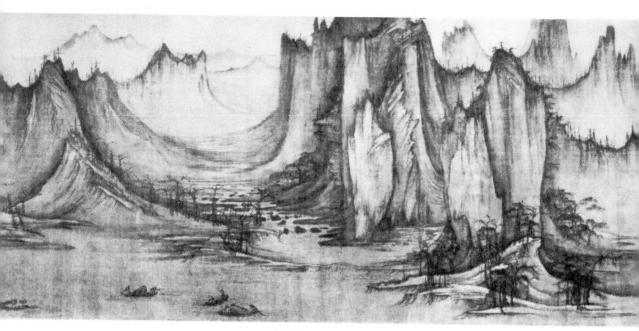

14 | *Fishing in a Mountain Stream* by Hsu Tao-ning, handscroll (detail)

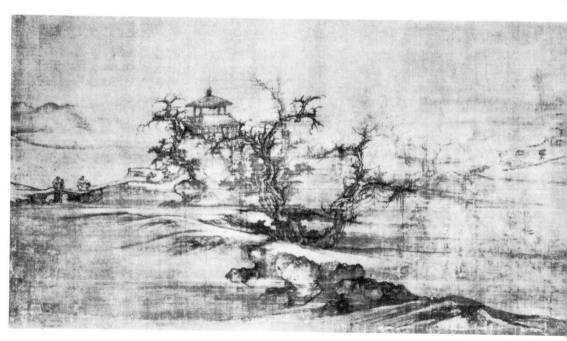

ity of nature within a highly schematic and intellectual format. The result is all-embracing and monumental, a true macrocosm.

In this post-T'ang period of the Five Dynasties and the Northern Sung Dynasty (960 to 1127), the speculative theories of nature attain an unmatched height, reconciling the rectitude of Nature found in the interrelationships of Heaven, Earth, and Man as expressed in *Li* or "principle," with the direct and keen observation of nature as it existed. Thus, for example, large trees must be on solid ground and "far-away figures have no eyes." This is the technique of landscape painting as expressive of the principles of nature. Nor are the seasonal, directional, and geographical aspects ignored. Added to these is pure enjoyment, both with regard to the object and to its depiction as we read in the surviving words

15 | *Trees on the Distant Plain,*
by Kuo Hsi, handscroll

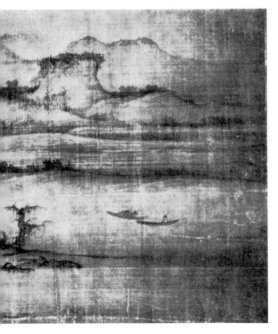

of the great painters Ching Hao and Kuo Hsi | 15 |.[81] These various preconditions for the fulfillment of great landscape painting were also due to "Buddhism's gradual subsidence from its high place as the most inspiring influence in Chinese life, a process which had begun in the eighth and ninth centuries."* As Focillon has shown, in other countries and other periods, once a sequence of related forms begins to evolve, the archaic or experimental period proceeds with great speed. Such is the case with Chinese landscape painting in the tenth and early eleventh centuries.

These two paintings have introduced us to the results of the experimental period as seen in the hanging scroll format. Later hanging scrolls of the Northern Sung period may often display a greater depth of space and an increased feeling of mood, but with an ensuing loss of monumentality. This loss is compensated for, and perhaps related to, the growth of interest in the handscroll format. This unique and almost musical format is more easily preserved through the vicissitudes of war and peace; and, happily, we are able to study in this country a rich assembly of Northern Sung landscape handscrolls | 14–18 |.

Perhaps the earliest of these, and certainly the most monumental in scale and symmetrically balanced in composition, is the scroll, *Fishing in a Mountain Stream* | 14 |. The traditional attribution is to Hsu Tao-ning who flourished in the early eleventh century and was known to his contemporaries as a master of winter "moods" and in his later years for a "fresh and spontaneous" manner.[96] Since the handscroll format for landscape was then a relatively experimental form, we can expect and do find a compromise between the verti-

* L. C. Goodrich, *A Short History of the Chinese People*, (New York, 1943), p. 155.

cality implicit in the older hanging scroll or wall format and the horizontal movement through time appropriate to the handscroll. The free and loose calligraphic brushwork attests to the remarkable speed with which the landscape art had matured. The second handscroll |15| is by Kuo Hsi, one of the greatest names in the history of Chinese painting, and shows an increased complexity in the presentation of a similar northern barren landscape view. The organization of space here does not depend upon planar overlaps so much as on staggered "islands" in a sea of flat, indefinite space. The natural forms have an even stronger grotesque character than those of Hsu Tao-ning and an even freer and wetter handling of the brush. Kuo was estimated at the head of his generation[96] and evidently justly so for his wry and personal outlook was supported by a great command of medium, representation, and format. He was a climactic figure and may well represent the end of a classic and balanced moment for monumental Chinese landscape painting following the almost legendary founders of the tenth and early eleventh centuries; i.e., Ching Hao, Fan K'uan, Chu-jan, K'uan Tung, Li Ch'eng, and Hsu Tao-ning.

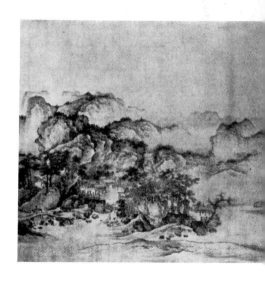

A virtual summary of accomplishment previous to the twelfth century, as well as a statement of new problems and insights, is to be found in the anonymous *Streams and Mountains without End* |16|.[56] It is a significant monument, not only for this, but also because its date in the first quarter of the twelfth century can be established beyond a reasonable doubt by consistent colophons going back to at least 1205, at which time the painting was already considered old; by its unique correspondence with the only archaeological evidence available, a fragment on silk from Khara Khoto; and by its stylistic conformity with paintings in the Palace Collection likely to be Northern Sung in date. As a summary, *Streams and Mountains without End* provides us, beginning with the first mountain range, with an archaic encircling mountain-space-cell of T'ang origins, a rolling and resonant distant mountain range in the manner of Tung Yuan, a crystalline and angular mountain range and valley in the style of Yen Wen-kuei, and finally a powerful vertical mountain statement, twisting and writhing like the mountains of Fan K'uan. The opening and closing flatlands are a new invention of the early twelfth century and illustrate a tendency to realism and, further, a gentler, lyrical, and more intimate approach than heretofore. The whole effect of a small and distant scale is also more in keeping with a realist attempt to reconcile the monumental with a small format, the conceptual and the austere with the visual and the intimate. All of these factors, both original and eclectic, combine with the excellent preservation to offer a "moistly-rich" original document of the transition from Northern to Southern Sung.

24

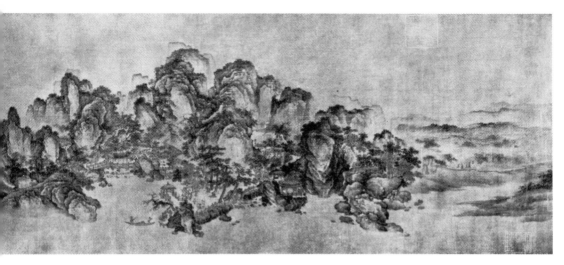

16 | *Streams and Mountains without End* by unknown artist, handscroll (two details)

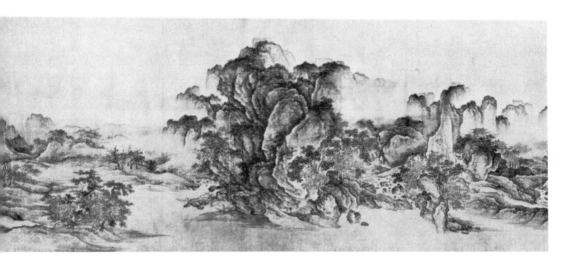

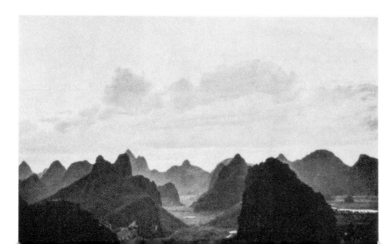

L | Mountains between
Kuei-lin and Yang-so

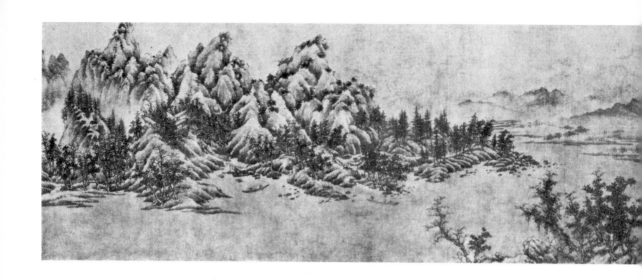

M | Mountains in Shensi

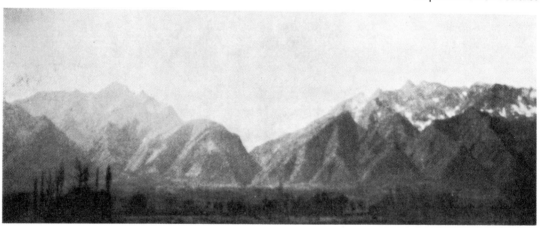

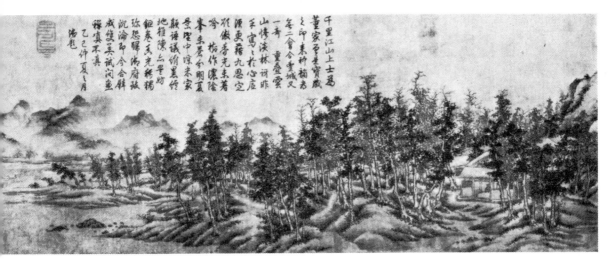

千里江山上士爲董家豐生寶嚴
之印素紆諸志
各二會合靈域又
一再重疊雲
山惟淡林詞昨
玉宜香光未著
雅傚香光未著
冷梢作濃陰
峯來芳今明夏
景空中深未家
顧語議俏甚佳
地推陳品筆功
鉅峯高光折稿
弥忽緯府故
沈淪印今合餅
戌微吳試閒查
梅真不眞
乙之仲夏之月
清訖

18 | *Verdant Mountains* by Chiang Ts'an, handscroll

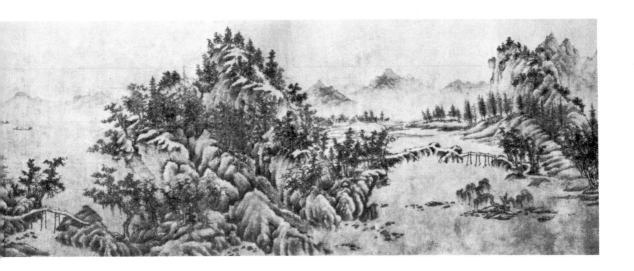

A second and equally well-preserved land-
scape of the transition is *Verdant Mountains*
| 18 | where a single personality is evident in
the informal composition and in the staccato
and delicate touch. Calligraphic and free as
this brush may be, the structural and visual
relationship of the mountain range to its
counterpart in nature, the mountains of Shensi
| M | is reassuring and certifies the belief of
the Chinese painter that art proceeds from
nature as well as from art.

The low horizon and near view partly seen
in *Streams and Mountains without End* is fully
expressed in the little album leaf by Li An-
chung of 1129-30 | 19, facing p. 65 |. It is
probably based on the innovations of the more

famous Chao Ta-nien, and evokes that quality of personal intimacy with nature typical of that master. On the same intimate scale, the little album painting from Boston | 20 | is another "in-between." It is like Northern Sung in its relative completeness and interest in far as well as in near detail. It is like Southern Sung in its asymmetry and arbitrary juxtaposition of the large units. The diagonal composition with the two boats reversing the main direction is as beautifully accomplished as the representation—a late summery day, still, save for an offshore breeze. The existence of the miniature-like detail is probably due to the "literal" style first sponsored by the Northern Sung Academy during the reign of Emperor Hui Tsung which ended in 1127; but the rather playful and repetitive rhythms of the brush strokes are more like the aristocratic mannerisms of such Southern Sung court painters as Ma Ho-chih. The measure of difference between the middle and late Sung styles can be determined by the comparison of the Boston leaf with another similar composition from the Metropolitan Museum | 24, p. 34 | which is almost completely vaporized.

Before turning to the new and different solutions of the Southern Sung painters, we must note a personal and unusual mode of brushwork which was the contribution of Mi Fei, followed by his son Mi Yu-jen | 17 |. While the format of *Cloudy Mountains,* with its firm, self-contained, and strongly architectonic composition, is basically Northern Sung and monumental, the brushwork is markedly different. The blunt strokes are massed, giving a rich tone and a compact solidity to the forms of the mountains. At the same time there are elements such as the long brush strokes of the shore at the right which are rather arbitrary and dramatic and which anticipate the extravagantly bold brushwork of the spontaneous style of late Sung. The low-lying hills with their gentle contours and enfolding clouds,

17 | *Cloudy Mountains* by Mi Yu-jen, handscroll

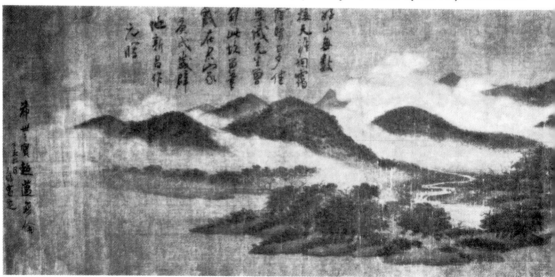

20 | *Cottage by a River in Autumn* by unknown artist, fan-shaped painting

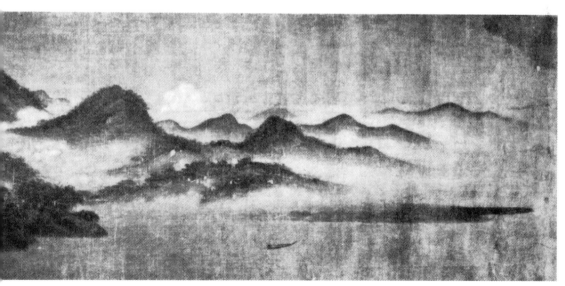

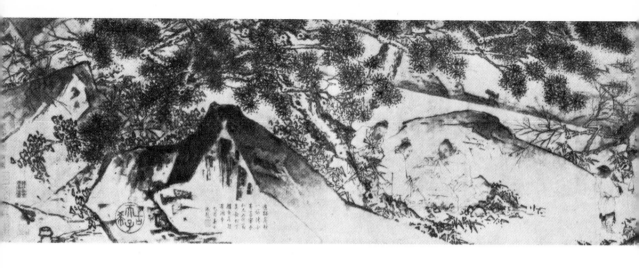

21 | *Second Excursion under the Red Cliff* by Li Sung, album painting

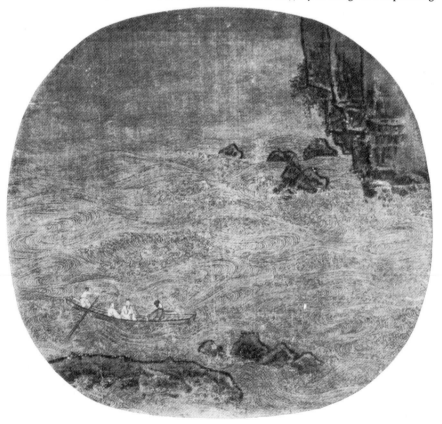

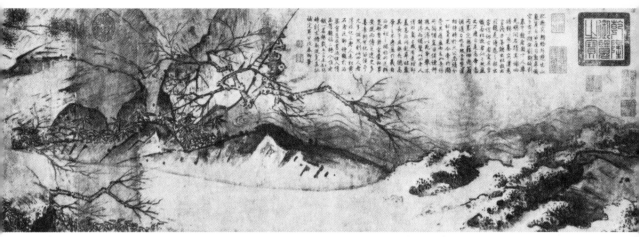

22 | *The Four Old Recluses in the Shang Mountains* by Ma Yuan, handscroll (detail)

rather than sheets, of mist are characteristic of the Southern coastal regions and should be contrasted with the more spectacular inland mountains or the great open spaces of the North.

The southward flight of the court after the Tartars' capture of the Northern capital in 1127 marked the beginning of a century and a half of academic and individualistic painting activity which developed a second climatic answer to the problems of landscape painting. In addition to the hanging scroll and handscroll, the album painting, square or fan shaped, was an important and significant ground for painting. The resulting implications of an intimate and introspective result are well founded. The typical styles of Southern Sung, despite sporadic efforts to revive monumentality, were the Lyric and later the Spontaneous.[54] The first used sudden and arbitrary juxtapositions of selected details or motifs combined with misty washes and highly calligraphic brushwork; while the second, more conservative, even archaistic in composition, expanded and specialized the intuitive and

spontaneous command of the brush even to the extremes of the "flung-ink" style.

A small, fan-shaped painting by Li Sung, *Second Excursion Beneath the Red Cliffs* |21| indicates the preliminary direction and emphases of the Lyric style of Southern Sung. The fragmented composition is asymmetrical in arrangement with a few accents of massed ink against the texture of the water. The rough sea is bound by a perfectly controlled linear-rhythmical movement, and hence we need have no fear for the boat with its occupants, close as it is to the rocks. The album leaf is treated like the emotive fragment of a lyric poet. A similar approach to a different subject can be found in the handscroll by Ma Yuan |22| where the romantic spirit is conveyed in part by the fragmented near elements of the composition: crackling pine trees, axe-hewn rocks, and bold diagonals. Again one feels more immediately involved in the depicted scene; the appeal is emotional and exciting rather than rational and exalting. Asymmetry has now become a normal device in organizing the picture space.

31

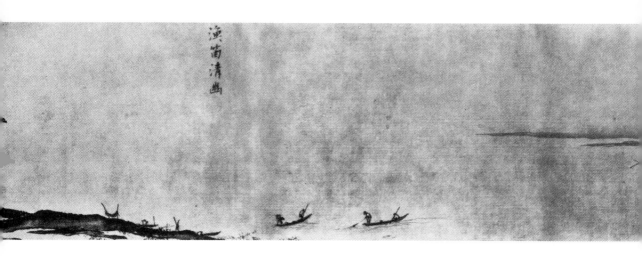

渔笛清幽

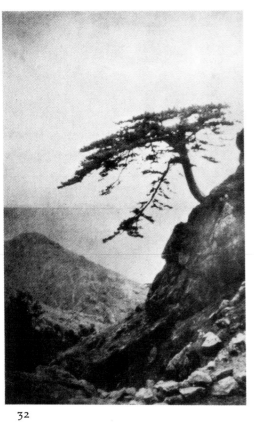

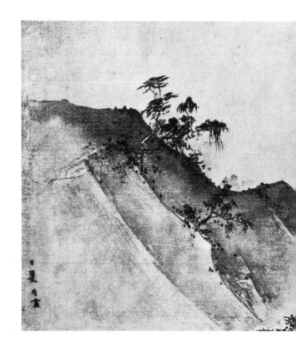

N | Pine on T'aishan (Shantung)

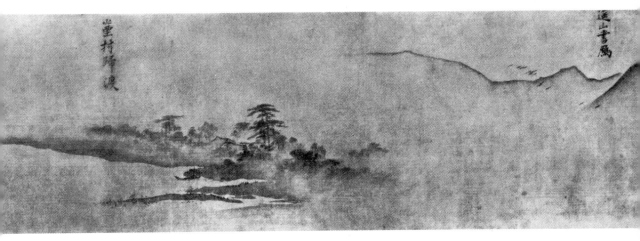

23 | *Twelve Scenes from a Thatched Cottage* by Hsia Kuei, handscroll (two details)

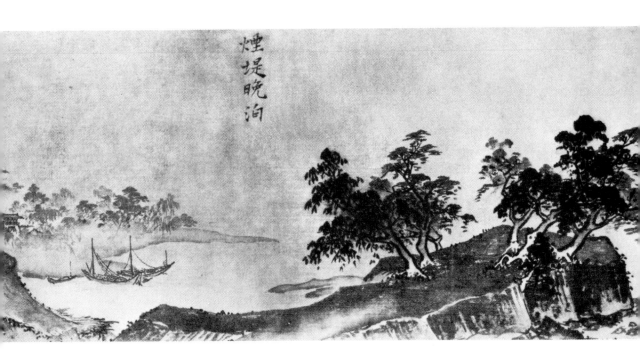

24 | *River Landscape in Wind and Rain* by unknown artist, album painting

25 | *Sunset over a Fishing Village* by Mu-ch'i, handscroll

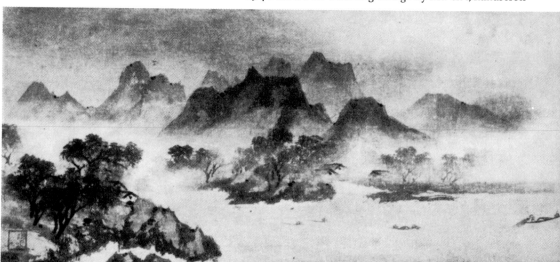

One of the few large-scale classic statements of the Lyric mode is the extraordinary but incomplete work by Hsia Kuei, *Twelve Scenes from a Thatched Cottage* | 23 |, of which the last four scenes are preserved. (A complete version, but a later copy, is at Yale University.)[42] It is the "type" solution of the style and period for the most difficult format, the handscroll. The essence of the achievement is dramatic contrast whether in details such as the transitions or juxtapositions of ink tones, contrasts of sharp brush strokes with soft, wet washes, or in larger matters such as near and far distance, complex units such as trees, nets, boats against empty silk-space, or a low, misty shore beside a soaring, sharp-edged mountain range. Where the Northern Sung painters had rather a uniformly detailed vision of nature in sharp focus, the Ma-Hsia school chose to see things sharply or dimly, in or out of focus, in accordance with a less rational, more emotional and dramatic approach. Where before the universal *Li* was expressed by rational examination and construction, it was now selected intuitively here and there, found with a sudden sense of awareness. If we compare this with the Wang Wei copy, while each scene in each scroll is labeled, one needs only to look at the cramped topography of the earlier scroll and the immediacy of vision in the Hsia Kuei, to realize the long process that has intervened. The tie to the actuality of nature is still very much present, as we can see in the photograph of the solitary pine on T'aishan | N |, but it is precisely that lighting and that silhouette, sharply outlined and divorced from its complete setting, that was only a part of the whole before and is now a symbol for the whole.

This suggestive art can be seen in numerous examples in this country. The small fan-shaped leaf of a stormy waterway | 24 | is evidence of the limits to which delicate suggestion can be pushed. Yet with all of its personal poetry, if we place this with a comparable subject by the individualists of the seventeenth century | 91 |, the unique nature of each expression is revealed and, in addition, the means of differentiation in time. The Southern Sung leaf is a filtered storm "recollected in tranquility," while the other takes one into the teeth of the wind. The psychological sense of direct involvement in a given picture, with little or no feeling of recollection or remove, is a sign of later individualism.

The final statement of Southern Sung landscape attitudes is made by practitioners of the Spontaneous mode, such as Mu Ch'i | 25 | or Liang K'ai. One of the *Eight Views of Hsiao and Hsiang* is a type example with its extremely bold "flung-ink" techniques, as drastically simple as a sword cut or an explosion.[84] The technique of the scroll reveals an abrupt and arbitrary personality as well as the final direction of Sung painting. Practiced largely by monks or others under Ch'an Buddhist discipline, this last Sung style is a pictorial parallel

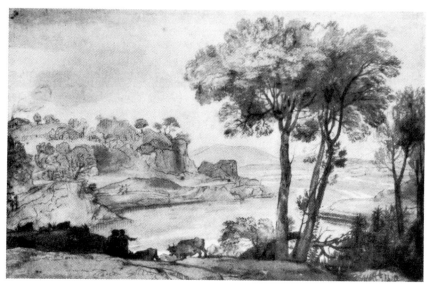

A | *Landscape with Figures* by Claude Gellee

to the mystic's sudden enlightenment, as well as to the individual's revolt against the times of trouble that were the last years of the Dynasty. Building on the increasingly dramatic brushwork of the Lyric painters, the Spontaneous masters often returned to more self-contained and even monumental compositions —the wild touch was their contribution and the end of a cycle, or period, in Chinese landscape painting. The tradition was carried on by secluded Chinese priests and, more significantly, the priest-painters of Japan, where the extremist nature of the Spontaneous style was more readily acceptable than in the country of Li and the golden mean.

Things are never what they seem or what we wish them to be. It would be a serious error to imagine that all of this unfolds in a lovely sequence. Many conservatives or eclectics confute the critics and produce remarkable works outside the pigeonholes. These can reasonably be placed in this period of shifting values: Late Sung or Early Yuan, thirteenth or fourteenth century. *Landscape with a Flight of Geese* | 26 | is a suggestive aesthetic parallel to the drawing by Claude | A |, as well as a subtle example of the wedding of the archaic colored decorative style with lyric fragmentation. The evident effort to realize a larger, more total effect recommends an early Yuan date.

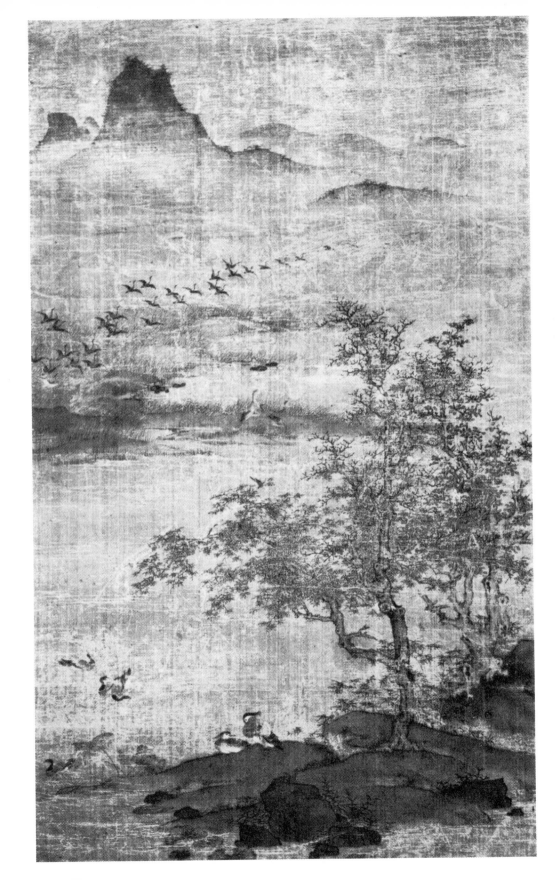

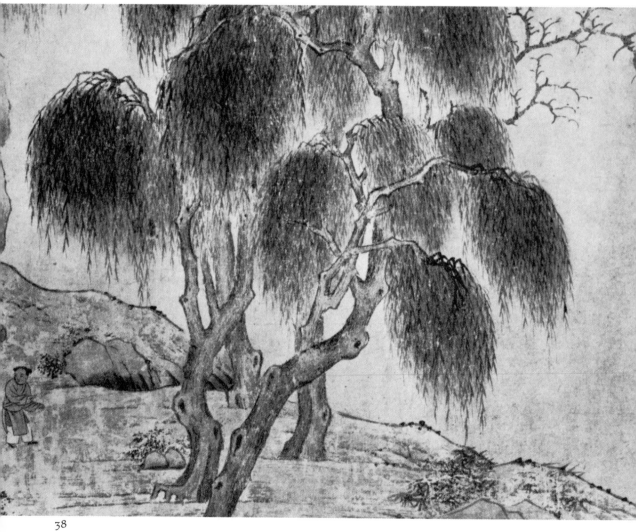

THE YUAN DYNASTY

Contributions of the landscape painters of the Yuan Dynasty (1279–1368), relatively little known at first hand in the Occident, were of the highest importance, not only in themselves, but also for the whole future development of the art. We have seen the fulfillment and elaboration of the monumental style followed by the baroque qualities of the Southern Sung painters. If we merely look for succeeding and similar qualities in the painting of the Yuan Dynasty, we will have missed the originality and real significance of that short ninety-year period. What happened is quite simple. The creative painters set into motion a new direction, a new cycle. Their experimentation, like that of the tenth century, was rapid, effective, and just as influential. The traditional deference to the past, inherent in Chinese society, influenced their pictures as evidenced by the writings and the colophons on them. But that homage, however sincere, should not conceal their real, and even revolutionary, originality.

All that went before existed and could not be erased. What is interesting is what was used and what was ignored. The reasons for a choice were in part aesthetic, for the major manifestation of traditionalism was a desire once more for completeness, for landscape with a rational *Li*, for the formats of hanging and handscroll rather than the fragmental album painting. They were also in part political and social, for non-cooperation with this foreign Mongol government, for a return to the strong virtues of the men of T'ang and Northern Sung rather than the supposed weaknesses of the retreating men of Southern Sung living on borrowed time. The highest ideal now was the sage-scholar-painter, aloof from the "dusty" world of affairs, immersed in the more wholesome world of nature with its inevitable principle, and expressing his allegiance to himself and to his friends through painting. With few exceptions, landscape painting was now omnipresent, the only proper subject matter for the creative painter.[25]

Let us first look at the Yuan painters who connect with the past, and then at the creative individuals who fixed the direction of the future. Ch'ien Hsuan lived only briefly into the Yuan Dynasty, refused its favors and so became the first, in point of time, of the virtuous Yuan masters. His *Home Again* | 27, see also 27a | is a most consistent example of archaism in style and subject. Based on a prose poem by the fifth-century T'ao Yuan-ming, the representation embodies the new ideals. The scholar-official returns from his disagreeable connections with the state to his rustic home in the country. The blue, green, and gold style is also archaistic, as are the stiff, angular strokes used to delineate rocks and mountains. Note well the peculiar and exaggerated perspective of the old earthen wall, tilted almost as if it had been painted in the Six Dynasties, or even

39

by Wang Wei. The figures, too, where not damaged or retouched, seem deliberately stiff and archaic. On the other hand, the fluent handling of the dead branches and the carefully realistic willows are very much up to date and in the accomplished manner of the still life, Ch'ien Hsuan's specialty.

The most famous conservative was Chao Meng-fu, accepted by later generations despite his official cooperation with the Dynasty. The *Landscape with Twin Pine Trees* | 28 | is one of the most important remaining examples of his landscape art and an excellent explanation of the fascination he held for the Chinese: that is, his truly calligraphic brushwork. For us it is a difficult picture. Derived from the Northern Sung masters, Li Ch'eng and Kuo Hsi, in tree and mountain types, it represents a cleaned-up and purified version of the style of the earlier men. There is a greater emphasis on "running-brush" virtuosity. In a very real sense, it is a *skeleton* or outline of the past. We are forced to see only the bones of brush and landscape. The latter is not the subject of the picture; the brush is. At the same time, there is some wonderfully observed structure transferred into terms of wash, the rocks being particularly notable. If we study the scroll with the drawing by Wolf Huber | B |, Chao's specialization of interest seems less strange. The compositions as well are comparable although the Huber seems to us more specific in locale.

Two lines of Chao's inscription are most significant in the light of Yuan attitudes to Southern Sung painting:

> I dare not claim that my paintings are comparable to those of the ancients; contrasted with those of recent times I dare say they are a bit different.

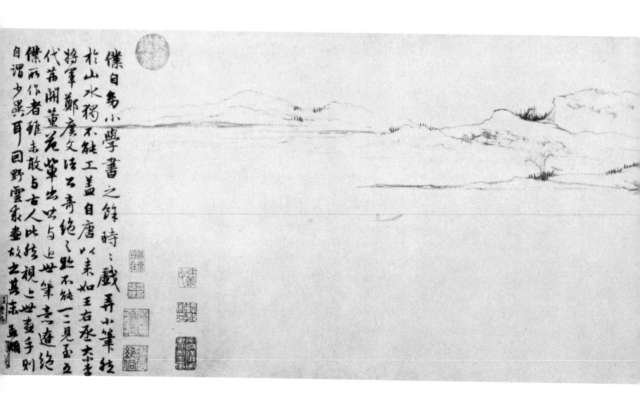

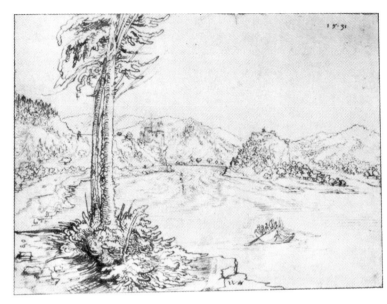

B | *The Rapids
of the Danube near Grein*
by Wolf Huber

28 | *Landscape with Twin Pine Trees* by Chao Meng-fu, handscroll

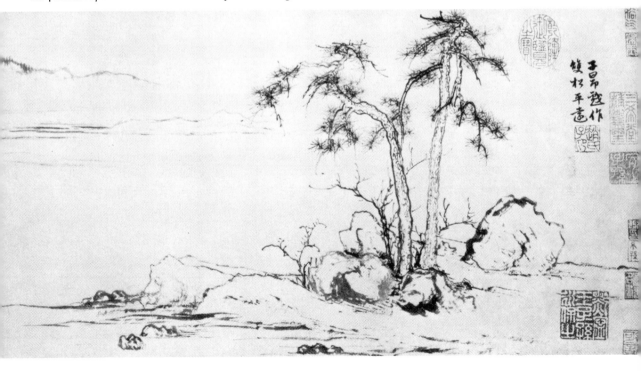

29 | *Landscape with Scholar Fishermen* by Chao Yung, hanging scroll

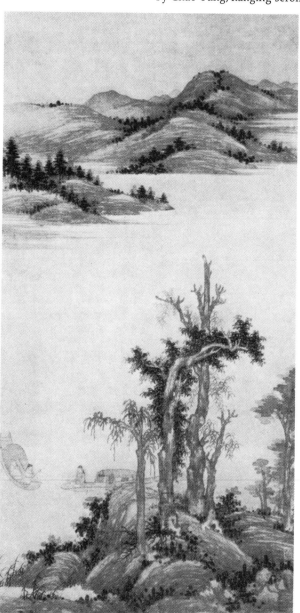

The Yuan masters knew well their originality and their indebtedness.

Chao Meng-fu's son, Chao Yung, is more conservative than his father, less brilliant in handling his brush, but rather more solid in his approach to nature's shapes. His *Landscape with Scholar Fishermen* | 29 | is evidently systematic in brushwork, with its carefully placed broad stubby strokes. While the format and general attitude are derived from Tung Yuan of Northern Sung, the sharp split in terms of surface pattern is typically Yuan. The split is only a surface one for the space does suggest, in depth, the great sweep of a body of water. The whole effect is a pictorial, not a calligraphic, one, and is achieved largely by the parallelism between the two main trees as foreground symbols of the distant protruding point and rising mountain range. This relationship, with the subtly controlled scale, tone, and suggested color, is the message of the picture, a quiet and seemingly coarse production until we find our way. This simplicity and roughness are surely deliberate archaisms designed to deceive the "crowd" in the best scholar-painter manner.

Another and lesser, but larger scaled example of Yuan conservatism is to be found in *The Guardians of the Valley* | 30 |. The study of ancient trees was already in evidence in the Northern Sung period, judging from copies or records associated with Li Ch'eng, Kuo Hsi, and others, and was followed after Yuan in especially notable fashion. The *Guardians* is typically more specialized than earlier productions. The only complex treatment is in the larch trees, the rest of the picture being a simplified setting for the main theme.

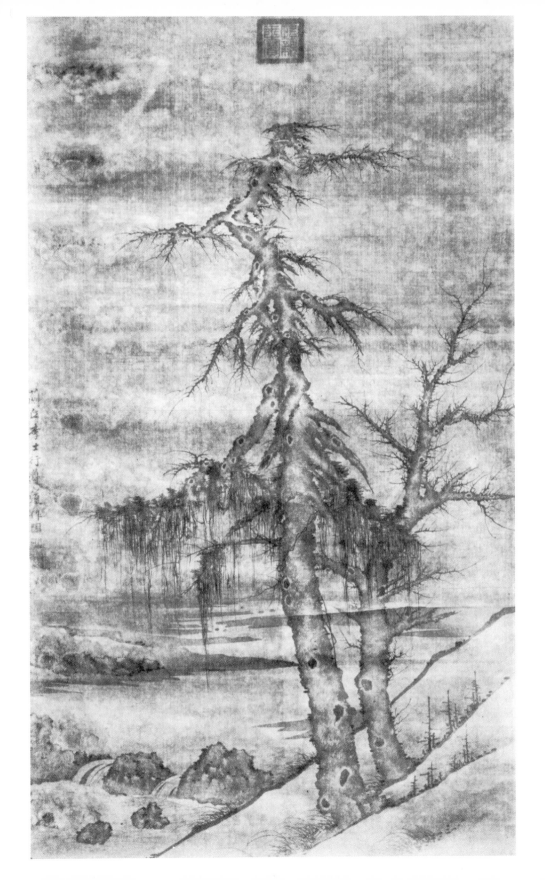

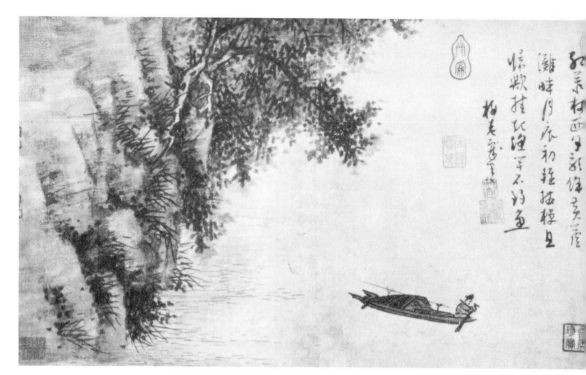

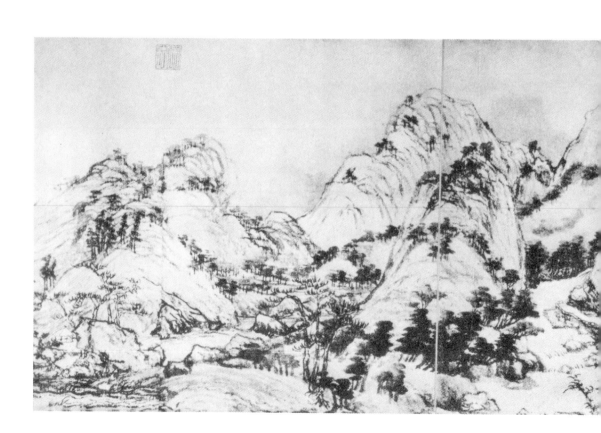

32 | *Fisherman* by Wu Chen, album leaf mounted as a handscroll

The Yuan conservatives are qualitatively of great interest but their original contributions are somewhat incidental to the traditionalism of what they conceived to be Northern Sung style. The most significant and creative contributions of the age were made by the "gentlemen painters" *(wen jen)*, especially the highly revered "Four Great Masters": Huang Kungwang, Wu Chen, Wang Meng, and Ni Tsan. Their testament must now be described and evaluated, beginning with Huang Kung-wang. A detail of his famous *Fu Ch'un Mountains* handscroll | 31 | may reveal something of the rational quality in brushwork and composition that seemed to his contemporaries a true return to the great masters of Northern Sung. But it is in effect a new style with a more abstract, less representational type of brush stroke, a purer and more remote air derived in large part from the judicious display of numerous and complex areas of white paper. Like the art of Poussin, Huang's art seems "aesthetic," self-conscious in the best sense, a style of painting for those who love painting, including first and foremost, other painters.

Fisherman | 32 | by Wu Chen, a subject we have seen in the Southern Sung album leaf by Li Sung | 21, p. 30 |, is just barely a landscape. Actually it falls equally well into that special category of Chinese painting described by its title. But the unified atmosphere of the painting conveys more than its limited repertory of shapes. The painter has executed a deliberately "homely" picture, but the brush dominates. It is a conservative brush, not unlike that of Chao Yung | 29 |, but freer, "untrammeled," less systematic, and more direct. Note, too, that Wu varies his tones drastically, using a typical Yuan variation of in-and-out tones in the foliage on the cliff. This picture and other reasonably sure works of Wu Chen show a closely knit combination of all the Sung styles with perhaps more emphasis on the early material. What is most significant about the artist is his insistence on "single-stroke" brushwork—abrupt, vigorous, and decidedly masculine. His contribution was the selection and emphasis of this one point within a more conservative framework than that of his two juniors.

The complicated textures of nature translated into the equally complex language of the brush had occupied earlier painters only up to a point, usually in terms of details rather than the allover surface of the picture. The new discovery and practice of Wang Meng was just this textural variety and complexity. In his *Fishing in the Green Depths* | 33 | we can immediately sense a new and unusual personality. At the same time we rediscover a unified relationship between the distance in the scene and the surface of the picture itself. This is accomplished by the textures made by inter-

31 | *Dwelling in the Fu-Ch'un Mountains* by Huang Kung-wang, handscroll (detail)

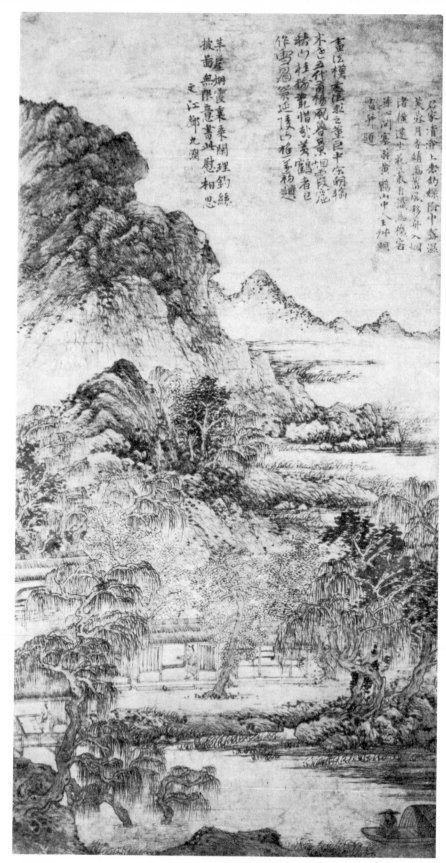

33 | *Fishing in the Green Depths* by Wang Meng, hanging scroll

woven brush strokes which function both in depth, as representation, and as strokes on the surface of the paper. With the realization of nature's complexity Wang also found the means to give movement to landscape, by the undulating brush strokes, and by rolling, even writhing profiles for his rocks, trees, and mountains. These textural and kinetic interests are accompanied by a coloristic quality, if such a word can be used in early Chinese painting. The limited washes of red-orange, blue, and green are used in a concentrated way. The composition of the picture is rather formal and well enclosed within the picture boundaries. In this Wang is, like his contemporaries, indebted to the Northern Sung painters. His style is, in the reliable works that have survived, seldom delicate or refined. Like Wu Chen, he displays in this picture a rough and ropy exterior which one must penetrate to find the substance of his art.

O | New Summer Palace Garden (Hopei)

It would seem wise at this mid-point of our discussion of these two innovators, Wang Meng, and next, Ni Tsan, to point out that all of their generally accepted paintings are on paper. The *Fishing in the Green Depths*, damaged as it is, was clearly painted on a polished paper with a hard surface capable of taking a sharp brush stroke. We shall see that the Ni Tsan is on a more absorbent paper allowing subtle and poetic effects of the brush. Paper became, for the progressive artists of the Yuan period, the most desirable ground for the brush. The reason is obvious. It is considerably more a servant to the brush than silk and where the emphasis was now on the brush stroke, the touch of the painter, paper was the answer.

Ni Tsan was probably the most imitated and copied artist in his period, if not of any period. His legendary "purity" and "loftiness" made him the scholar's ideal; and the apparent simplicity of his painting made superficially accurate imitation rather common. With Wang Meng, Ni influenced more later scholarly painting than any other man. *Rock, Tree and Bamboo* | 34 | is characteristic of his developed style. Where Wang Meng tended to cover the paper with his network of lines, Ni Tsan used a great deal of blank or lightly touched paper throughout the picture, but without opposing dense areas to blank areas as did the Ma-Hsia school of Southern Sung. The result is a delicate, pure, even feminine, visual impression. He is very sparse in his use of the brush and usually tends to two extremes—very wet or very dry ink. The dry textures build up whatever mass is suggested while the wet touches define boundaries and add liveliness to the areas concerned. Usually there are no figures—an empty, ideal, cleansed world of nature. The composition of this picture occurs often in his work and is quite in keeping with his period, but with Ni the minor variations are all important.

47

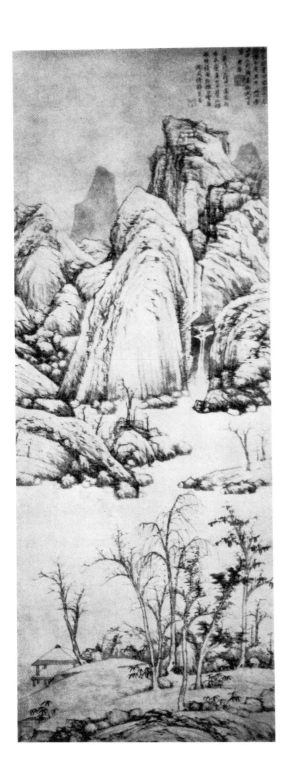

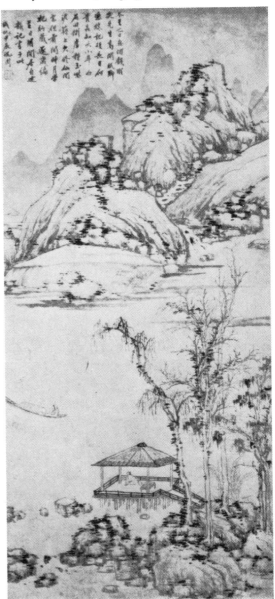

49

These minor variations are not merely technical but are primarily variations in mood. Often the key to the mood is the artist's inscription. Almost none of his paintings, or indeed those by most of the Yuan individualists, are lacking in a reasonably long inscription by the artist which tells or hints at the mood, *raison d'être* and/or circumstances of its creation. These painters are not called literary without reason. They took for granted and used their manifold literary, calligraphic, and pictorial accomplishments almost interchangeably. Further, the mood which the picture aroused in notable individuals, priestly or secular, was important and hence their inscriptions were added to those of the artist | 34 |. The delicate, almost prim character of Ni Tsan's calligraphy is as much a part of the painting as is the meaning of his inscription:

> Windy and rainy days—what a chilly
> wheat-harvesting season,
> With brush in hand, I fight depression by
> copying.
> Fortunately, I can depend upon you, my friend,
> to send me consolations—
> "Pine-lard" wine, and meat with bamboo shoots
> that never fail to awaken appetite.

The most interesting characterization of the art of Ni Tsan is given by another great individualist of a later date, Shih-t'ao | 88–91, pp. 111–116 |:

> The paintings by Master Ni are like waves on
> the sandy beach, or streams between the stones
> which roll and flow and issue by their own
> force. Their air of supreme refinement and
> purity is so cold that it overawes men.
> Painters of later times have imitated only the
> dry and desolate or the thinnest parts, and
> consequently their copies have no far-reaching
> spirit.[90]

50

Since the style of Ni Tsan is so important in later painting, *Rock, Tree and Bamboo* is compared with two works in the manner of Ni Tsan by early Ming painters of the first rank, Liu Chueh | 42 | and Shen Chou | 53 |. In so doing, we hope that the idea of "copying" is dispelled. Within the set limits one can visually differentiate the individual variations on the given theme: first, the suggestive and cloaked style of Ni Tsan; second, the more brittle and dramatic composition by Liu Chueh; and third, the rougher, bolder, playful, and at the same time more solid style of Shen Chou. The relationship is not so much that of a musical composition played by two virtuosi as it is a variation on an earlier composer's theme by two creative composers of a later day.[30] One thinks of Brahms' *Variations on a Theme by Haydn,* or the less acknowledged "borrowing" by any creative musician.

Ni Tsan and Wang Meng were not alone. Others explored similar ground and priority of discovery is not too clear from Chinese histories, though precedence is always assumed to be with these two. Thus Ts'ao Chih-po has much in common with Ni Tsan. While Ts'ao died well before Ni, he is always described as influenced by the latter, when the opposite might well be indicated. Both artists share an interest in wet and dry textures, spare composition, and a lack of interest in figures. While looking at *A Pavilion near Old Pines* | 35 |, one should always remember it is an album page and meant to be seen at close range. Then the tremendous changes in scale, the in-and-out treatment of the upper pine branches, the lovely, free brushwork of the left hand tree, and the rich "soot-varnish" ink are at their most effective. Like the Chao Meng-fu | 28, p. 41 | and the Li Shih-hsing

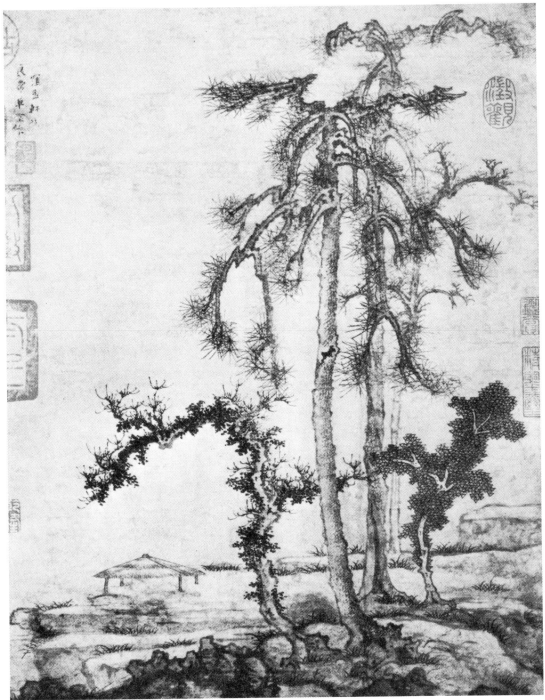

51

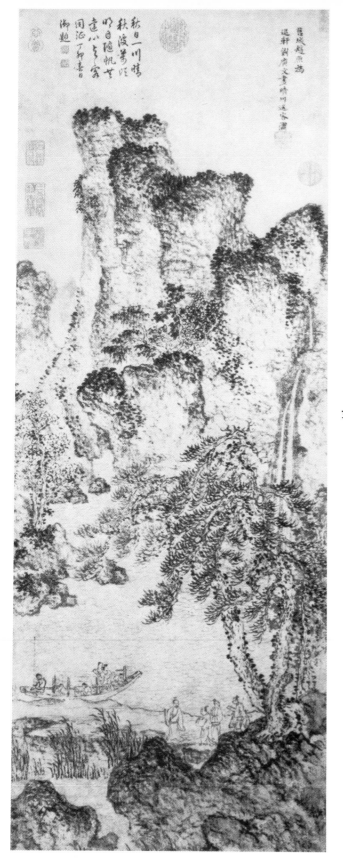

36 | *Saying Farewell to a Guest on a Fine Day*
by Chao Yuan, hanging scroll

| 30, p. 43 |, this old tree type of composition goes back to such Northern Sung masters as Li Ch'eng.

But more often we find late Yuan pictures by masters essaying the complex textural problems that fascinated Wang Meng. The first of these pictures, *Saying Farewell to a Guest on a Fine Day* | 36 |, is by Chao Yuan, one of those worthies who gained posthumous fame by their death at the hands of the powerful Hung Wu, first emperor of the Ming Dynasty. The scroll has an obvious textural relationship to Wang Meng, except that Chao uses smaller strokes, even points of ink. The two most evident dissimilarities and very original, too, are: the forcing of ink tone at the edges of large forms so that a rather dramatic contrast appears, with resulting clear separations instead of the unified surface characteristic of Wang Meng; and the deliberately ghostly quality of the figures, impalpable before the powerful background. The splendid preservation of the picture is extraordinary and permits us to savor the ink tones and touch to a higher degree than is usual in originals of the period. We can find here the careful "glazes" of ink that contribute to the richness of the whole.

Another fourteenth-century textural style is to be found in the little handscroll by the almost unknown Yao T'ing-mei | 37 |. It presents a consistent and somewhat unusual manner of building up tones by scumbles of ink finished with dark, wet accents, but always following an irregular, twisting line whether in rocks, trees, or mountains. The composition is equally original with its irregularly shaped space holes through which we move away from near areas of heavy texture. The result of these devices is a surface feeling of quiet gravity with a certain turbulence beneath. Two other details attest a master deserving of some fame: the "fade-out" of the landscape into the inscription and the delicate, precise brush strokes in the foreground grasses.

37 | *The Scholar's Leisure* by Yao T'ing-mei, handscroll

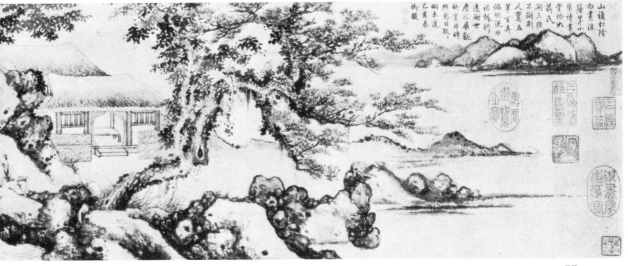

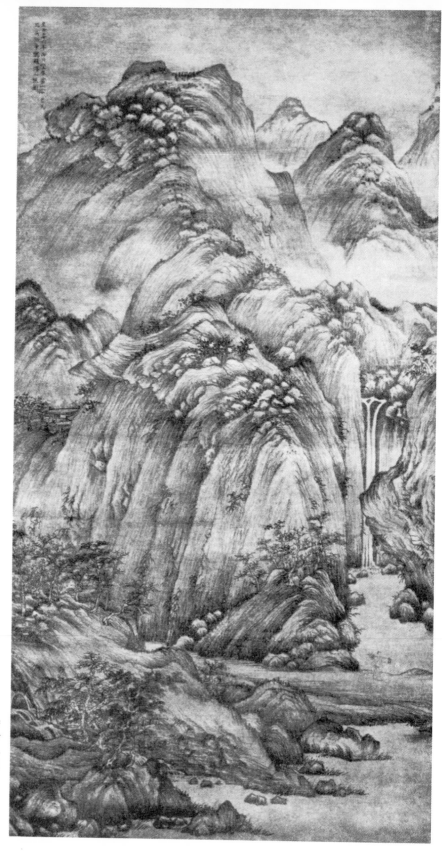

38 | *Lo-fou Shan's
Woodcutter*
by Ch'en Ju-yen,
hanging scroll

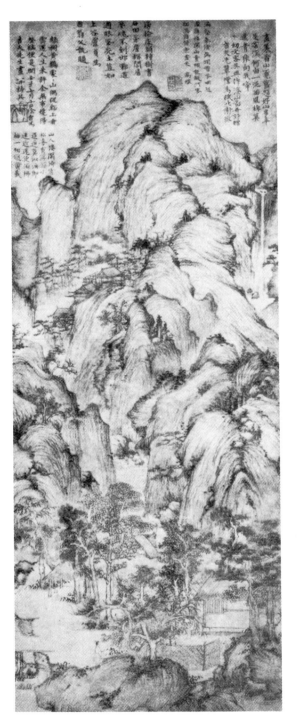

The last two Yuan paintings to be discussed | 38, 39 | are by Chen Ju-yen and Hsu Pen, another of those unfortunates whose death was arranged by the Emperor Hung Wu. *Lo Fou Shan's Woodcutter* is the more conservative of the two, owing much to Northern Sung monumentality. But the overall texturing of the surface evidences the influence of Wang Meng | 33, p. 46 | as well as a more consciously aesthetic, "picture-making" activity.

The painting by Hsu Pen provides a fitting end to our view of this all-important period for it is both a creative and an eclectic picture and so gives us that neat and tidy summary so much to be desired. The artist owes much to the way of Ni Tsan for his delicate tree forms and dry textures, and to Wang Meng for his complex and rolling vision of nature. This marriage of two seeming incompatibles is an accomplishment in itself, but when a truly monumental composition within a small format is added the result is completely satisfactory. One should note as well the additional element of the fantastic, for the twisting metamorphic shapes are quite unusual. They may be found occasionally in Wang Meng, only once in Ni Tsan, and that because of a specific subject, the *Lion Grove* near Suchou,[33] where there were carefully selected rocks that looked like animals. Much later, Wu Li | 85, p. 106 | was to dwell in this realm of the grotesque. Hsu's landscape is well provided with literary inscriptions and that, too, is typically Yuan. His *Streams and Mountains* is a true accomplishment in a single work as complete and final as the total accomplishment of the Yuan painters on a larger scale. Another period of ever quickening experimentation in the continuing life of Chinese landscape painting was drawing to a close.

THE MING DYNASTY

40 | *Ten Thousand Bamboo* by Chin Wen-chin, handscroll (detail)

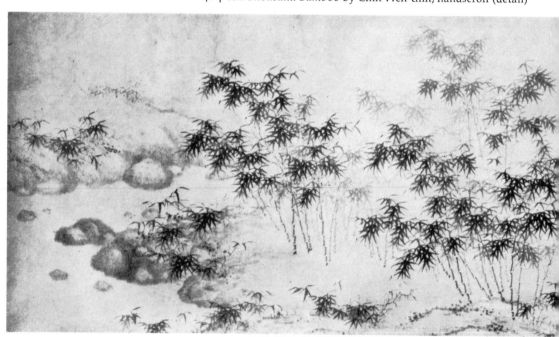

56

Curiously enough, the return of a native Chinese dynasty to power in 1368 did not cause a mass return to the Academy of the Court on the part of the literary painters. Perhaps the fatal experiences of Hsu Pen, Chao Yuan, and others with the first Ming Emperor helped to maintain the disinclination for official posts. But fundamentally the garment of remote and solitary isolation "above the crowd" fitted the progressive painters so well that the idea of a return to the restrictions of Imperial or official patronage was never seriously entertained. Like late nineteenth-century "Bohemia," the scholar's retreat, literal or figurative, had become the accepted climate for artistic creation. This climate was radically different from the re-created official Academy and its adoption of a very conservative pre-scholarly style of painting which could be taken as Southern Sung or at least conservative Yuan.

The real history of landscape painting in the Ming Dynasty is to be found outside the painters of the official Academy and this history can be organized without undue distortion into: (1) a short period of about fifty years' continuation of the Yuan literary style, (2) a simultaneous flourishing of a more conservative non-literary style, (3) a brief classical moment of controlled emotion and rationality in the art of Shen Chou, (4) the elaboration of the literary tradition, and finally (5) the new impetus provided by the experiments of Tung Ch'i-ch'ang and the later individualists of the seventeenth century.

The Dynasty begins as a brief continuation of Yuan Dynasty styles and interests in the works of such men as Wang Fu and Yao Shou. Two bamboo-landscape handscrolls, one by a pupil of Wang Fu, illustrate this continuity and the beginnings of change. Bamboo painting, beyond our scope here, was a particular favorite of the scholar-painter, for it was a specialized form, a final test of brushwork. But these paintings combine that specialized interest with a true landscape vision. The scroll by Chin Wen-chin | 40 | does not derive from the near view implicit in bamboo painting, but from a relatively distant, objective, and contained viewpoint like that of the Yuan artists and before them the masters of Northern Sung. However, the delicate and poetic quality of *Ten Thousand Bamboo* speaks with the voice of the fourteenth and early fifteenth centuries.

The second bamboo landscape, *Bamboo Bordered Stream in the Spring Rain* | 41 |, is markedly different. The composition is daring and very much not Yuan in effect. If a precedent must be cited it is to be found in the truncated and arbitrary compositions of Southern Sung. But Hsia Ch'ang goes beyond those earlier concepts. The origin of his dra-

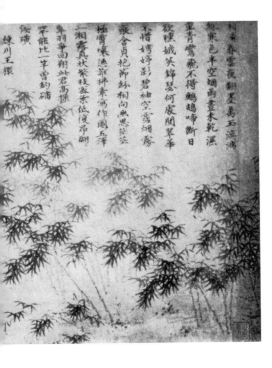

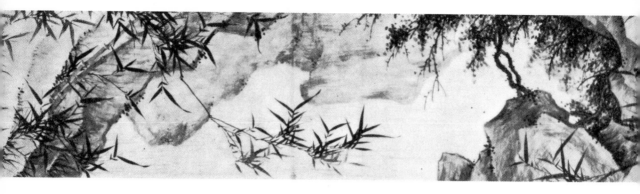

matic composition is in the eye. There is a visual unity in the picture as if one saw a narrow, panoramic strip of landscape through a slitted aperture. Further, the wet, glazed washes of the rocks act as a slightly blurred, out-of-focus foil to the sharply rendered grasses, bamboo, tree, and rocks in the foreground areas. The viewpoint, too, is striking, "a frog's-eye view" of the river bank. The fully realized daring of this scroll marks Hsia Ch'ang as one of the first Ming masters of an original stamp.

The conservative side of the fifteenth and early sixteenth centuries is presented by the Che (from the old name of the Chekiang region) School and its associates. It is usually maligned by the scholar-painters of the more progressive school deriving from the greatest fifteenth-century master, Shen Chou. But the relegation of the Che School to a subordinate position in an evolutionary sense need not obscure its very solid and aesthetically interesting achievement based largely on the Ma Yuan-Hsia Kuei style of Southern Sung. The most representative Che painter is Tai Chin and his long scroll, *Ten Thousand Li of the Yangtze* | 43 |, shows his style at its most conservative. The dominant influence is that of

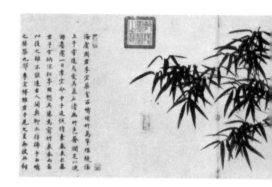

the most famous Southern Sung painter of that subject: Hsia Kuei. The crystalline rocks and the sharp, acutely angled manner of the brush are his, as are the contrasting juxtapositions of landscape detail. Still, with all of its traditionalism, if we examine the scroll carefully, many parts are not unlike the work of Shen Chou | 54, p. 70–72 |, and we are not far wrong if we say the prince of literary painters owed much to such men as Tai Chin.

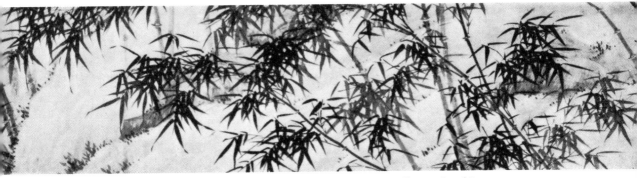

41 | *Bamboo Bordered Stream in the Spring Rain* by Hsia Ch'ang, handscroll (two details)

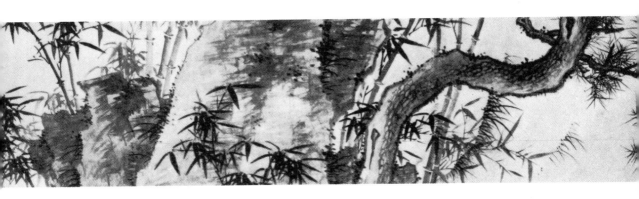

43 | *Ten Thousand Li of the Yangtze* by Tai Chin, handscroll (detail)

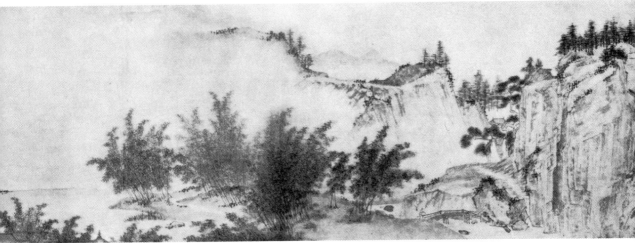

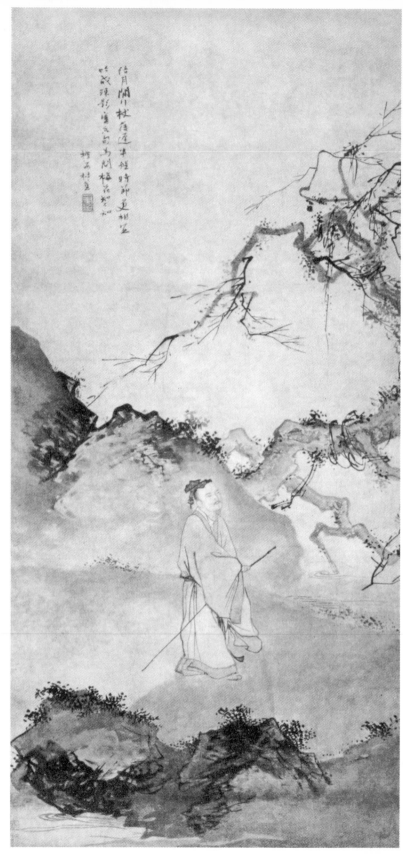

信月閒行杖屨遙半醒時神更超至時放疎影重叠為問梅花知不知

墙石邨

44 | *The Poet Lin P'u*
Wandering in the Moonlight
by Tu Chin, hanging scroll

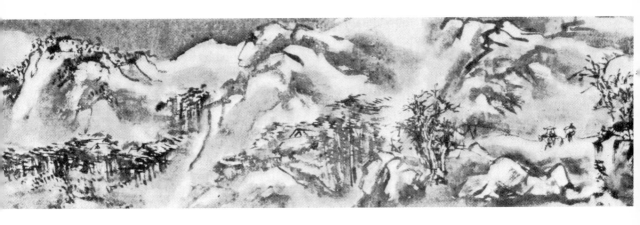

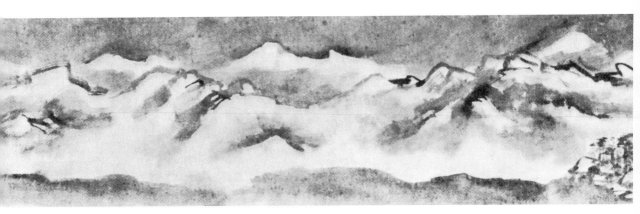

45 | *Winter Landscape* by Shih Chung, handscroll (two details)

The hanging scroll |44| by Tu Chin is equally under the influence of Southern Sung, but with an easy technique and composition that should place Tu with Tai Chin as one of the greatest men of the conservative group. The tree, violating the picture boundary, and the gaze of the sage beyond that frame, are typically derived from Southern Sung, but the rapid brushwork, with warm and cool tinted inks, is the virtuoso trademark of the Che painter. Perhaps the most extreme example of such virtuosity is seen in the *Winter Land-scape* by Shih Chung |45| where the wild abandon of the artist is expressed not only in the brushwork but also in his self-appellation, "The Fool."[115] Many such works were executed while the artist was under the influence of wine, a not uncommon state for Shih Chung. Inspiration is inspiration, however obtained, and the line between the fool and the wise man or the drunk and the inspired may often be thin indeed. One recalls the almost ritual drinking of the Seven Poets of the Bamboo Grove in the T'ang Dynasty.

This extremely bold and abbreviated style, rough in Shih Chung, tranquil and reserved in the scroll by Kuo Hsu | 46 |, is easily comparable to that of some Western masters such as Rembrandt | C |. The single stroke and the skillful use of wash and blank paper is common to both. The reed pen of the Dutch master provides the variety of line widths which the Chinese accomplished with the brush.

In contrast to this facet of the conservative tradition we find numerous works in an almost miniature technique, richly detailed and with a close fidelity to the traditional conventions of natural representation. The two most famous names in this connection are Chou Ch'en and his pupil Ch'iu Ying. The little album painting | 47 | attributed to the former, but for the tiny figures of common people, could well be by either. Where the Che School went to the Ma-Hsia group for their Southern Sung inspiration, Chou Ch'en and sometimes Ch'iu Ying were influenced by such early Southern Sung painters as Li T'ang or others | 20, p. 29 |, who tried to keep something of the earlier monumentality. *Haven of Tao Yuanming* | 47 | shows this conservative manner well, but the angular, linear touch, the rhythmically repeated trees with their feathery foliage and the minuscule detail are all characteristic of the second Ming conservative style. This detailed style was also used by Ch'iu Ying for archaistic, richly colored pictures in

C | *A Winter Landscape* by Rembrandt

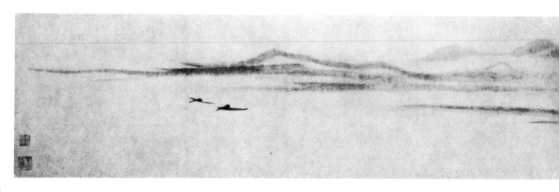

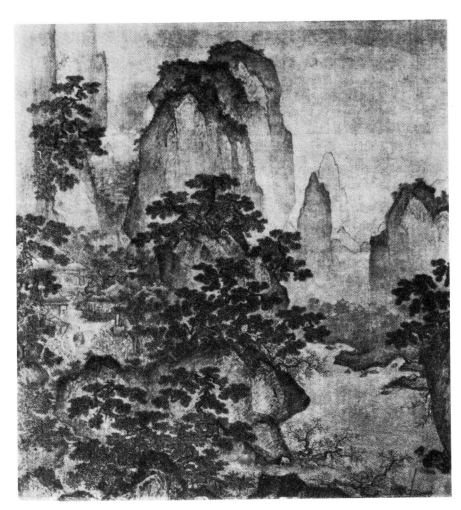

47 | *The Haven of Tao Yuan-ming* by Chou Ch'en, album painting

46 | *Landscape: Pavilions and Water* by Kuo Hsu, handscroll

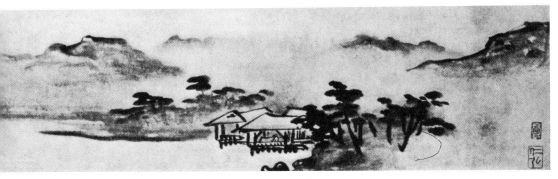

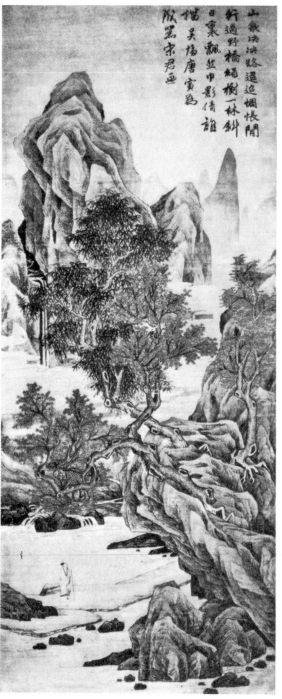

山氣決決路迢迢煙帳間
行過野橋緣樹一林彴
日裏飄紈甲影倩誰
横吳楊唐寅為
啟岩宋君畫

the T'ang decorative mode, as in the brilliantly colored hanging scroll |48|.

The second follower of Chou Ch'en was T'ang Yin, and with this master we come to the most important link between the conservatives and the literary school.[30] He can be placed in either, stylistically or socially, but the finest pictures available in the West illustrate his more conservative style. *Strolling Across a Summer Stream* |49| is an off-center Li T'ang type with diagonal thrusts and recessions and more angular, tenser shapes. The touch and methods in both scrolls are the same. The oyster-like incrustations that form rocks and mountains are built up by parallel but irregularly directed strokes of heavy ink. It is a manner as massive in detail as the pictures are as a whole. This massive quality is enhanced by a particular handling of the lighter materials, especially foliage and mist. The leaves are loosely and irregularly handled, while the bands of mist are arranged in thin planes at almost right angles to the picture surface. These feathery motifs and thin, flat sheets serve to emphasize the mass and weight of the major landscape elements. One should note also the narrow, jumping ribbons of water and the angular, grasping exposed tree roots. T'ang Yin's skill as a figure painter is suggested by the scholar with staff. Although there is also a free and delicate style associated with his name, making him acceptable to the scholar critics, T'ang Yin stands slightly apart from both camps. He is almost the last voice of the monumental style and by no means the smallest.

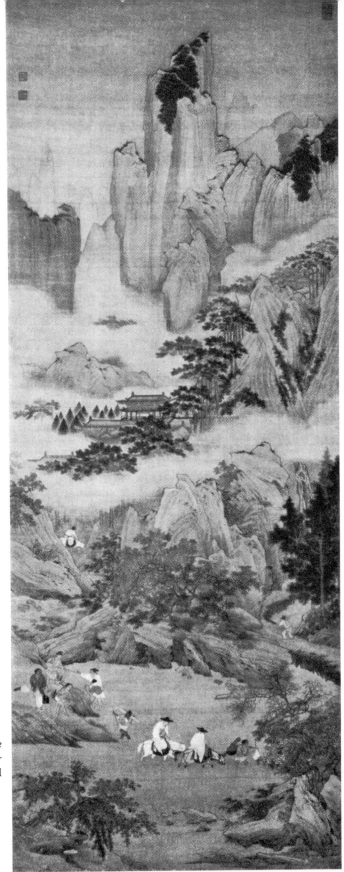

48 | *Emperor Kuang-wu of the Eastern Han Dynasty Fording a River* by Ch'iu Ying, hanging scroll

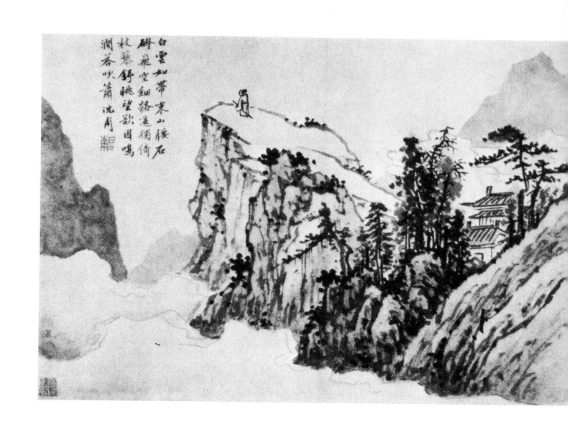

白雲如帶東山橫石
磷礧空細路連偏倚
枕慈舒桃坐欲眠嗚
澗谷吹簫沈周 ▣

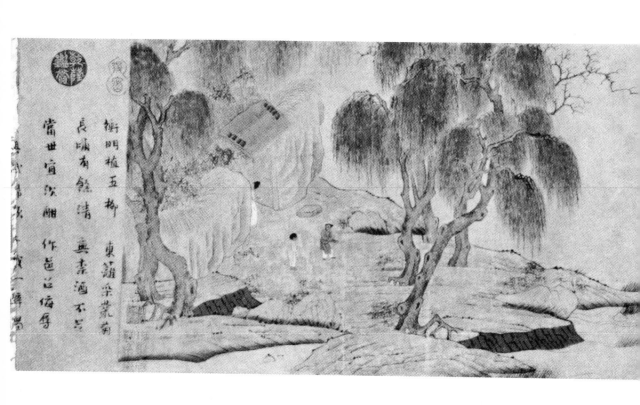

衡明植五柳
長嘯有餘清 東籬采荒菊
當世宵於醹 無素酒不足
作芭止偶辱

The Artist-poet on a Mountain by Shen Chou, album painting

27a | *Home Again* by Ch'ien Hsuan, handscroll

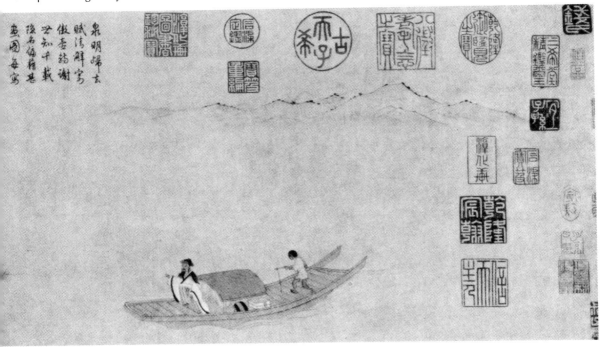

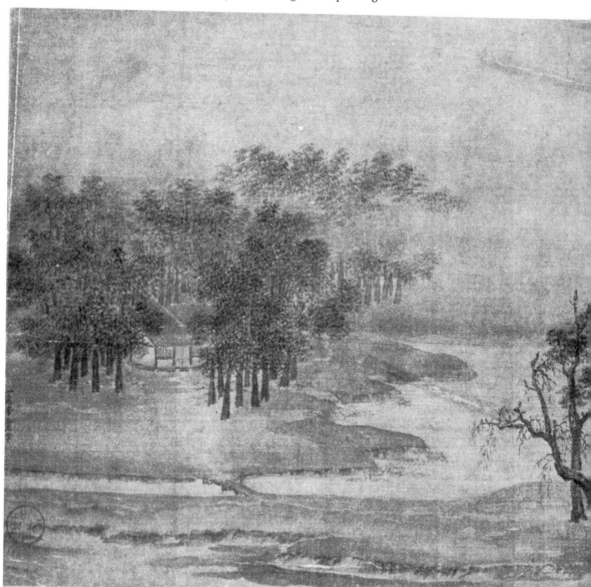

THE MING DYNASTY

THE WU SCHOOL

The Wu School, named after a part of the southern garden city of Suchou, is the great scholar-painter school of the Ming Dynasty and from a development viewpoint represents the main limb of landscape painting in this period. From it and its later off-shoot, the Sung-chiang School, stem almost all of the later creative developments in Chinese painting. The school begins with Shen Chou. He is its classic expression and his followers are the elaborators and refiners of his contributions. Shen's art is well represented here and we can begin by an examination of a key work in establishing his artistic personality, the album in the Boston Museum | 50 |.[116]

Use of a landscape as a sequence, like a handscroll but retaining the artist's control of the "frames" of the "moving pictures," while it may have begun earlier, would seem to have been fully exploited first in the fifteenth cen-

50 | *Landscape* by Shen Chou, album painting

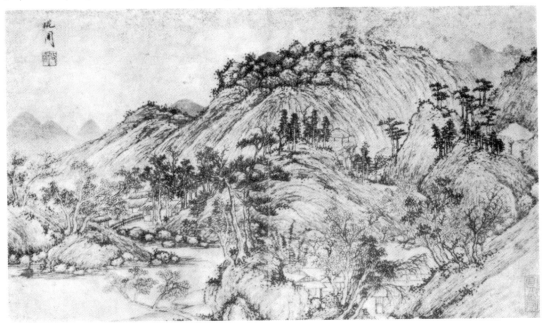

tury and especially by Shen Chou. The sequential album satisfied the more consciously aesthetic and specialized demands of the scholarly style and could now compete on equal terms with the scroll forms. Further, the album is after all a book and hence a more accustomed format for scholar-artists steeped in a literary tradition. The Boston album of eight double leaves is a perfect union of poetry, calligraphy, and painting, and so conforms to the highest ideals of the Wu School. While the pictures may be in different "manners," they are all unified in touch with an emphasis on the single stroke, broad, strong, and incisive, a style that confirms Shen's traditional dependence on the Yuan painter, Wu Chen. So that even when he paints in homage to Ni Tsan (leaf No. 4) | 53, p. 49 |, his brusque and posi-

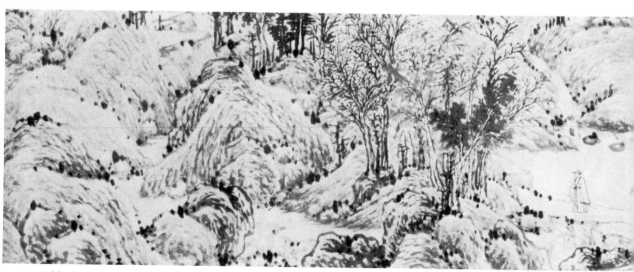

tive manner constructs a more solid, if less poetic world than that of "old Ni." Shen Chou can be complex or simple, his unity is given by the brush. The colophon written in 1604 by Wang Chih-t'eng on the Boston album praises the artist with the traditional but well-justified cliché: "absorbed in play, unfettered by rules."

This is not to say that his paintings are unresponsive to careful examination, and indeed it is only then that we begin to realize the rationality and clarity of his art. The short handscroll, *Traveling in Wu* | 51 |, may at first seem just a rough and hasty improvisation. The sureness in placement of objects in space is particularly important, as well as the extremely subtle modulations of tone. The mood is melancholic, even elegiac, and the shading of that mood with a great variety of grays is especially noticeable. The vertical dots and strokes are most skillfully varied in size, weight, and relationship to each other. They are never mechanical or monotonous. The movement of the scroll from right to left—from the poem and the lacy transparency of the trees to the solid encompassing rocks and hummocks—is particularly well handled. The path is effective, appearing on stage at right, continuing parallel to the picture plane, and finally turning back into the distance and disappearing as unobtrusively as it appeared. It serves as a representational parallel to the kinetic act of unrolling and rerolling the scroll. Such is the "play" of Shen Chou.

In this last example and in the four-leaf album | 52 |, we are aware of certain staccato

51 | *Traveling in Wu* by Shen Chou, handscroll

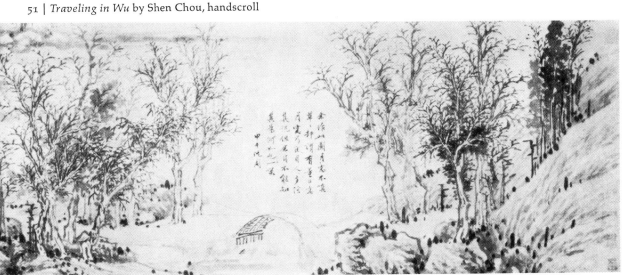

effects of the brush, dots and slashes, sudden and abrupt, which remind us strongly of one of the great pen-draftsmen of the modern Western movement, van Gogh |D|. Like Rembrandt in the drawing shown on page 62, Vincent uses the reed pen to achieve effects similar to those of the brush of Shen Chou, save that Shen and van Gogh are interested in complexity rather than simplification.

The fragmental album mounted as a handscroll |54| shows the highest achievements of the artist in his fully developed style. Again we have a sequential album, but with a stylistic conception different from the one in Boston. The more mature work is built on variations within the artist's personal style rather than, as in the latter, with personal variations on the styles of others. The sequential organiza-

D | *View of Arles* by Vincent van Gogh

52 | *Scenes at Tiger Hill: Oak and Hummocks with Three Figures at a Well* by Shen Chou, album painting

69

54.1 | *Three Gardeners in a Fenced Enclosure* by Shen Chou, album painting

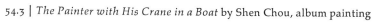

54.3 | *The Painter with His Crane in a Boat* by Shen Chou, album painting

tion is clear. For example, Leaf 54.1 has no horizon and an open, receding alley composition with a fence used as a space divider. Leaf 54.2 | between pp. 64-65 | is in total contrast: a spacious composition with a mass in the center, audacious and dramatic. The individual strokes of the brush are comparable but their arrangement in Leaf 54.1 is tighter, and with less contrast than those in Leaf 54.2. Another leaf picks up the suppressed diagonals of Leaves 54.1 and 54.2 and combines the sharp, diagonal split of the composition with the strongest statement of color in the whole series. Similar relationships are to be found in the remaining two leaves by Shen Chou. Leaf 54.2, with its cliff towering above the clouds, is about as complete a visual and literary symbol as possible of Shen Chou's original style and contribution. The poem reads:

White clouds like a belt encircle the mountain's
 waist.
A stone ledge flying in space and the far,
 thin road.
I lean on my bramble staff and gazing
 into space
Make the note of my flute an answer to the
 sounding torrent.
 —tr. R. Edwards

His is the remote but personal world of the scholar-sage-hermit towering above the crowd. He can support his remoteness by the strength of his brush and the clear intellect shown in his compositions. Where the contemporary and conservative T'ang Yin built mass and structure by accumulation, Shen built mass and structure in the brush stroke itself, and in this lies the secret of his stature in the history of Chinese painting.

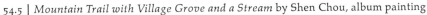
54.5 | *Mountain Trail with Village Grove and a Stream* by Shen Chou, album painting

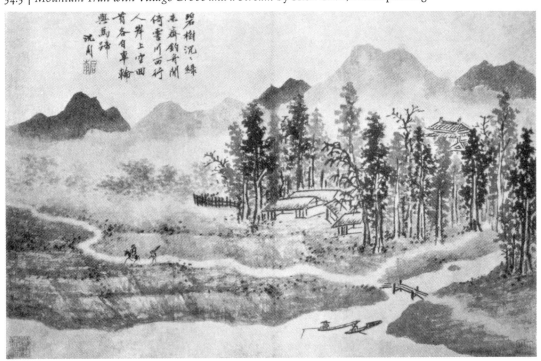

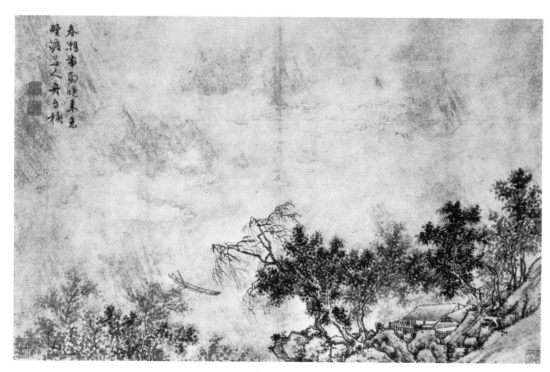

54a | *Storm over a Lake* by Wen Cheng-ming, album painting

The sixth panel | 54a | in the Kansas City album is by Wen Cheng-ming, the only one remaining of four by him originally contained in the album. The relationship of this picture to those by Shen Chou in the album verifies the record that Wen was his foremost follower and the second great light of the Wu School. Wen's album leaf was presumably painted in 1516, early in his career when the influence of his master was paramount. The vocabulary of the rocks and trees is that of the older man, but handled in a more restrained and delicate manner and tied to a greater interest in dramatic subject matter—in this case a rainstorm. If we compare, for example, the house and fence with similar renderings by Shen Chou, we can see the difference of temperaments most clearly. Wen Cheng-ming is the perfect scholar-painter, elegant and refined. Shen is

less conventional; the hermit dominates the scholar.

Wen worked in a variety of styles, but his most original contribution, a combination of drama, taste, and carefully controlled dry brushwork, is well represented. The small painting, dated 1531 | 55 |, is one of the earliest manifestations of this style. In this case it is overlaid with a tribute to the T'ang decorative style in its use of blue and green color as well as in its rather careful finish. The dominance of the rocks is noteworthy and reflects the already established interest in these grotesque and gnarled shapes which was characteristic of the art of gardening, especially strong in Suchou and Hangchou | P |.

This susceptibility to the grotesque reaches its height in a picture | 56 | painted in the following year, 1532, where the drama of the

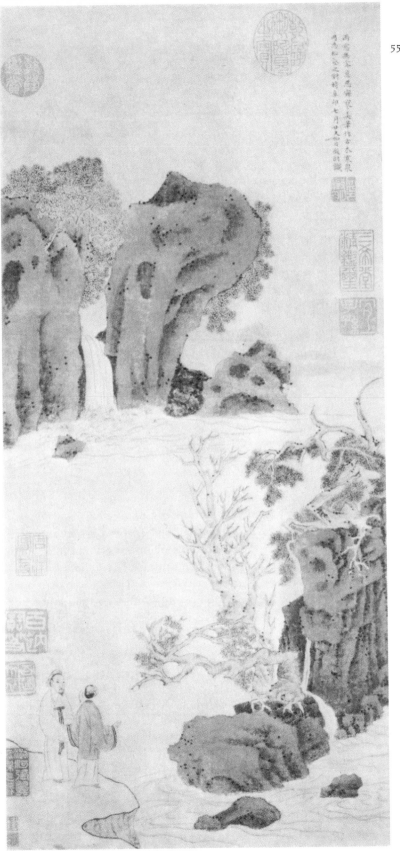

55 | *Ancient Tree and a Cool Spring*
by Wen Cheng-ming, hanging scroll

P | T'ai Hu Stone (Suchou)

Q | Junipers at T'ai Shan (Shantung)

subject and composition are fully exploited. Again the interest is paralleled in nature and garden art, the twisted junipers being much prized in gardens or in a more natural setting |Q|. Wen Cheng-ming's *Seven Junipers* is not only an ideal record of a specific place, but a literary and cosmic symbol of the greatest interest. The artist's colophon is the best expla-

Constellation of the Seven Stars. Power divine had planted them back in the time of Liang. Never dared Sui-jen's flaming fire seize them, never. Forms superb, flawless idols, spirits infinite, their shadows guard the ancient halls, cover the jade seats. They hallow the Palace of the Stars, attendants subservient to Heaven's

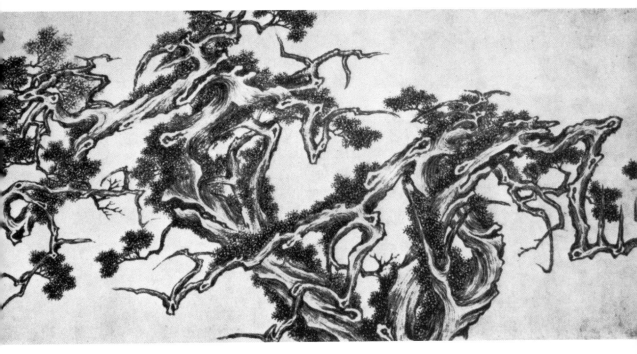

56 | *Seven Juniper Trees* by Wen Cheng-ming, handscroll (detail)

majesty. Up float their sleeves, their hair hangs deep in tufts, chaste, taut forces of mystery. Poems unheard are deepest. Ten thousand oxen will not pull the spreading roots grappled in a soil of pristine power. They wedded the weird in thunder and darkest Yin. Mosses dry at their bone knots. Now trail their boughs ... now soar they up ... swinging in curls or drooping abruptly. Martial-like spears now, now oppressed as a platter. Now they writhe like ape arms grasping at the shifting peak, haughty cranes now, bending their necks, combing their feathers. Wrinkles crack as axes strike. Where the russet bark bursts, pierces through tiny leafage. Crawl their broom-like tails in desolate night, in day time roaring waves in the trunk's gaping hollows. Writhing, twisted ropes dance they to the wail of the wind, as the chill spreads. Horns split, blunted claws, wrestling of dragon and tiger, whales rolling in the main. The giant birds snatch unexpectedly. Like ghosts, now vanishing, now re-appearing, in boundless intricacy. To further their perfection, sky bestows his auspices, dropping sweet dew into the well of elixir. Fairies, gods, pay them visits, tuning songs in stringed encores. Color of dawn their morning meal, heavenly nectar their wine.

The world's hasty uproar they disdain, be it danger or peace, be the bronze camels hidden by weeks, while Sun and Moon ever hasten, [spheres] of the firmament. ...

In the year 1532 Summer, Cheng-ming painted and wrote this for Shih-men.
—tr. by Gustav Ecke

Eighteen years later, at the age of eighty-one, the artist painted a similar motif in a much

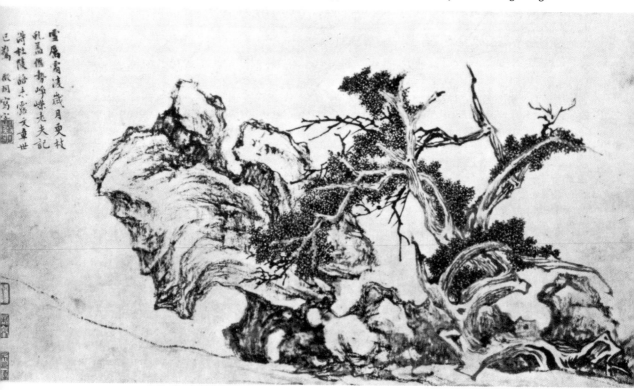

57 | *Cypress and Old Rocks* by Wen Cheng-ming, handscroll

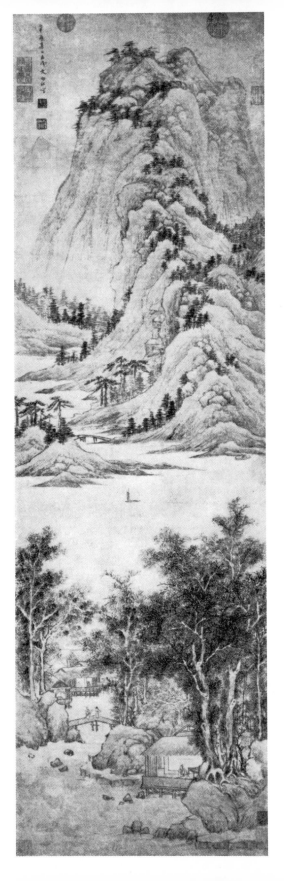

less grandiose manner in the *Cypress and Old Rocks* | 57 |. In many ways it is his masterpiece in this country and one of his most perfect works. There is no striving for effect. The brushwork is more flexible and varied with a brilliant use of contrasting dry and wet textures. All of his sense of antiquity, of restraint, and of the full use of the scholar's brush is combined in a small format. Again, as in the Yuan painting by Chao Meng-fu | 28, p. 41 |, the twig ends, executed with a swift "running brush," are a pleasure to us, if not to the extremely high degree experienced by the Chinese critic. These qualities, plus the moral and literary virtues attributed to the artist as scholar and critic, have placed him on a level with his immediate predecessor, Shen Chou.

Wen's followers in the Wu School include members of his family. Perhaps the most notable of these was his nephew with the alliterative name, Wen Po-jen. His contribution is derived in part from his uncle, especially in the often complex use of dry textures. But there is something a little larger in scale to be found in Wen Po-jen. Perhaps his interest in atmosphere and his often spacious compositions owe much to Sung and Yuan predecessors. Thus the *Landscape* | 58 | is in the spirit of Wen Cheng-ming, but the upper mountains are more massive and fully realized than anything similar in that artist. The poignant contrast between the luxurious textures of the trees below and the spare, austere distant mountains is especially well realized. The same restraint and subtlety is communicated by the

little handscroll of *The Lute Song* | 59 | where the layout reminds us a little of Southern Sung. Again we can see the continued close relationship of the painter to nature in a photograph of a Min River scene in Fukien | R |. *The Lute Song* possesses that intimacy and personal touch found in the fans painted as personal gifts by the scholar-painters.[30]

The dry-brushed textural style of Wen Cheng-ming was often used by one of his pupils, Chu Chieh, and his *Watching the Stream* | 60 |[59] shows the extent of his specialization. Like some drawings by Paul Klee, the narrow hanging scroll must be read from bottom to top and from side to side, observing each sign on the way. Something of the same

R | The Min River (Fukien)

59 | *The Lute Song: Saying Farewell at Hsun-Yang* by Wen Po-jen, handscroll

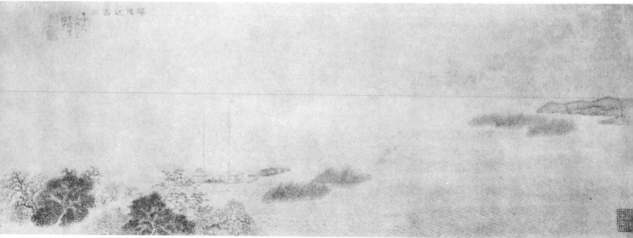

detailed texture of nature was the stock in trade of Pieter Brueghel in his drawings | E |, even to his mannerist pen-stroke symbols for foliage. The word mannerist is no accident here, for Wen Cheng-ming and his followers were just that, in the best sense of the word, testing, examining, refining, and elaborating the Yuan and Wu contributions.

60 | *Watching the Stream* by Chu Chieh, hanging scroll

E | *Waltersburg* by Pieter Brueghel the Elder

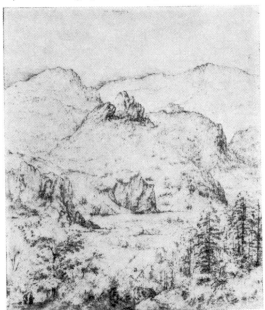

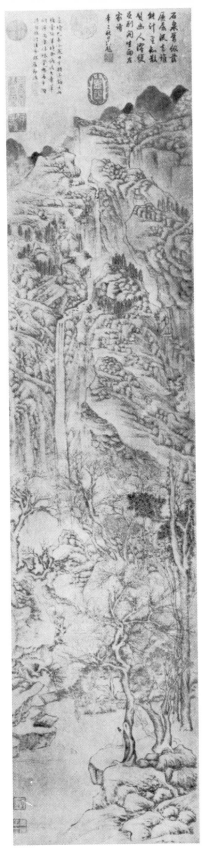

One of the most interesting painters in this group, Lu Chih, is usually listed as a painter of flowers. But in a few of his landscapes he uses a most individual, crystalline-like brush stroke to construct pictures of striking clarity and refinement. While he is rarely original in composition, the handscroll, dated 1549 | 61 |, is just that, with a particularly rich use of color within a horizon-less landscape and with no area left without texture. The sudden views through this texture to rice paddies, caves, houses, are also unusual. The typical brushwork can be studied most easily in the Chicago hanging scroll | 62 |. The composition and the brushwork are both influenced by Ni Tsan but Lu makes his strokes smaller than those of the Yuan master. The strokes are extremely angular with many little sharp, vertical accents. These, plus the color, usually on the cool side in the blue-green range, with some touches of orange, give to his work a certain prim tartness. Only in the total composition is he ill at ease, especially in handling the conventional Ni Tsan type of break in the middle distance.

One other painter of this group, Ch'en Shun, was also known primarily as a bird and flower painter, but where Lu Chih followed the dry

62 | *Landscape with Clear Distance*
by Lu Chih, hanging scroll

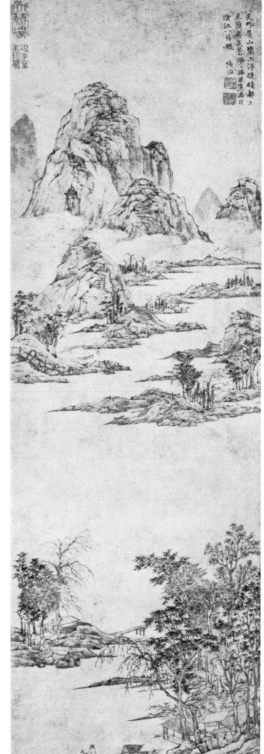

61 | *Rocky Landscape*
by Lu Chih, handscroll (detail)

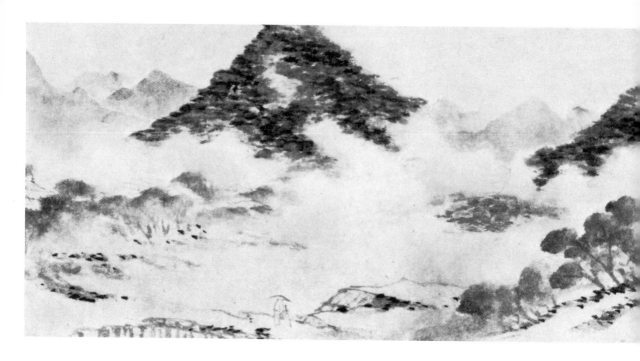

and brittle style, Ch'en seems to have special-
ized in the opposite direction. His strength was
the "boneless" manner, emphasizing the broad
use of washes, usually colored, and without
much reinforcement from brush strokes. Not
that his hand was incapable of sharp brush-
work; numerous flower pictures attest to his
ability in that manner. Ch'en Shun's finest
landscape style combines the boneless method,
color, and massed brushwork of the Sung "Mi
style" | 17, p. 29 |. *The Landscape and Poems*
| 63 | is a beautiful example of this style. The
composition, gracefully bending down, then
up, is surprisingly real. The color is soft and
rich, enjoyed in itself. In this sense, the scroll
is a prototype for seventeenth-century color-
istic developments | 87–89, pp. 108–113 |.
Ch'en Shun's paintings seem as free and easy
as his calligraphy, usually written in the "run-
ning style."

63 | *Landscape and Poems* by Ch'en Shun, handscroll

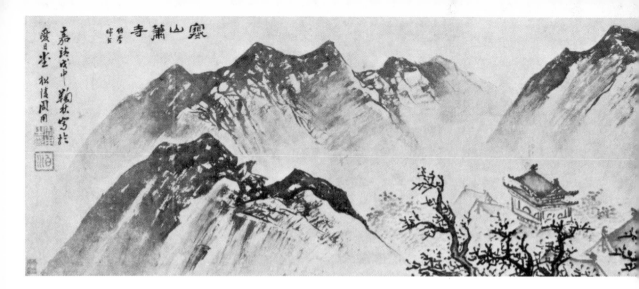

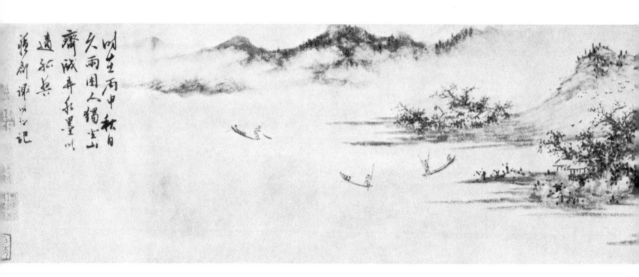

The direct influence of Shen Chou, the original founder of the Wu School, is less evident than that of Wen Cheng-ming, but it did inspire two men: one, his direct pupil, Chou Yung, a successful official; the other, Hsieh Shih-ch'en. Chou's works are extremely rare and *Winter Mountains and Lonely Temple* |64|

64 | *Winter Mountains and Lonely Temple, after Li T'ang* by Chou Yung, handscroll (detail)

65 | *Tiger Hill, Suchou* by Hsieh Shih-ch'en, handscroll (detail)

may well be his only work in the Occident. In figures, architecture, and trees it recalls Shen Chou, but the heavy use of washes in the "axe-hewn" mountains is derived from Southern Sung, Li T'ang in particular, as stated on the title colophon. The result is bold and original, somewhere between the Wu and Che Schools. Hsieh Shih-ch'en also falls between the two camps and for this he was criticized by the scholar-critics. But *Tiger Hill, Suchou* | 65 | is in a more purely scholarly vein. It has his distinctive soft, slightly blurred touch and is obviously based on Shen Chou's style, particularly in trees and architecture.

85

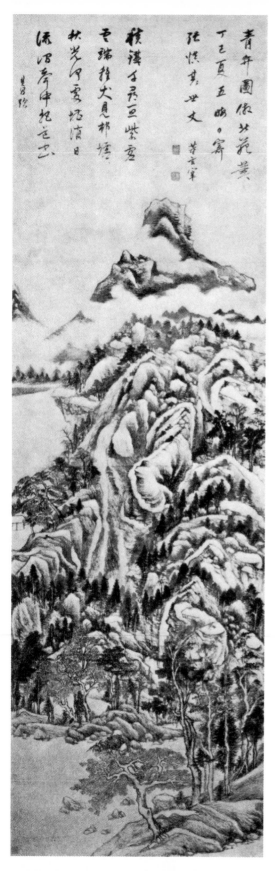

THE MING
DYNASTY

TUNG CH'I-CH'ANG
AND SOME
INDIVIDUALISTS

67 | *Ch'ing Pien Mountain*
by Tung Ch'i-Ch'ang, hanging scroll

The end of the sixteenth century closes this period of elaboration in the accomplishments of the Wu School. A new impetus was needed and it was forthcoming in the theories and paintings of Tung Ch'i-ch'ang who dramatically changed the course of Chinese landscape painting. His importance and the extent of his influence is comparable to that of Caravaggio for European painting, who, coincidentally, was active at almost the same time: about 1600.

There is little doubt that we must speak of later Chinese painting as "before Tung Ch'i-ch'ang" and "after Tung Ch'i-ch'ang." His literary, critical, and calligraphic influence is paramount, and so is his painting, like it or not. In his writing he asserts the supremacy of the Northern Sung and Yuan masters, and in his painting he attempts to recapture the monumental strength of the former and the controlled calligraphy of the latter. No one could describe the Wu School as having been

monumental or universal in an objective way. In opposing the previous direction of the literary school, Tung Ch'i-ch'ang was both a supreme reactionary and a supreme revolutionist. While the result is a loss of the outward reality of nature, there is a really significant aesthetic gain in an arbitrary, even fierce, reorganization of the elements of landscape painting into a monumental format. This aesthetic specialization involves striking distortions in his most typical pictures |66, 67|. Ground or water planes are slanted, or raised and lowered at will. Foliage areas are forced into unified planes regardless of depth, and often in striking juxtapositions of texture. No small details or minuscule textures are allowed to stand in the way of the artist's striving for a broad and universal expression of the traditional attitudes to nature. Malraux's subtle distinction between Chardin and Braque, "In Chardin the glow is on the peach; in Braque the glow is on the picture," applies

66 | *Autumn Mountains* by Tung Ch'i-ch'ang, handscroll

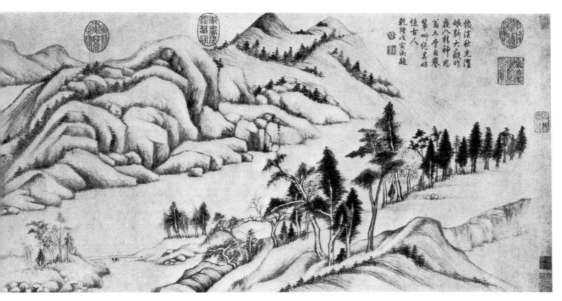

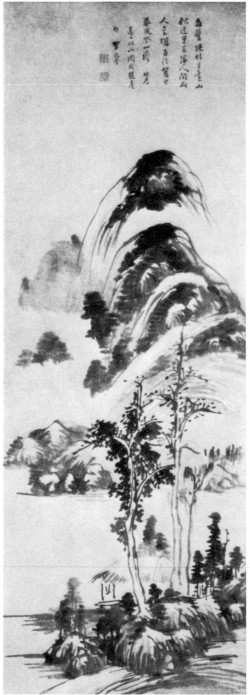

as well to the works of Tung. The result is difficult and not completely realized when we compare his works with such later giants as Chu Ta | 92, 93, pp. 116–117 |, or even the more academic Wang Yuan-ch'i | 80, facing p. 101 |, for theirs was a pictorial genius which accomplished what Tung Ch'i-ch'ang indicated.[25] And others of the later individualists, Kung Hsien | 94, p. 118 |, for example, took details or specific elements out of Tung's pictures and enlarged or elaborated them.

We must not assume, as the writer once did, that the appearance of Tung Ch'i-ch'ang's pictures results from a lack of competence. This competence could be commanded if desired, but, like the Post-Impressionists, the artist was desperately striving to reconstitute the powerful and virile forms rather than the surface likeness of the earlier painters. Tung Ch'i-ch'ang had the last word: "Those who study the old masters and do not introduce some changes are as if closed in by a fence. If one imitates the models too closely, one is often still further removed from them."[88]

Tung's official position and his pictorial and critical acceptance as the arbiter of taste and authenticity certified the triumph of the literary-painters' tradition, identified by him and his colleagues with the "Southern School," in opposition to that tradition represented by the Che School and described as "Northern." His own immediate following, Ch'en Chi-ju, Mo Shih-lung, who coined the sometimes obfuscating Northern and Southern categories,[20] and others, is usually described as the Sung-chiang School, after the town near Suchou which was their center.

The influence of Tung can be seen in numerous other important masters who can only be described as seventeenth-century individualists, a description that can be narrowed to these late Ming men alone, or broadened to include all of the distinctive personalities of the troubled late years of the century, even into the early part of the Ch'ing Dynasty (1644–1912). However, since this latter group is involved in the social and political picture of the new and alien dynasty, these later individualists will be considered subsequently, as a contrast to the almost neo-classic academicism that was the early Ch'ing by-product of the Sung-chiang School. The other Ming individualists are too numerous and relatively recently known to Westerners to be presented in more than a summary way. Although the poem on one of Li Liu-fang's boldest pictures | 68 | mentions Ni Tsan, and the brushwork is influenced by the brusque style of Wu Chen, the over-all effect of the landscape would be unthinkable without the intervention of Tung Ch'i-ch'ang. We should note in passing, as a post-Yuan characteristic, the way in which the so-called Ni type composition is visually and compositionally unified from bottom to top. The excellent preservation of the ink and the particularly simplified brushwork combine to offer details which reveal the order of the successive strokes and washes with an almost kinetic force. Or consider the fantastic boldness of Sheng Mao-yeh's *Lonely Retreat*, dated 1630 | 69 |. Sheng[31] has taken a small segment of a monumental landscape, a mountain notch, and magnified it, treated it with great bravura, producing a large scale painting with an immediate rather than a cumulative effect. Nevertheless, the fading mists are suggestively handled and show the subtle touch that is found in many of the artist's smaller pictures. The painter is not without humor in the figure

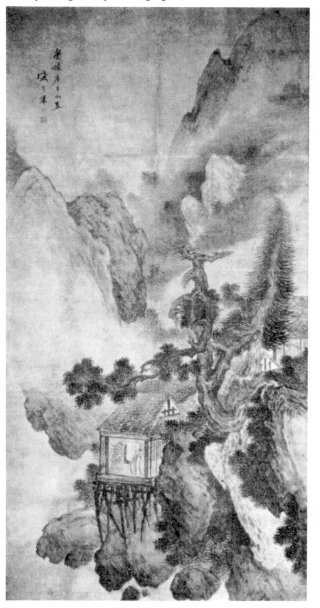

69 | *Lonely Retreat beneath Tall Trees*
by Sheng Mao-yeh, hanging scroll

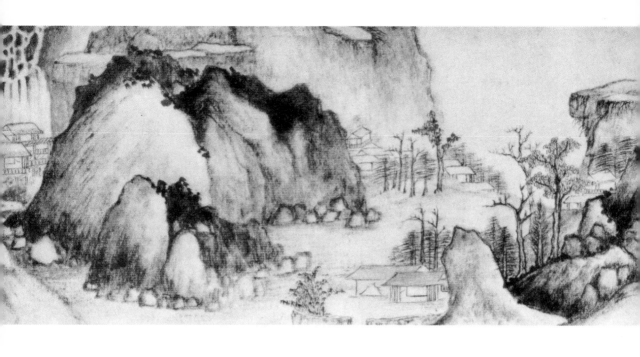

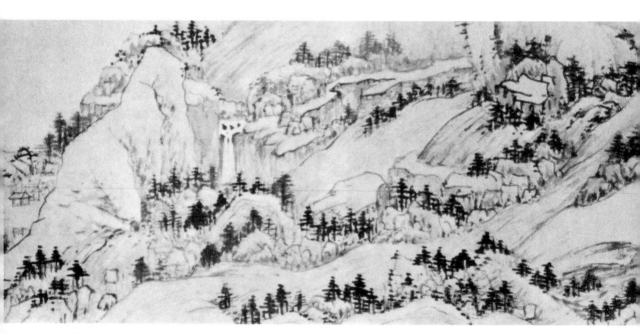

90

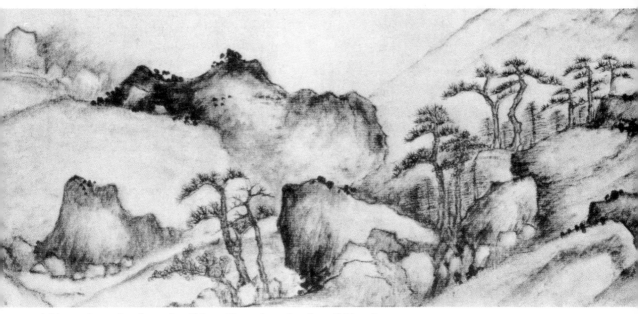

70 | *Mountainous Landscape* by Ch'eng Cheng-kuei, handscroll (detail)

71 | *Dream Journey among Rivers and Mountains* by Ch'eng Cheng-kuei, handscroll (detail)

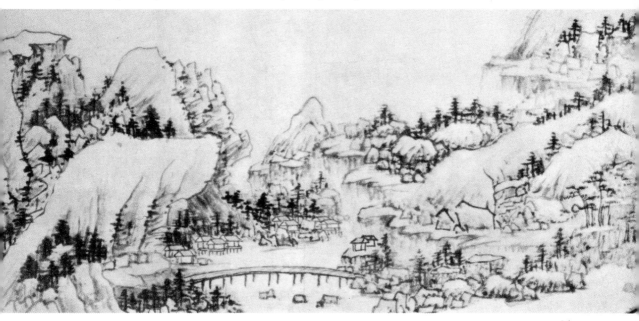

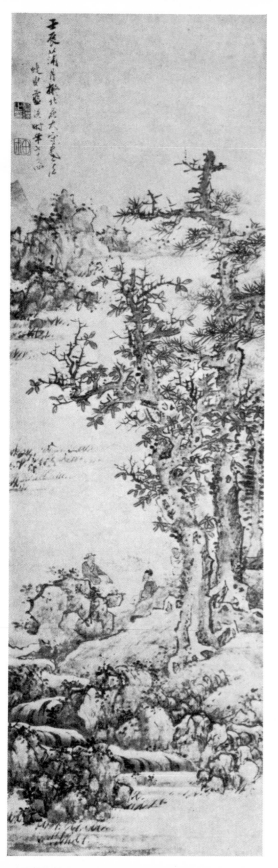

of the Sage and in the grotesque trees. The painting fascinates precisely because of its wild, off-beat quality.

Another of these individualists was a direct pupil of Tung Ch'i-ch'ang. We can see the art of Ch'eng Cheng-kuei in an early |70| and late |71| handscroll. The former is particularly interesting as it confirms Ch'eng's use of "a dry and stumpy brush" as mentioned in the *Kuo Ch'ao Hua Cheng Lu*. The effect in the early scroll is almost like that of Western chiaroscuro. The unusual dry-textured and shaded areas are accomplished by the use of a sooty ink, sparely watered and applied with a relatively stiff brush. The composition is equally strange and willful, and is based on

73 | *Old Trees by the Water* by Lan Ying, hanging scroll

near masses and sudden break-throughs, with a jerky, erratic rhythm that is typical of the artist. In later years, as in the second scroll, he exploits this mode even further, but with a wet brush and a rapid, unshaded handling, using slight and rather turgid color, this time in an excellent variation on the style of Huang Kung-wang | 32, p. 45 |. This extreme specialization carries over to the titles and inscriptions on his pictures, for he uses the same title for nearly all his scrolls and even goes so far as to number them for each year!

In contrast to this specialization are the wide-ranging interests of Lan Ying, an effervescent and skillful, if secondary, talent. He delights in playing the improvisation game and his long scroll in the style of Tung Yuan, Huang Kung-wang, Wang Meng, and Wu Chen | 72 | is a type example of variations on given themes. The last passage, inspired by Wu Chen, is especially good—wet and free— and seems to best express the temperament of the late Ming man. The same exuberance is found in the hanging scroll | 73 |, dated 1652, twenty-eight years later, where the spicy and saucy flavor is increased by the decorative use of clear, warm color. Lan Ying's lack of "loftiness" certainly reduced his rank in Chinese criticism.

Of course, many in this period continued to practice a more conservative and detailed manner, especially in figure painting. Of these,

72 | *River Landscape in the Style of Four Early Masters* by Lan Ying, handscroll (detail)

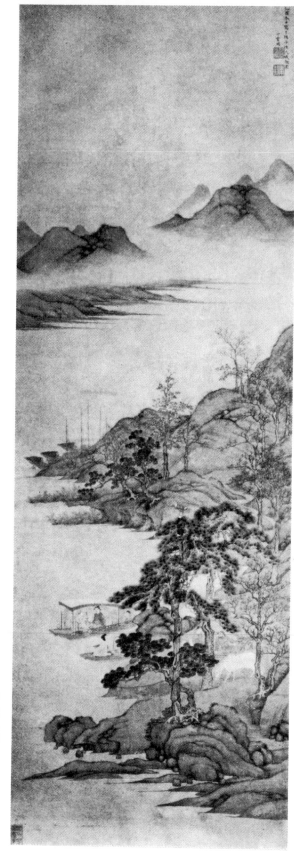

74 | *The Lute Song:
Saying Farewell at Hsun-Yang*
by Ting Yun-p'eng,
hanging scroll

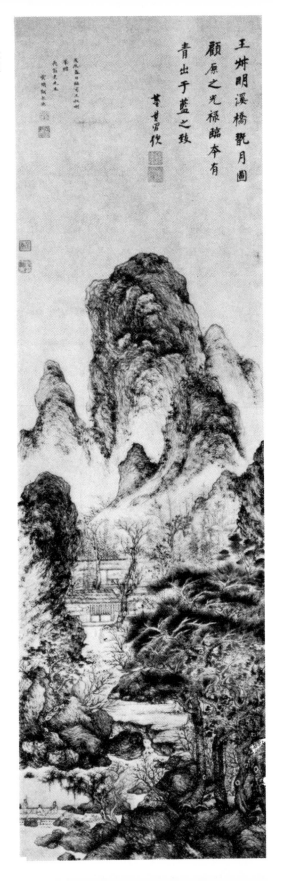

one of the most noteworthy was Ting Yun-p'eng whose works even Tung Ch'i-ch'ang praised as "every hair alive." His rather rare landscapes | 74 |, in this case in T'ang style, are very traditional in details, but quite proper for their period in their unified and realistic atmosphere. Tightly and carefully painted, they use color as a surface coating. Ting's hanging scroll must rank as one of the finest ultra-conservative works in this seventeenth century period. The most original of these "miniature" painters was Wu Pin. His *Greeting the Spring* | 75, facing p. 100 | is a compact handscroll crowded with much detail and tinted with clear washes of color. However, the daring convolutions of the massed mountains display his indebtedness to Tung Ch'i-ch'ang's manner of composition | 67, p. 86 |.

Still another phase of traditionalism was the continued close copying of great painters of the past. One of the very best manifestations of this form of filial piety is *Enjoying the Moon* by Ku I-teh | 76 |.[57] The scroll is after a now lost original by the Yuan master, Wang Meng. Much can be learned by the visual comparison of these known later copies with originals or presumed originals. Thus the painting is texturally and compositionally close to Wang Meng | 33, p. 46 |, but the color and brushwork combine to produce a more immediately charming effect without that rough and rustic exterior which often seems characteristic of the earlier artist. The later washes are wetter in the foliage, the pine needles and bark are more carefully and precisely treated. The ropy and strong brush of Wang Meng has been transformed into an idiom that takes for granted the existence of the sixteenth century, and especially Wen Cheng-ming and Wen Po-jen | 58, p. 77 |.

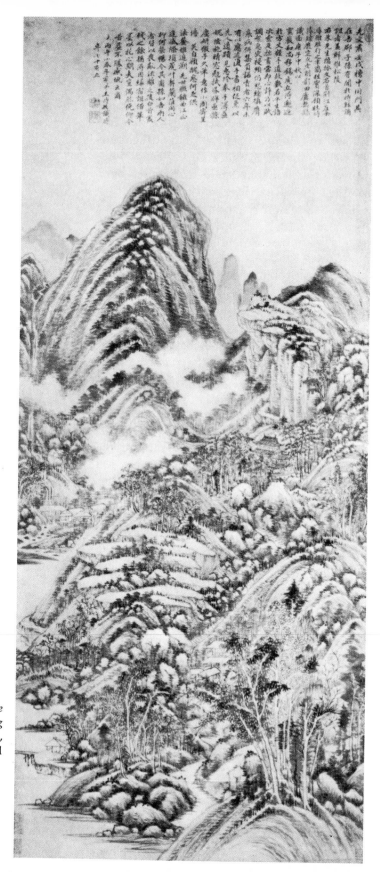

77 | *Landscape in the Style
of Huang Kung-wang*
by Wang Shih-min,
hanging scroll

All of these painters worked in a confused and troubled period which ended with the triumph of the alien Manchu Dynasty in 1644. The parallel with the Mongol conquest of the thirteenth century immediately suggests itself and has in it much of interest. There is a similar dichotomy involving a strongly traditional-eclectic group and a nonconforming group of rugged individualists, rebellious in aesthetics as well as in politics. With the Ch'ing Dynasty we see the revolutionary style of Tung Ch'i-ch'ang and his followers become the academic manner of the late seventeenth century. This manner is embodied in the work of "The Four Wangs." In evaluating their contribution we must be especially tolerant of eclecticism and unusually sensitive to the fine shadings involved in variations on earlier styles. Almost all of their paintings are "in the manner of" or "in homage to" some earlier master and fall quite readily into a pattern comparable to the performance of a great composition by a musical virtuoso. In most of their production the Wangs, with the possible exception of Wang Yuan-ch'i | 80, facing p. 101 |, can largely be appreciated in terms of their consummately skillful brushwork. Consequently they will probably always rank much higher in Chinese eyes than ever in ours.

Wang Shih-min, | 77 | was the oldest and the most careful and conservative of the four. Wang Chien was of the same generation and a friend of his namesake. His variation on Wang Meng | 78 | possesses no originality in composition but does have a personal touch, a kind of waving, rolling rhythm of considerable grace. The wet and transparent dots are skillfully placed on the foreground rocks and serve to pinion their linear movement. Nevertheless this is painting for other painters and critics in an even more limited sense than in the usual literary man's style.

THE CH'ING DYNASTY

ORTHODOX PAINTERS

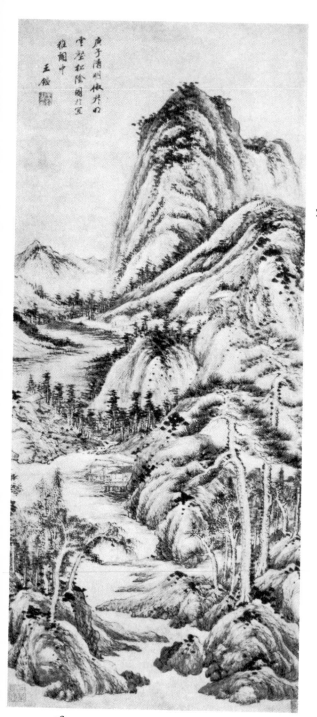

78 | *Pine Shades in a Cloudy Valley at I-ya-ko*
by Wang Chien, hanging scroll

The subsequent generation produced the
other two and more interesting members of
the Four Wangs. Wang Hui was the pupil of
both the older Wangs and achieved extremely
high marks from them as well as from other
critics. Wang Hui's *Bamboo Grove and Distant
Mountains* |79|, after Wang Meng, is an ex-
cellent example of an improvisation which
the Chinese define as a "copy," or even a
"tracing." It could never be taken as a Wang
Meng or anyone except Wang Hui himself.
If there is no daring or boldness in the com-
position there is the most amazing control
of all the nuances possible with brush and
ink, a control comparable to that found on
the porcelains of the period. The in-and-out
movement of the bamboo leaves, the abso-
lutely sure placement of the rocks in space,
the variety of texture and tone, and the pre-
cision of the brush strokes, all these attest
the refinement and amazing skill of the artist.
We feel admiration rather than wonder or
excitement. This is nothing to be despised;
we still leave space in our aesthetic hearts
for the small but genuine pleasures of a
Fantin-Latour or a Richard Wilson.

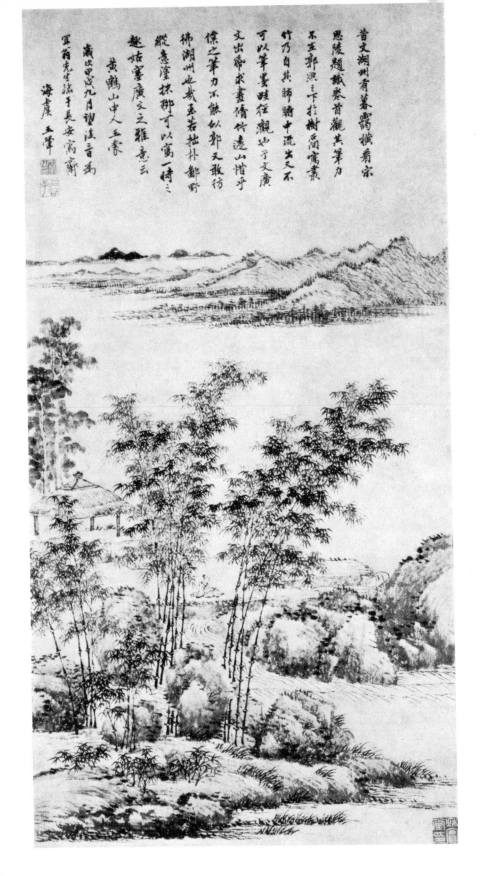

昔文湖州有墨竹横斜偃宗
思陵題試卷首觀其筆力
不至郭興之下枝樹間寫叢
竹乃自其師瞞中流出矣不
可以筆景昩往觀地乎文廣
文出希求畫脩竹透山楷乎
傑之筆刀不能似郭文張彷
彿湖州也成五若拙朴鄙野
縱意塗抹邨可以寬一時之
趣姑塞廣文之雅意云
黄鶴山中人王蒙

歲此甲戌九月望後三日為
宜翁先生端手長安寓齋

海虞
王肇

If Wang Hui is the greatest virtuoso of the group, then Wang Yuan-ch'i is by all odds the most original. He must have studied Tung Ch'i-ch'ang's distortions in paint more than his critical emphases on tradition; and he added to these gleanings a careful, intellectual technique with an original and constructive use of color. His monochrome pictures seem more traditional than those with color, such as the work after Ni Tsan | 80, facing p 101 |. His monochrome landscapes provide a fine demonstration of the typical continuous space of later Chinese paintings essaying the earlier monumental styles. While there is tilting and distortion of the various ground and water levels, the space in which they are placed seems all of a piece, not divided and separated as, for example, in the Northern Sung hanging scrolls. But color gives Wang Yuan-ch'i a greater opportunity for innovation and with it he finds his full means of expression.

We shall soon have occasion to mention the use of color again, but in a different technique. Wang's careful, almost laborious, method is really watercolor painting, not tinted ink painting. The method is not unlike that of Cézanne in his water colors | F |. Glazes of color, more limited in range of hue than those used in the West, are applied one above the other and in the distant island of the picture "after Ni Tsan" | 80 |, produce an extremely solid and well-placed structure. The contrast with the supposed prototype style of Ni Tsan | 34, p. 48 | is a decided one and rests largely on the successful and solid use of color as opposed to the delicate and evanescent monochrome of the earlier painter. A contemporary source gives us an excellent description of Wang Yuan-ch'i's working method and, incidentally, additional proof of the often time-consuming approach of Chinese painters. The single brush stroke, which once put down is never erased, is only one of various creative techniques.

100

He started by spreading the paper, and then he cogitated for a long while. He took some light ink and drew some general outlines indicating in a summary way the woods and the valleys. Then he fixed the forms of the peaks and the stones [cliffs], the terraces and the folds [of the mountains], the branches and trunks of the trees, but each time before he lifted the brush [to paint] he thought over the thing very carefully in his mind. Thus the day was soon ended.

The next day he invited me again to his house and took out the same scroll. He added on some wrinkles [on the mountains]. Then he used some reddish brown [ochre] colour, mixed it with a little yellow gum-raisin [sic] [gambodge] [sic], and with this painted the mountains and stones. Thereupon he took a small flat-iron, loaded with hot coals, and with this he ironed and dried the picture. After that he went over the stones and the whole structure of the picture again brushing with dry ink. The leaves of the trees were dotted in a scattering manner, the woods on the

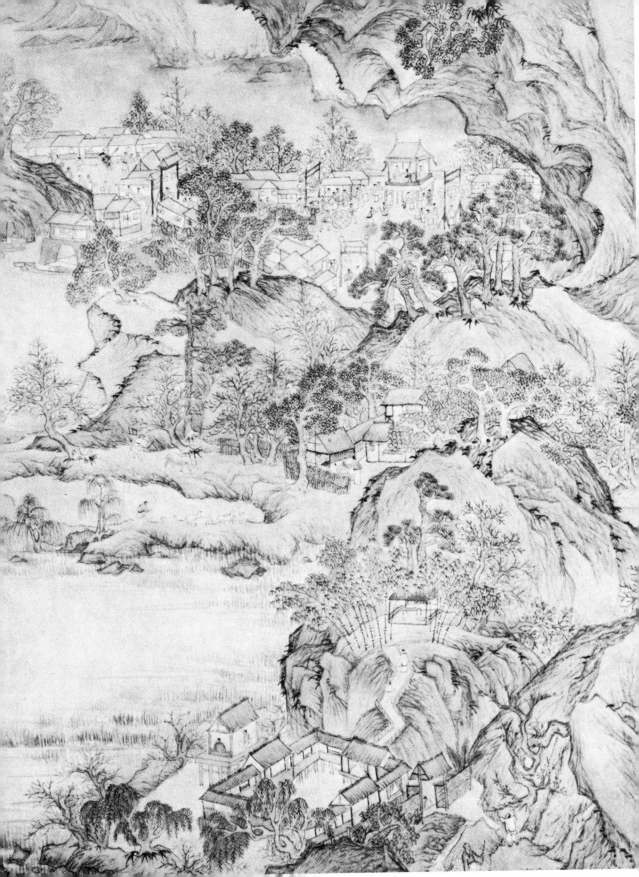

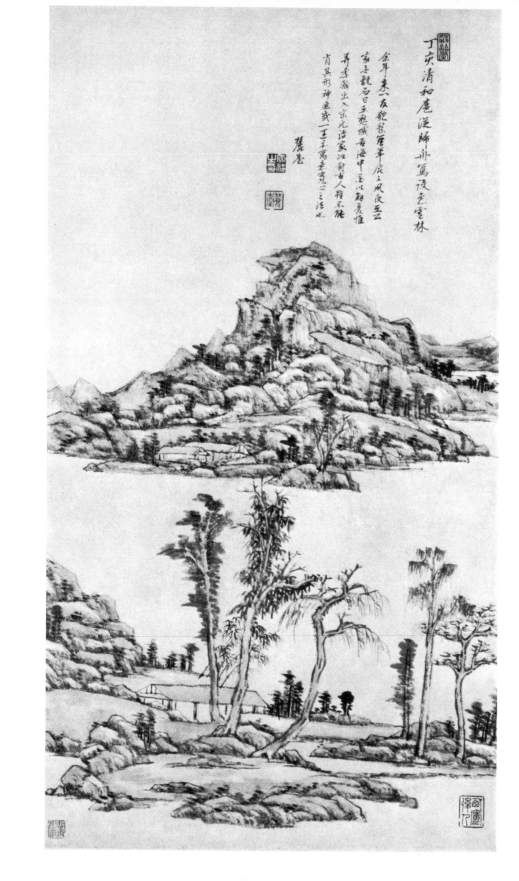

mountains, the buildings, the bridges, ferries, streams, and beaches were brought out clearly. Next he took some green colour mixed with water and ink and with this he washed quite lightly and slowly, emphasizing the lights and shadows and the relief. Then again he used the same flat-iron as before to dry the picture. And once more he went over the hooks and horizontal strokes, the coloured and the dotted spots from the lightest to the darkest parts thus making the picture gradually more dense. It took him half a month to finish a picture.

At the beginning it was all in a nebulous state *[hun lun]*, but gradually this was broken up, and then the scattered parts were brought together; finally the whole thing returned again to the nebulous state. The life-breath *[ch'i]* was boundless, the emptiness was filled with beauty, not a single stroke was carelessly done. That is the reason why he spent so many days on a work. The saying that the old painters used ten days for painting a water course and five days for a stone may not be an exaggeration.[89]

F | *View of Stream between Cliffs* by Paul Cezanne

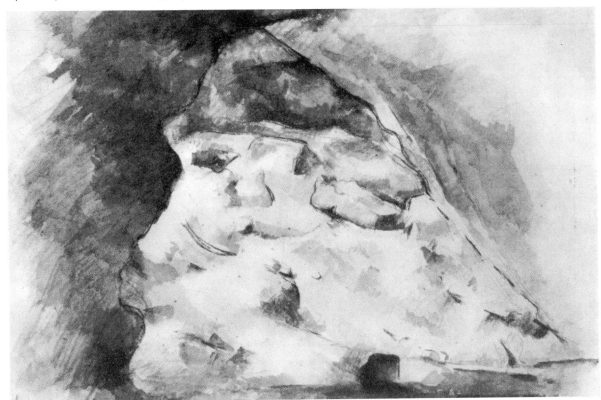

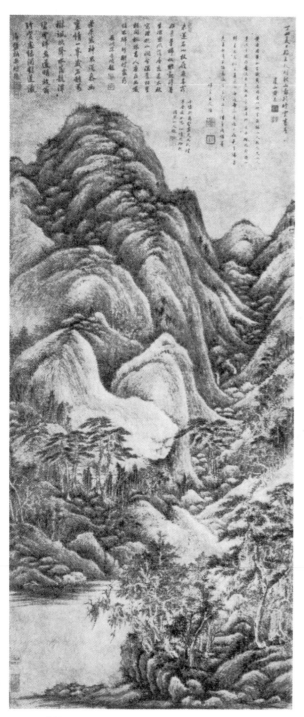

The Four Wangs are the principal luminaries of what the Chinese call the Lou-tung School which formed the basis of conservative scholarly painting of the period. One need only examine the landscape dated 1697 | 81 | by Huang Ting, a pupil of Wang Yuan-ch'i, to realize that fine painting was produced outside of the big four, but within the limits of the school. While the painting is based texturally and compositionally on Wang Meng, the artist has made two important changes. The rounded contours do not bulge, but are treated as flat planes with textured surfaces; and these planes recede, not by rolling masses, but by overlapping in a manner analogous to pre-Yuan painting. The result is a combination of monumentality and intimacy which is quite unusual and very successful. In turn, take Huang Ting's pupil, Chang Tsung-ts'ang | 82 |, a favorite painter of the Ch'ien Lung Emperor (1735–1796). While superficially similar to Wang Yuan-ch'i, Chang has relied more on ink and less on color. The effect is dense and compact with a minimum awareness of space or air for containing these densities. The result is highly abstract, almost a diagram of mass in a vacuum. In addition the picture is marvelously well preserved and shows, perhaps as much as any late painting, the sheen and liveliness of ink and transparent color on paper.

The more purely official painters and decorators interest us little save for one quite individual artist, Yuan Chiang, whose *Carts on a Mountain Road* | 83 | was painted in 1754 "after Kuo Hsi," the Northern Sung master. This is a late mannerist kind of painting with an intense interest in lava-like forms with metamorphic overtones and strikingly like some European drawings of rocks such as the one by a follower of Paul Bril | G |, which

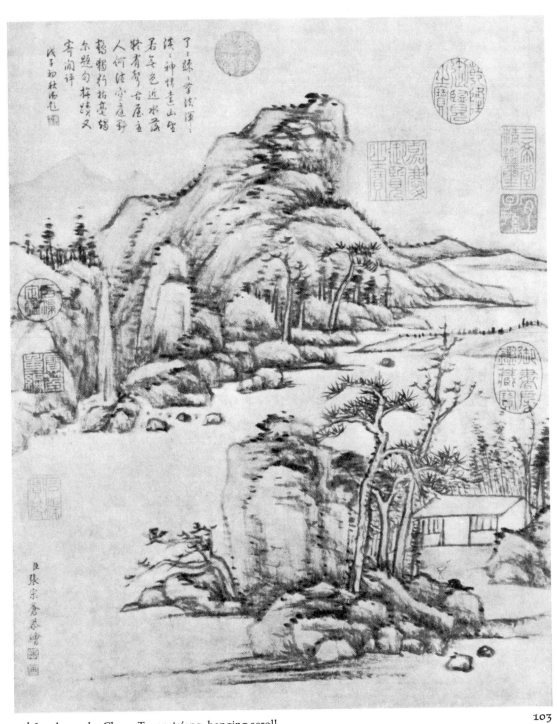

82 | *Landscape* by Chang Tsung-ts'ang, hanging scroll

83 | *Carts on a Winding Mountain Road,*
after Kuo Hsi by Yuan Chiang,
hanging scroll

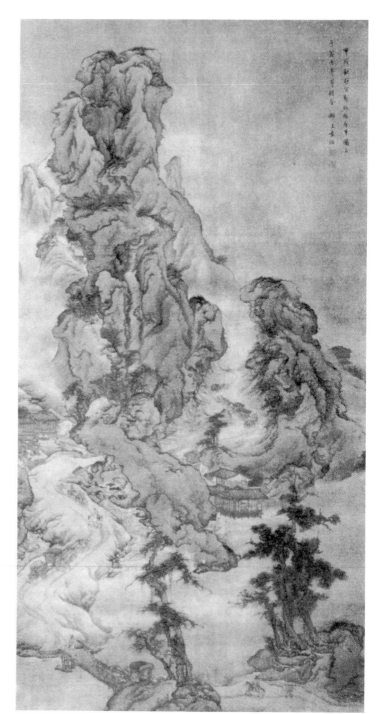

G | *Rocky Cliff at Tivoli*
by a follower of Paul Bril

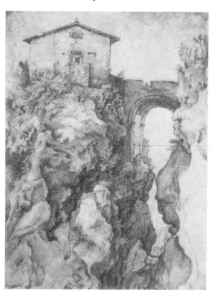

also borders on the grotesque. Yuan's monumental composition of a continuous mass in continuous space is belied by the pale, almost pastel-like, color which reduces the monumentality while helping the decorative qualities. There may well be European influence, quite common in eighteenth-century Chinese painting, in the more realistic treatment of the individual parts. This also adds to the tensions in the picture, tensions which make the whole unreal, however real the parts. Here we can see very well how totally real the Sung and Yuan landscape paintings are by comparison, and that this earlier reality was achieved by magnificient intellectual control.

The aesthetic bridge between the new conservativism of the Four Wangs and the priest-hermit-individualists of the seventeenth and eighteenth centuries is formed by two painters usually assigned to the Lou-tung School: Wu Li and Yun Shou-p'ing. They belong, but not quite. Wu Li[9] especially is possessed by a rather different genius and the results justify his contemporary fame and the growing appreciation of his works today. Although he was a boyhood friend of Wang Hui and a pupil of Wang Chien, Wu Li proved his essentially different nature by his painting and by becoming a Christian and a Jesuit. His faith did not affect the style of his painting but may have influenced its later mood. His earlier paintings seem no different in intention or level of accomplishment than those of the Wangs. But he could, on occasion, step over the boundary of accepted taste into the realm of the unusual or the grotesque. The hanging scroll in the style of Wang Meng, dated 1674 | 84 |, was painted two years before he became a Christian and seems a tense and turbulent, even subjective picture. The extraordinary convolutions of the rocks and the mountain peak may derive from the Yuan master, but they go far beyond him in exaggerated tension. These, with the large

84 | *Reciting Poetry before the Yellowing of Autumn* by Wu Li, hanging scroll

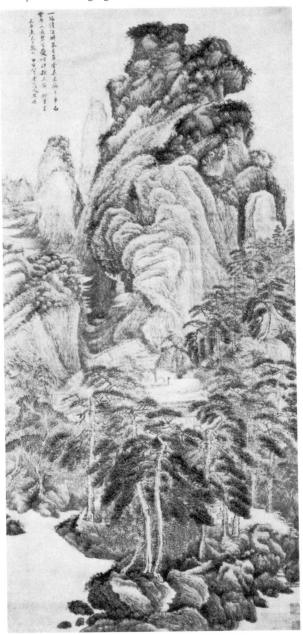

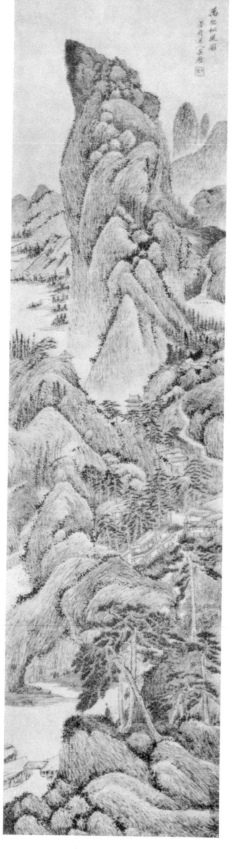

scale, the enclosed composition, and the somber ink make for a dramatic and disturbing picture really outside the bounds of then conventional taste. His second scroll | 85 |, while not dated, seems to belong to his Christian years. It is a mature and serene work of after 1700, with a real fusion of delicate color and touch with a monumental composition of extreme verticality. Like Huang Ting | 81 |, the artist knew very well how to flatten the planes and to overlap them in direct relationship to the picture plane. The sharply vertical composition is stabilized by the suggested breadth of the base which supports the upper half by the contrapuntal, upward thrust of the foothills. The detail reveals a delicacy and control of the brush comparable to Wang Hui. It also suggests the metamorphic character of the landscape, as

H | *Metamorphic Landscape* by Pavel Tchelitchew

85 | *Pine Wind from Myriad Valleys* by Wu Li, hanging scroll

in the cliffhead with a large nose at the right. Such an interest in anthropomorphic forms in nature was not just Chinese but universal. We can cite the Great Stone Face in New Hampshire, the remarks of Leonardo on the subjects to be found in the worn and damaged surface of a wall, or more recently the metamorphic landscape of Pavel Tchelitchew |H|. That these disquieting forms were significant to Wu Li can be guessed from his paintings of the human-rock formations of Huang Shan. These, as well as his strongly individual and often tense compositions, link him to such more daring individualists as Shih-t'ao. Conversely he is far less subjective and informal than the rebel artists and such a composition as |85| attains a compact and timeless expression undreamed of by either the individualists or the orthodox.

The Four Wangs, Wu Li, and Yun Shou-p'ing are usually classed as the Six Famous Masters of the Ch'ing Dynasty,[21] the foremost exponents of orthodoxy deriving from Tung Ch'i-ch'ang. Yun Shou-p'ing is more often thought of as a flower painter, but his landscapes are reasonably numerous. If Wu Li was a strong and individual variant of orthodoxy, Yun was his suave and subtle counterpart. His large hanging scroll of rocks, bamboo, and flowers |86| is of interest for several reasons. Concepts of nature's principles fade before the captivating charm of subdued tone and fluent wash. The combination of the archaistic roughness of the tree, the delicate brush strokes of the bamboo, and the "boneless" washes of the bamboo-leaves, is markedly sophisticated as is the warm, golden patina of all the painted parts. Such sensuousness cannot be fully equated with the Four Wangs, any more than can Wu Li's strangeness. Both painters were individuals as well as conformists. More than a few creative artists went all the way of nonconformity.

86 | *Old Trees and Bamboo in a Rockery,*
after K'o Chiu-ssu by Yun Shou-p'ing, hanging scroll

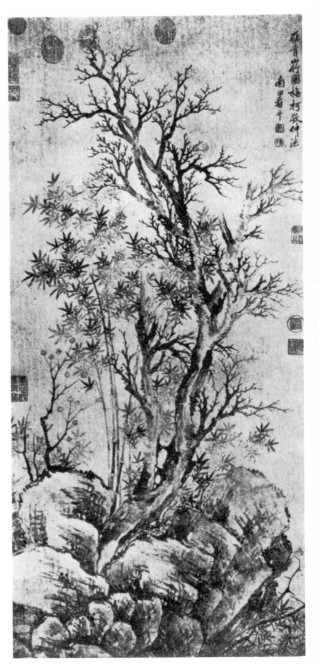

石谿曰佛不是閒漢乃至菩薩聖賢亦
閒王老莊孔子亦是有漢世閒只因有漏未空以至
家不治國不治業林不北乃舊天行健君子以自強不息
自羲棄我田虞東西起手師舉世自送濁了些不
美田之閒青田廬束閒長平乃旨完未求
公挹手似弓宗軍居業住藏社桂樹大藏之居
指石置千年冊十年中事經過莫子百閒生安於更之
不言庵色面叉所謂布施高僧保國祐民之俳子未
當少義昔之辰祖師廄見倒場回恩目瞪舌
居此不思而居一念庵雨亮之達是出矢大業使居
扭蟄林廣慮屠似不肯將此世吳好自利利已故住
者閒之之頗西漲振揚了異不讓而慮思亮之見好
事而懷寶於玉乖住
青漢大樓越瑪伯居士授劍于亞侯住裡異孔熟悲
一新冬十月余因跳柵枉平師出此屋林士書慶恩國主
以壽居士為傾神幕架云
石谿殘道人乩

THE INDIVIDUALISTS

I am always myself and must naturally be present in my work. The beards and eyebrows of the old masters cannot grow on my face. The lungs and bowels of the old masters cannot be transferred to my stomach. I express my own lungs and bowels and show my own beard and eyebrows. If it happens that my work approaches that of some old painter, it is he who comes close to me, not I who am imitating him. I have got it by nature and there is no one among the old masters whom I cannot follow and transform.[88]

—Shih-t'ao

The question is how to find peace in a world of suffering. You ask why I came hither; I cannot tell the reason. I am living high up in a tree and looking down. Here I can rest free from all troubles like a bird in its nest. People call me a dangerous man, but I answer: "You are like devils."[89]

—K'un-ts'an

With these writings and these pictures |87–94| we enter a radically different world. In many ways the styles of painting and the attitudes towards past or present of these Ch'ing individualists were the most extreme in the history of Chinese painting until modern times. While they were just as aware of tradition as any of their more conservative contemporaries, their use of that tradition was free and original. In many cases they went to Tung Ch'i-chang's paintings rather than his writings, and ex-

tracted that artist's most advanced and unusual approaches to form for their own use and development.[25] This is particularly true of Chu Ta and Kung Hsien. Nearly all of these men were, in one way or another, rebels in retirement, actively out of sympathy with the new Dynasty in particular and the world in general. In the cases of Pa-ta-shan-jen, Shih-t'ao, and K'un-ts'an, their assumed monk's names alone witness their chosen path of retreat from the world. Further, the first two were connected with Ming royal and princely lines, and the fall of that Dynasty in 1644 was more to them than just a foreign triumph. Their position, like that of the other, slightly later individualists, was well understood by the new powers, for their works are scarcely represented in the enormous Imperial collections. While they were rather untouchable, these individualists were not completely so, and their position of moral isolation was respected and often admired, even by officialdom. We must also remember that this rebellion and isolation was aesthetic, verbal, and ethical. Had it spilled over these limitations there might well have been martyrdom, as with a few late Yuan painters.

K'un-ts'an (also known as Shih'ch'i) and Shih-t'ao are usually considered together as the "Two Stones" (Shih).[24] Their relationship is more than that of a pun or a personal relationship, for among their contributions was a mutual understanding of the creative possibil-

109

毛道見地透脫只須
放筆直掃千巖万
壑縱目一覧望逸若
驚電奔雲屯�'自
趙荊關耶董巨耶倪
黃耶沈耶趙耶誰与
名家動輒傚其家
法某派書與画元生
安名余當見諸話
黃郎沈趙耶倪
自有二人職掌一
代之事從何處
說起大滌子舉為
翁年萬茔芷一嘆
癸未二月青蓮艸閣

ities of color. We have already seen the constructive use of color by Wang Yuan-ch'i and its sensuous application by Yun Shou-p'ing, but in the case of the Two Stones the use was governed equally by a desire for emotional expression. In the seventeenth century, for the first time, we find various artists experimenting with color, another index of their personal and visual approach. Of the Two Stones, K'un-ts'an was the more specialized. Nearly all of his paintings |87| have a rather grandiose and dramatic view of nature in movement, within and beyond the picture. The trees and rocks dance and twist—only the temple is quiescent. The orange color used throughout the picture suggests summer heat and the rosy color of light coming through clouds in the late afternoon. If any source for K'un-ts'an's art should be mentioned, that inspiration would be Shen Chou in such pictures as |54, p. 70|.

The second "Stone," Shih-t'ao, is even less traditional and more varied than the first, and this variety is well represented here. He seems at his best in the small, personal format of the album leaf. Two of these dated 1703 |90|, are not only of interest for their varied brushwork and composition, but because their inscriptions are excellent statements of Shih-t'ao's unusual aesthetic position.[117] The contrast between the soft, wet washes and strokes of one, and the crisp, dry edges of the other is evident and this variety is carried out in other leaves from the album. Then there is the **painting of six years earlier |88, facing p.116| which uses a wonderful asymmetry with warm color, a complete range of brush stroke, and texture. The result is a personal statement, but still related to what the eye sees of nature in a similar situation |S|.** The suavity of the painting goes well with the highly interesting and virtuous inscription translated in the list of illustrations.

90 | *Mountain Path* (left)
and *Retreat under a Cliff*
by Shih-t'ao, two album paintings

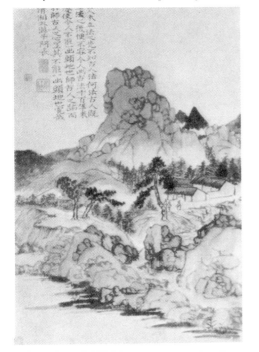

S | Mountain Pines near Peking

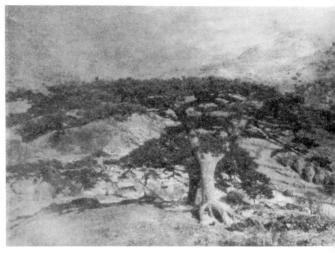

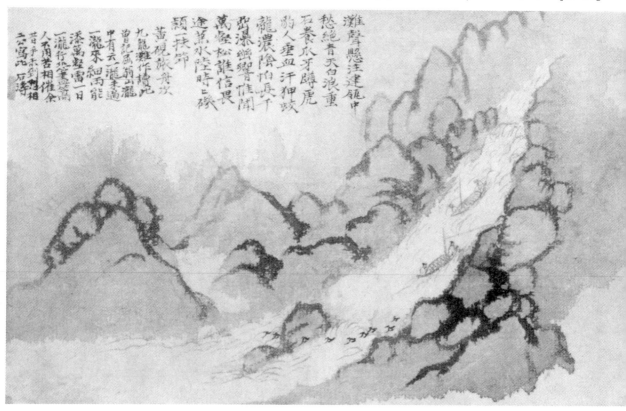

The album of seven leaves | 89 |, left from an originally much larger total, is of a different nature. Small in size and very sketchy in treatment, the pages were intended as personal notes for a friend, based on famous scenes throughout the country. They are, therefore, more specific, not only in a descriptive sense, but in the sense of the spectator sharing an intimate experience with the artist rather than observing something presented. This intimacy is refreshingly new. Leaf 6 is of great importance because of its relatively complex use of color; in addition to the standard triad, based on red, blue, and green, we have a purple and a mixed blue-green used in small but significant areas. The result is comparable to as advanced a modern painter as John Marin | I |. Both pictures must be described as water-color painting, with emphasis on the word color. Still another album by Shih-t'ao | 91 | is purely pictorial with no inscriptions or literary material. Again there is a great variety from a dry and crabbed handling of fantastic and forbidding rock forms to the most dashing and fluent representations of nature in various moods. The leaf with boat and rainstorm is extremely direct and immediate and has a more than casual connection with the equally torrential storm scene by Claude | J | where the tempest is all water and boat rather than tree and land. The universality of Shih-t'ao is due, in part, to his free and often un-Chinese attitude toward the brush. Few, if any other Chinese painters use the brush more pictorially with relatively little emphasis on precision and accuracy of the stroke. His brush-stroke method, or as he would say, "no-method,"[90] is one of non-commitment. Like a great general he holds back until he sees what is needed, and then he supplies it to meet the particular demand. "The method is complete when it is born from the meaning, but the method of the meaning has never been recorded," or, "the method which consists in not following any method is the perfect method."[88] This attitude governs the great variety and universality of his work, which includes one of the most interesting and unusual of all Chinese treatises on painting, the *Hua Yu Lu* (Notes on Painting).[24] In this, as in his painting, he goes directly to the original words of the Ch'an Buddhist and Taoist philosophers and starts from them, brushing aside the intervening years of commentary. Like his pictorial brothers, the spontaneous masters of Southern Sung | 25, p. 35 |, he is frighteningly direct and seemingly naive. He makes us think and look anew. Study of the old masters is for him not archaism but *"Pên-hua"*: Transformations. Painting is merely painting to Shih-t'ao. Real painting is *"I-hua"*:

I | *Marin Island, Maine, 1914* by John Marin

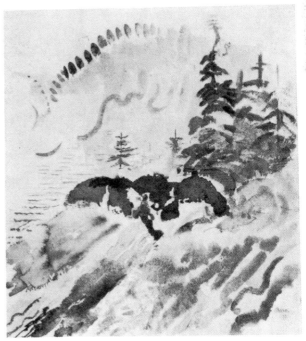

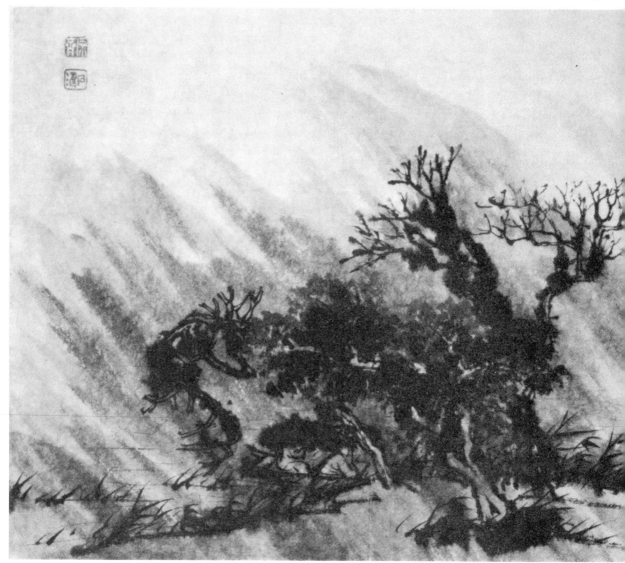

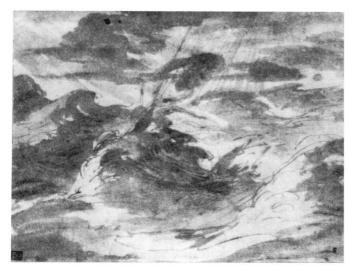

J | *Ship in a Tempest*
by Claude Gellee

91 | *Landscape* by Shih-t'ao, album painting

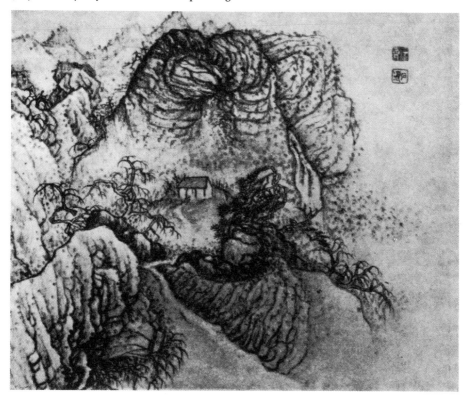

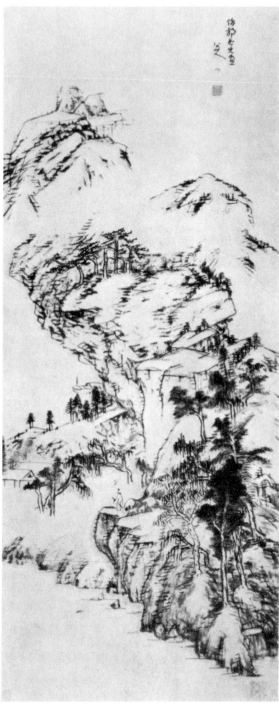

one-stroke painting in the sense of relationship to the first, primordial stroke of creation.

The third of these four most famous seventeenth-century individualists is the Chu Ta of imperial lineage who became Pa-ta-shan-jen, the priest. His most characteristic works are fish, flower, bird, and rock pictures, but enough of his landscapes remain to show his originality and his greatness. The landscape after Kuo Chung-shu | 92 | is derived in some of its parts, notably the trees at the lower right, from Tung Ch'i-ch'ang. But from there on into the picture a bolder and more accomplished hand takes over. Kuo was a rare Northern Sung master and we have nothing to go by in determining the extent of Chu Ta's dependence. As we look, we can feel safe in assuming there is very little. Chu has achieved monumentality in size and scale with the great twisting movement of his cliff capped by the two peaks beyond. The view past the cliff at the left is not new in itself, but its pictorial and abstract validity is. His metier is not color or wash but linear and calligraphic brush strokes. The second hanging scroll | 93 | is a colored and calmer view of flat islands and distant shore in which the musical play of the brush is particularly delightful. The fatness and cleanness of this brush-play is characteristic from the largest scrolls to the tiniest album leaf. The landscapes of Pa-ta-shan-jen, unlike those of his three parallel masters, seem more rational and less sensuous in general effect. What sensuous quality exists is to the Chinese one of the most sensuous of all qualities, the brush stroke. But to us he must seem a more purposefully abstract and constructivist master than the others.

99 | *A Pleasure Excursion in the Stream after the Style of Wang Fu* by Ch'a Shih-piao, album painting

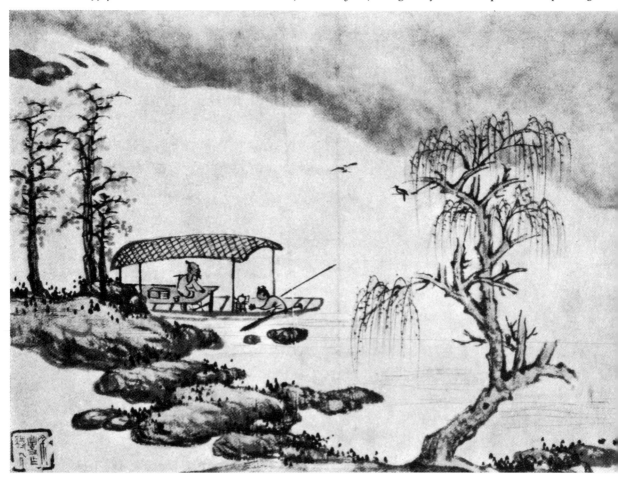

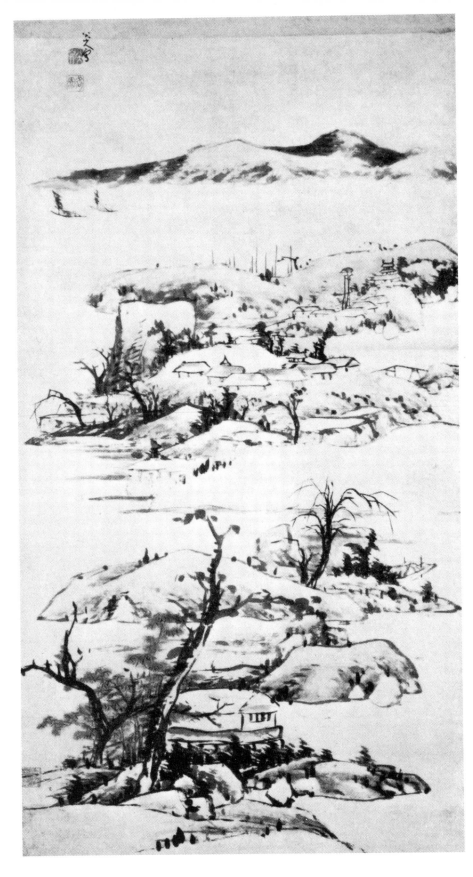

93 | *Landscape*
by Chu Ta,
hanging scroll

117

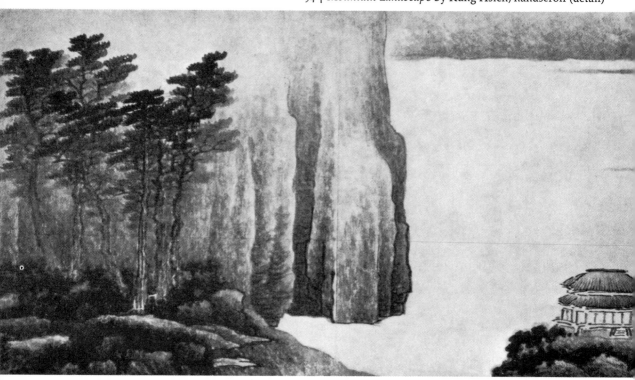

The last of the four is Kung Hsien, no priest but nevertheless a recluse, a cultivator of his own garden, and a painter. Kung seems the most limited of the individualists in terms of mood and general pictorial appearance. Perhaps, unlike Shih-t'ao, he had a method, for in addition to authoring a critical treatise, he also prepared a manual for painters. The long handscroll | 94 | is typical, and shows Kung's characteristic dark and ghostly view of nature. He depends upon a heavy massing and glazing of ink, perhaps more so than any other Chinese painter. In these masses he places sudden appearances of ribbons and patches of light, like wraiths before his night world. The gloomy drama of his landscapes is strangely Western as is his systematic massing of similar brush strokes and the almost completely covered surface of his paper. The interest in light as a true pictorial phenomenon is apparently a development of later Chinese painting.

The measure of the originality of these and other individualists is the ease with which we recognize their personal styles and instantly separate them from the styles of nearly all other Chinese landscape painters. Their uniqueness is also a snare since their manner is so distinctive that it can be superficially reproduced with considerable ease. To reproduce their touch is another matter, as it is with a Rembrandt or a Renoir. Who can justify such an interest in later painting? Even in traditional China the trace and touch of the individual became more and more important, culminating in these and other painters of the seventeenth and eighteenth centuries.

The importance of local geographic factors, including physical isolation and environment, is always present in Chinese painting. Contag has stressed the importance of local collections of paintings and the local landscape in the formation of an artist's style;[25] and for this reason the standard Chinese histories of Chinese painting tend to a rather too neat geographic basis of classification: "The Four Masters of Anhui"; "The Eight Masters of Nanking"; "The Strange Masters of Yangchou." But this over-emphasis should not lead us to overlook the partial validity of the geographic idea. Anhui Province, south and west of the usual school centers, is a case in point. Two Anhui men of late Ming and early Ch'ing stand apart as individuals with unusual but related styles. Hung Jen, a priest-recluse, died before Hsiao Yun-ts'ung, but was his pupil. The student became more famous than the master. Both are very much worth attention. Hsiao is represented by one of his masterpieces, a long handscroll of *Clear Sounds among Hills and Waters* | 95 | and a perfect example of his late style, a small album | 96 |. *Clear Sounds*

119

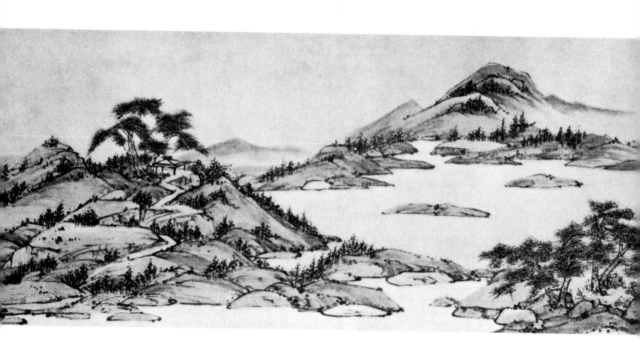

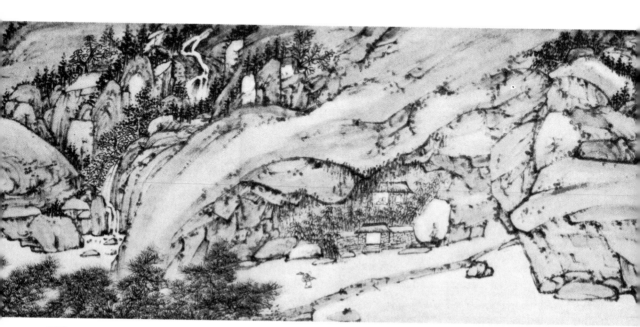

120

95 | *Clear Sounds among Hills and Waters* by Hsiao Yun-ts'ung, handscroll (two details)

冬日烘門畫始
開島皮拂淨絕
叢埃梅花又放
亭前樹香遠簷
手自捆懷
戊甲十月
七十三叟石雪岩

122

is dated 1664 and is a composition based on free-swinging rhythms and cool, crisp color. The variety of landscape representation aids the uniformity of the brushwork system based on angles and arcs. The clear, sharp, almost tart, flavor of the scroll, like that of high mountain country, must have impressed the eighteenth-century scholar, Shen Feng, who chose the title. The second work is thinner and more delicate, in part because it is an album, but also because of the intervention of the pure and cold style of the dead pupil, Hung Jen.

Hung Jen does to Hsiao's style what Chao Meng-fu did to Li Ch'eng's |28, p. 41|. He deletes the color and flesh and leaves only the bare bones. Of course Hung is also an ardent admirer of Ni Tsan | 34, p. 48 | and the large hanging scroll | 97 | is even more a tribute to his spiritual god-father Ni than to his actual master Hsiao. The most crystalline and angular treatment possible produces a calculated air of unreality and refinement, as if one were in the thinnest air of the highest mountains. The spare details are wedded to a delicate touch and a large scale composition. His use of the old device of flat planes, overlapped and receding into space, relates the details to the picture surface and gives a large effect that belies the thin and delicate brushwork. Hung Jen's style is an essence of an essence, refined to the breaking point and always on the verge of disappearance. But it seldom fails and the end product if specialized is fine and rare.

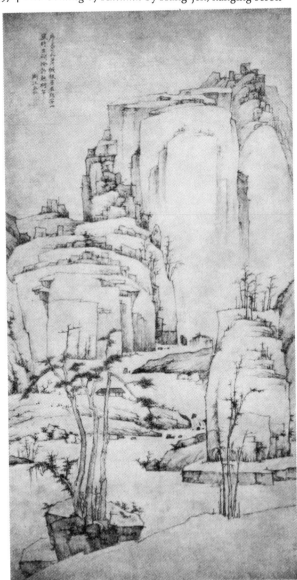

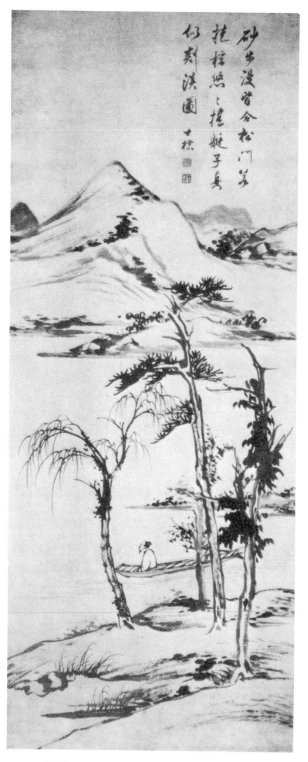

砂
出
浸
岩
令
松
門
茸
拖
揠
瑟
之
搖
挺
子
兵
似
尌
溪
圖
士
標

Another product of Anhui, Ch'a Shih-piao
| 98; 99, facing p. 119 | is more traditional
and more approachable. His abbreviating and
free-flowing brush is used to produce scenes
with an immediate impact of great physical
charm, often in an almost full water-color
technique. The last of these individualists, Mei
Ch'ing, seems less concerned with brush vir-
tuosity and more with the Yellow Mountains
in his native Anhui. Most of his albums are
made up of scenes from this range executed
"in the style of" various earlier painters. The
album | 100 | presents considerable variety in
subject and quality. Mei is at his best in more
complex organizations, where the rolling, ro-
coco movement of the landscape, not unlike
the movements of a Fragonard drawing |K|,
successfully overrides his brush. The appar-
ently common idea of metamorphosis, as
found in Wu Li and others, is found here too.
For Mei Ch'ing the landscape is reduced to
small rhythmical motifs and repetitions: trees
are like flowers, mountains like rocks, etc.
While he reminds us at times of Shih-t'ao, he
does not possess the amazing inventive fecun-
dity of that artist. Mei invented some six or
eight motifs and varied them ad infinitum.
For Shih-t'ao every picture is an invention.
Mei Ch'ing's works are very special concoc-
tions, not for constant use, but well worth
knowing.

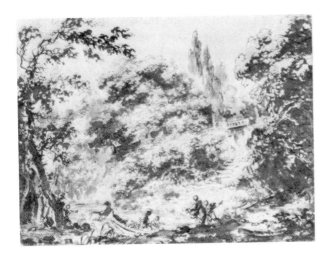

K | *Scene in a Park*
by Jean Honore Fragonard

100 | *Landscape* by Mei Ch'ing, album painting

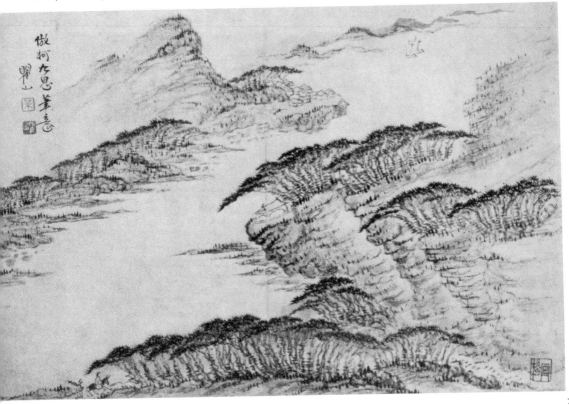

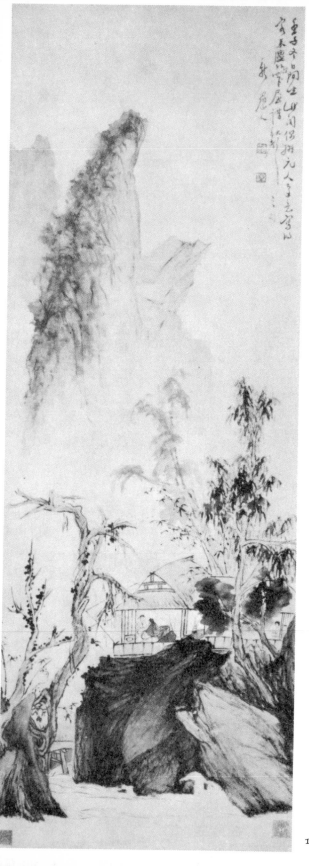

As in the case of the orthodox painters and the academicians, the eighteenth century produced fewer individualists of great intrinsic worth, but those few are quite up to the high levels of the preceding century. Most of these interesting personalities are included in the "Strange Masters of Yangchou," from the city where they were born or to which they migrated. Hua Yen is one of these and at his best, as in the famous *Conversation in Autumn* | 101 |, dated 1732, is a stunning painter. He is not only a brush virtuoso, but a colorist and a pictorial organizer. The twisted rocks below are heightened in their tone and movement as counterpoint to the tall mountains washed with color in the "boneless" manner. There are innumerable telling contrasts of wet wash, dry texture, and crisp, small strokes that seem as if flicked upon the paper. The viewer feels the hand of the artist as it literally flies over the paper. As much as any painting, this one has touch and it should be compared with the fifteenth-century Tu Chin | 44, p. 60 | for the same spirit in a different age. Hua Yen's brushwork is buttressed by a strong sense of structure as in the pierced tree trunk at the left, or in the larger organization by contrast of excitement below and tranquility above. Diversified but integrated, *Conversation in Autumn* is a completely satisfying picture. His later compositions are often more carefully handled but even more original in composition. The *Enjoyment of Chrysanthemums* | 102 | uses this later interest in off-balance compositions with an unusual representation of a highly literary activity: the tranquil scholar with his books and his flowers in the midst of garden-like nature.

Chin Nung is a far "stranger" Yangchou scholar-painter, a priest with bizarre pictorial tendencies that go farther from the norm than those of any of the individualists. The Weng album, | 103 |, dated 1754, is painted in a free

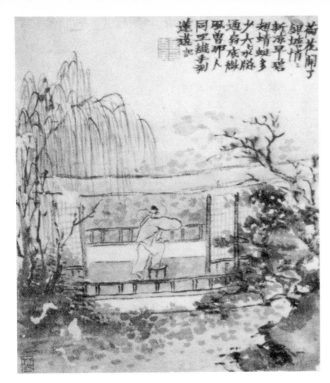

荷光開了
眼塘情
斬涼早碧
翅塘蜓多
少大水勝
通向底橋
映喜卿人
同子攏秀刻
蓮遊記

103 | *Ink Play*
 by Chin Nung, album painting

102 | *Enjoyment of the Chrysanthemum Flowers* by Hua Yen, hanging scroll

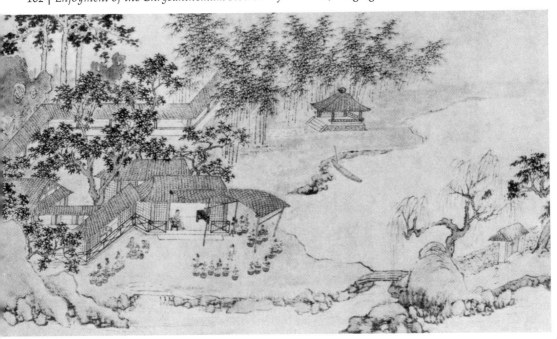

127

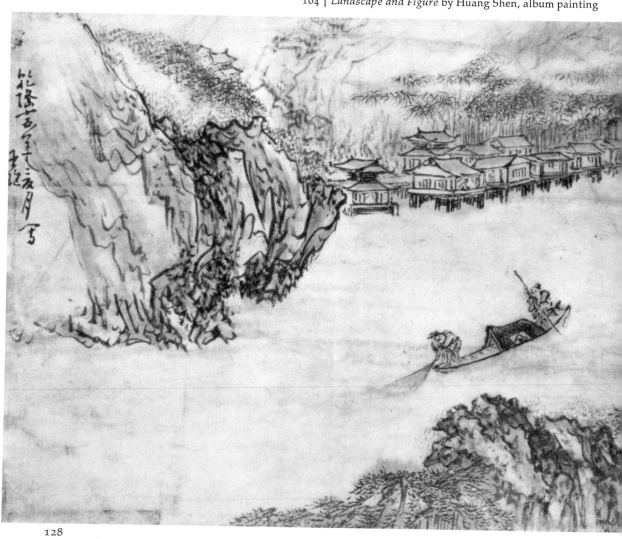

and easy, almost slight manner. Aside from the evidently unusual compositions, we are aware that strong linear elements are dominant, while washes of subtle color supplement the more varied lines. The quality of these leaves is rather close to that of the "intimist" drawings of Bonnard or Vuillard. Even his contemporaries called Chin Nung "most peculiar" or "quite startling," but the illustrated painting seems as warm and sensitive as the poem written on it:

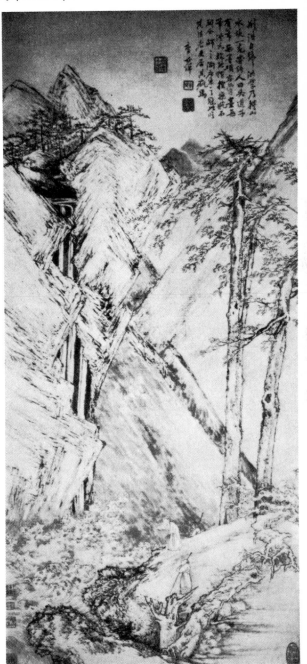

> The lotus have been flowering
> The silvery pond is still
> in the early cool season;
> There are countless dragon flies
> with green wings.
>
> Once the six pairs of water-windows were
> opened,
> a gentle breeze moved under the fan,
> While I was sitting with someone
> looking at lotus seeds being peeled
> by exquisite hands.

Chin Nung is a highly serious artist, even in his sketchy style. Huang Shen has a touch of humor transmitted with a nervous, flying touch. In his album | 104 | we see him as a kind of "sport" descendant of the Che School. His fluttering brushwork is usually used for figure painting, but in the landscapes he gives it even freer rein and so the outlines and wrinkles of the rocks seem to dance in a syncopated way. His exaggeration and his humor evidently puzzled his countrymen who called him "too extravagant" and "lacking refined beauty and harmonious ease."[89] Perhaps this explains why his best pictures are to be found in Japan where the extremes are more easily acceptable.

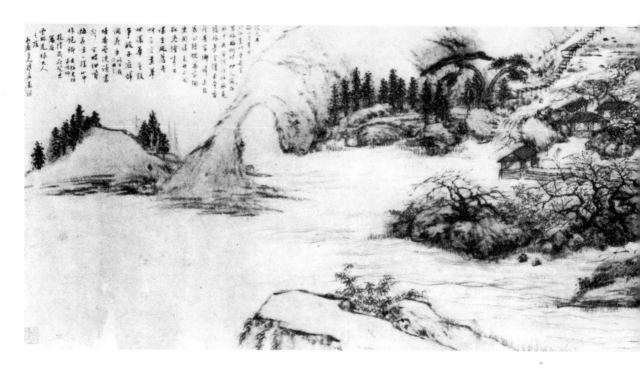

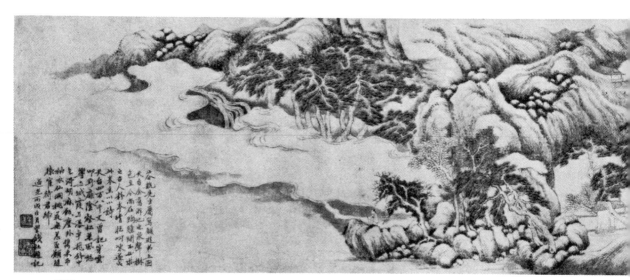

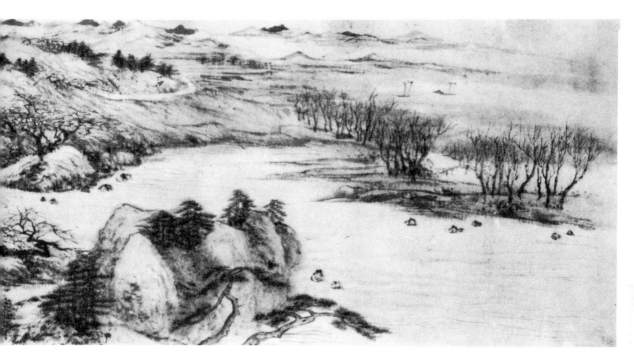

106 | *Landscape in Blossom Time* by Chang Tao-wu, handscroll

107 | *Longings to Travel: T'ien T'ai* by Ch'ien Tu, handscroll

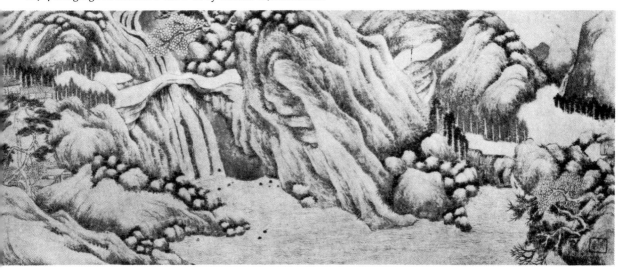

With these, after all, not-so-strange masters, one nears the end of creative landscape production. An orthodox painter like Li Shih-cho may occasionally produce a striking example of dry brushwork in a bizarre and angular composition which is almost a play on the similarity of dry and crumbly textures in nature: water foam, crumbling rock, and rotting tree | 105 |. Or an unknown, sad, and unsuccessful scholar, Chang Tao-wu, will take a hackneyed seasonal subject, blossom time, and contribute a fresh and charming handscroll | 106 |. But by 1800 landscape and all painting has run dry in theme, technique, and mood. And so the last of our talented painters, Ch'ien Tu | 107, 108 |, living on to 1844, sets himself a limited scale of dry brushwork within a severely limited size and so is able to keep touch and breath alive—just barely. He is a miniaturist with absolute command within his tiny range and his dense and tight view of nature seems terribly introspective, slightly twisted, and carefully censored. The dry-rot of latter day Imperial China required Ch'ien Tu's traditional scholarly response: cultivate your garden, avoid the dusty crowd. He was enough an artist to turn the dryness into style, but even his contribution is minuscule in the depressing light of the beginning time of troubles. The Chinese view of nature was still a valid one and its pictorial expression depended upon other new and individual replies, but exhaustion made no answer.

IDENTIFICATION OF SEALS

LIST OF ILLUSTRATIONS

1 | Ewer

Bronze with incised decoration of figures in a landscape; H. 3"; W. 8 1/2"; D. 9 1/2". Reputedly from Ch'ang Sha, Late Chou period (5th–3rd c. B. C.). PUBL: Bibl. 102.* Seattle Art Museum, Eugene Fuller Memorial Collection.

2 | Tomb Tile

Terra cotta with stamped designs; H. 14"; W. 3' 5 1/2". Later Han Dynasty (A. D. 2nd–3rd c.). The Cleveland Museum of Art, Gift of Mr. and Mrs. Ralph King.

3 | Rural Landscape Scene

Rubbing of a tomb tile, the original of molded clay. H. 16 1/2"; W. 18 1/8". From Ch'êng-tu, Szechüan; Han Dynasty (206 B.C.–A.D. 220). PUBL: Bibl. 79, p. 32, pl. 76. Dr. Richard Rudolph, Los Angeles.

4 | "Hill Jar"

Hard reddish pottery cylinder on three feet, lead glaze. H. 10 1/2"; D. 10 3/4". Han Dynasty (206 B.C.–A.D.220). The Cleveland Museum of Art, Purchase from the J. H. Wade Fund.

5 | Painted Tomb Tile

Black and red color on slip over gray earthenware. L. 41"; H. 8 1/2". Late Han or Early Six Dynasties (3rd–5th c.). PUBL: Bibl. 101. The Cleveland Museum of Art, Gift of Mr. and Mrs. Nasli M. Heeramaneck.

*Bibliography numbers refer to items in the Selected Bibliography, page 153.

Ku K'ai-chih

Ch'ang-k'ang, Hu-t'ou
ca. 343–406, Kiangsu (Wu-hsi).†

6 | *Mountain Landscape with a Hunter*

Handscroll; ink and color on silk. L. 136 2/3"; H. 9 3/4". Third scene from the scroll *Admonitions of the Instructress to the Ladies of the Court.* Early T'ang copy (?) of Ku K'ai-chih's illustrations to a text by Chang Hua (232–300) of the Western Tsin period. Text to this scene:

> It is the universal way that nothing can stay in exultation without being brought down, and nothing will reach its zenith without beginning to decline. The sun begins to sink after it has reached its midcourse; the moon begins to wane when it is full. The rise to towering height is only like the accumulation of dust, and the fall into misfortune is as quick as the sudden ambush by a cross-bow.

Present scroll consists of nine scenes. A later version now in Peking Palace Museum shows the original complete design in eleven scenes. Numerous collectors' seals. EX. COLL: "Hung-wên-kuan-yin" of the T'ang period; Sung Ch'i (998–1016); Emperor Hui Tsung (reigned 1101–1125); Hsiang Yüan-pien (1525–1590); Liang Ch'ing-piao (1620–1691); An I-chou (1683–ca. 1742) Emperor Ch'ien-lung (1736–1795). RECORDED: Mi Fu, *Hua Shih; Hsüan-ho hua-p'u;* Tung Ch'i-ch'ang,

† The artist's style (name), studio name or nickname are followed by his life dates and place of origin.

Hua-ch'an-shih-tsui-pi; Ch'en Chi-ju, *Ni-ku-lu*; Wu Ching, *Shih-ch'ing-cha-chi*. PUBL: Laurence Binyon, *Asiatic Art in the British Museum*, Paris, 1925, pl. XIV. Bibl. 5, p. 14; 91, III, pl. 11; Ma Ts'ai, *Ku K'ai-chih yenchiu* (A Study of Ku K'ai-chih), Shanghai, 1958. British Museum, London.

Anonymous

7 | *Jataka Story: the Deer King*

Fresco. From Cave 257 (Pelliot 110), Ch'ien-fô-tung, Tun-huang. About 500 A.D. PUBL: Bibl. 70, III, pl. 189; 115, pl. 6; 91, III, pl. 33; Basil Gray and J. B. Vincent, *Buddhist Wall-Paintings at Tun-huang*, London, 1959, pl. 4. Cave 257, C'hien-fô-tung, Tun-huang, Kansu.

Anonymous

8 | *The Miracles of Avalokitesvara*

Votive painting; ink and color on silk. H. 32 3/4"; W. 25". From Tun-huang; dated 943. PUBL: E. Matsumoto, *Tonkō-ga no kenkyū*, II, pl. XLI, right. Musée Guimet, Paris.

Ku K'ai-chih

Ch'ang-k'ang, Hu-t'ou
ca. 343–406, Kiangsu (Wu-hsi).

9 | *The Nymph of the Lo River (one section)*

Handscroll; ink and color on silk. L. 122 1/8"; H. 9 1/2". Sung copy. One of the three extant versions. The other two are in the collections of Peking Palace Museum and the North-eastern Museum at Mukden. First section is lost; colophon by Tung Chi-ch'ang. EX.COLL: Liang Ch'ing-piao (1620–1691); Tuan Fang (1861–1911). PUBL: Bibl. 5, p. 27; 91, III, pl. 9. RECORDED: T'ang Hou, *Hua Chien*; Mou Wei, *Nanyang ming-hua-piao*; Wang Ko-yü, *Shan-hu-wang*; Li Pao-hsün, *Wu-i-yu-i-chai tu-hua-shih*, *Hai-wang-tsun so-chien-shu-hua-lu*. Freer Gallery of Art, Washington, D. C.

Wang Wei

Mo-ch'i, Yu-ch'eng
701–761, Shansi (P'u-hsien).

10 | *Wang-ch'uan Villa*

Handscroll; ink and color on silk. L. 15' 9 1/2"; W. 11 13/16". Late Ming or early Ch'ing copy of the so-called Kuo Chung-shu version which is preserved notably in the form of a stone engraving at Lan-t'ien

hsien, Shansi, dated 1617. PUBL: Bibl. 91, II, list 21; I, 129–130. Seattle Art Museum, Eugene Fuller Memorial Collection.

Anonymous

11 | *Emperor Ming Huang's Journey to Shu*

Originally a hanging scroll; ink and color on silk. H. 32 5/8"; W. 44 3/4". 10th–11th c. PUBL: Bibl. 5, p. 61. *Bulletin of the Metropolitan Museum of Art*, October, 1943. The Metropolitan Museum of Art, New York.

Attributed to Li Ch'êng

Hsien-hsi
d. 967, Shantung.

12 | *Buddhist Temple in the Hill after Rain*

Hanging scroll; ink and very slight color on silk; slightly cut down. H. 44"; W. 22". Northern Sung Dynasty (960–1127). EX. COLL: Imperial collection of Sung Dynasty; Liang Ch'ing-piao (1620–1691); Hsü Ch'ien-hsueh (1631–1694); Miao Yueh-tsao (1682–1761); Miao Tsun-i, son of Miao Yueh-tsao; Shen Shujung (1832–1873). PUBL: Bibl. 5, p. 30; 91, III, pl. 151. Nelson Gallery of Art and Atkins Museum, Kansas City.

Attributed to Chu-jan

act. 975, Kiangsu (Nanking).

13 | *Buddhist Monastery by Stream and Mountains*

Hanging scroll; ink on silk H. 73"; W. 22 5/8". Northern Sung Dynasty (960–1127). RECORDED: *Hsüan-ho hua-p'u*; *Mo-yüan-hui-kuan*; *Ku-yüan-ts'ui-lu*. EX. COLL: Sung Government; Ming Government; Liang Ch'ing-piao (1620–1691); An I-chou (1683–ca.1742); Emperor Ch'ien-lung (1736–1795). The Cleveland Museum of Art, Gift of Mrs. Katharine Holden Thayer.

Hsü Tao-ning

act. 10th c.
Hopei (Ho-chien) – Shensi (Ch'ang-an).

14 | *Fishing in a Mountain Stream*

Handscroll; ink on silk. L. 82 1/2"; W. 19". Northern Sung Dynasty (920–1127). 25 seals including 10 of Keng Chao-chung (1640–1686), C. & W., p. 564; 1 of Prince I (see 32); and 2 of An Ch'i (1638–ca.1742). RECORDED: *Ta-kuan-lu*, XIII/25. PUBL: *I-lin yueh-k'an*, nos. 53 and 54; 91, III, pl. 158, II, list 53. Nelson Gallery of Art and Atkins Museum, Kansas City.

Kuo Hsi

Ho-yang
act. ca. 1068–1078, Honan.

15 | Trees on the Distant Plain

Handscroll; ink on silk. L. 40 11/16"; W. 13 7/8". Nine colophons on separate sheets, written by Feng Hai-shu; Chao Mêng-fu; Yü Chi; K'o Chiu-ssu; Liu Kuan; Wang Shih-chen and others. EX. COLL: Feng Hai-shu; Wang Shih-chen; Liang Ch'ing-piao (1620–1691); Songgotu (d. 1703 ?); Chang Tâ-chien. PUBL: Bibl. 6, IV, pl. 8; 40, no. 9; 91, II, list 57. John M. Crawford, Jr., New York.

Anonymous

16 | Streams and Mountains without End

Handscroll; ink and slight color on silk. L. 83 7/8"; W. 13 13/16". Northern Sung Dynasty, early 12th c. 49 seals and 9 colophons, the earliest dated 1205, the last by Wang To (1592–1652). The most notable colophon author is K'an Li-kuei, the famous Yüan calligrapher. The seals include those of Liang Ch'ing-piao (1620–1691) 8 seals, Emperors Ch'ien-lung through Hsüan-t'ung (18th–29th c.) 9 seals, and Chang Tâ-chien, modern painter and collector. PUBL: Bibl. 56; 65, no. 11; 91, II, list 94. The Cleveland Museum of Art, Gift of Hanna Fund.

Mi Yu-jên

Yüan-hui
1072–1151, Hupei.

17 | Cloudy Mountains

Handscroll; ink, lead-white and slight touches of color on silk. L. 6' 3 15/16"; W. 17 3/32". Poem and inscription by the artist:

Innumerable are the wonderful mountain peaks
 which join the end of the sky,
Clear or cloudy, day or night, the misty atmosphere
 is lovely.
To make known that the gentleman has been here,
I am leaving traces of my playful brush at your
 house.
[1130 A.D.] year, done at Hsing-ch'ang, Yüan-hui [signature], "Yüan-hui made" [seal]

4 colophons, 3 by Wang To (1592–1652), 1 by Chen Kuang. EX. COLL: Prince Ch'eng; Pi Chien-fei; Li Chih-kai, Wang To; T. Yamamoto. PUBL: Bibl. 19; 43; *Chōkaidō shoga mokuroku*, 1932 I/98 (Cat. of the Yamamoto Coll.); 91, III, pl. 189. The Cleveland Museum of Art, J. H. Wade Collection.

Chiang Ts'an

Kuan-tao
act. first half of 12th c., Chekiang.

18 | Verdant Mountains

Handscroll; ink and slight color on silk. L. 9' 8 1/2"; H. 12 3/4". Four character signature: Chiang Ts'an of Chiang-nan. (Signature and two seals of the artist are an interpolation.) Colophon by K'o Chiu-ssŭ (1312–1365), colophon by Emperor Ch'ien-lung, dated 1785. 22 seals, including those of Liang Ch'ing-piao (1620–1691), Sung Lo (1634–1713), and the Emperors Ch'ien-lung, Chia-ch'ing, and Hsüan-t'ung. RECORDED: *Shih-ch'ü pao-chi*, part II, *Yü-shu-fang*. PUBL: Bibl. 91, III, pls. 257 and 258, II, list 46. Nelson Gallery of Art and Atkins Museum, Kansas City.

Li An-chung

act. ca. 1115–ca. 1140, K'aifeng and Hangchou.

19 | Cottages in a Misty Grove in Autumn

Album leaf; ink and color on silk. W. 9 3/4"; H. 10 2/3". Signed and dated 1129 by the artist. EX. COLL: Kao Shih-ch'i, 2 seals. PUBL: Bibl. 91, III, pl. 228, II, list 58; 65, no. 13. Mr. and Mrs. Severance A. Millikin, Cleveland.

Anonymous

20 | Cottage by a River in Autumn

Fan-shaped painting; ink and color on silk. H. 9 1/2"; W. 10 3/8". Traditionally attributed to Liu Sung-nien, act. 1174–1210. 5 collectors' seals. EX. COLL: Wu Ts'an (18th c.), Li Tsai-hsien (19th c.). PUBL: Bibl. 114, pl. 88; 91, III, pl. 310, II, list 68. Museum of Fine Arts, Boston.

Li Sung

ca. 1190–1265.

21 | Second Excursion under the Red Cliff

Oblate circular form album leaf; ink and slight color on silk. H. 10 1/4"; W. 9 3/4". Signature of the artist on face of cliff, upper right. PUBL: Bibl. 87, II, pl. 71; 91, III, pl. 313, II, list 62. Nelson Gallery of Art and Atkins Museum, Kansas City.

Ma Yüan

Ch'in-shan
act. ca. 1190–1224, Shansi (Ho-chung)–
chekiang (Hangchou).

22 | The Four Old Recluses in the Shang Mountains

Handscroll; ink on paper. L. 9' 13"; H. 13 1/4". Signed

by the artist. Numerous seals. 40 colophons including 1 by Ni Tsan, 2 by Emperor Ch'ien-lung on painting proper. EX. COLL: Hsiang Yüan-pien; Pien Yung-yü; Liang Ch'ing-piao (1620–1691); Emperor Ch'ien-lung (1736–1795); T'an Ching. PUBL: Hugo Munsterberg, "The Collection of Chinese Paintings in the Cincinnati Art Museum," *Art Quarterly*, Winter, 1952; Philip R. Adams, "Random Notes on Chinese Painting," *Cincinnati Art Museum Bulletin*, III (March, 1953), no. 2. Bibl. 91, III, pl. 287, II, list 76. Cincinnati Art Museum, Cincinnati.

Hsia Kuei
Yü-yu
act. ca. 1180–1230, Chekiang.

23 | *Twelve Scenes from a Thatched Cottage*
Handscroll; ink on silk. L. 7' 6 3/4"; W. 11". Four character signature: "Painted by your humble subject, Hsia Kuei." 10 seals, most of them unidentified. The round seal with a square interior near the end of the painting may be a nien-hao of Emperor Sung Litsung. The *Chiang-ts'un hsiao-hsia lu*, describing the complete painting in the late 17th c., mentions at both ends five Sung Dynasty seals and three of the Yüan Dynasty. 8 colophons, including colophons by Shao Heng-cheng act. in the late 14th c.; Tung Ch'i-ch'ang (1555–1636), Wang Shih-ku (1632–1717), Viceroy Tuan Fang (1861–1911). Each scene is titled:

Flying Geese Over Distant Mountains
Returning Ferryboat to Village in Mist
The Clear and Sonorous Air of the Fisherman's Flute
Boats Moored at Night in a Misty Bay.

RECORDED: *Shan-hu-wang hua-lu*, XXIII/38 (1st half 17th c.); *Shih-ku-t'ang shu-hua hui-k'ao*, XIV/64 (ca. 1682); *Chiang-ts'un hsiao-hsia lu*, I/30 (1693); *P'ei-wen-chai shu-hua p'u*, LXXXVIII/26 (1708); *Nan-sung yüan-hua-lu*, VI/3 (1721); *Mo-yüan hui-kuan 6* (hsu) III (1742); *Chu-chia ts'ang-hua p'u*, IX/XIV (2nd half 18th c.). PUBL: Bibl. 17, V; *Kōkka*, Tōkyō, 1936, no. 2. Bibl. 73; 91, III, pl. 303–304. Nelson Gallery of Art and Atkins Museum, Kansas City.

Anonymous
24 | *River Landscape in Wind and Rain*
Fan-shaped album leaf; ink on silk. H. 9 1/2"; W. 10 1/8". Southern Sung Dynasty (1127–1279). 3 seals of Hsiang Yüan-pien (1525–1590). EX. COLL: A. W. Bahr. The Metropolitan Museum of Art, New York.

Mu-ch'i
Fa-ch'ang
born in the early part of 13th c., act. ?–1279, Szechuan.

25 | *Sunset over a Fishing Village*
Handscroll, ink on paper. H. 13". One section of a large scroll representing the *Eight Views of Hsiao and Hsiang*. Four more sections of the same scroll in the following collections: Count Matsudaira; formerly Viscount Matsudaira now Sasaki, Tōkyō; formerly Marquis Homari Maeda, now Yada Coll. in Katayamazu; formerly Marquis Tokugawa, then Suenobu Collection, now destroyed. One seal "Dōyu" of Ashikaga Yoshimitsu, the third Shōgun of the Muromachi period, who ruled from 1368–1394. PUBL: Bibl. 5, p. 93; 91, III, pl. 340; 93, I, pl. 35; 120, I, 102. Nezu Museum, Tōkyō.

Anonymous
26 | *Landscape with Flight of Geese*
Hanging scroll; ink and color on silk. H. 25 1/2"; W. 15". 13th–14th c. From a Japanese provenance. The Art Institute of Chicago, Chicago.

Ch'ien Hsüan
Shun-chü
1235–ca. 1298, Chekiang.

27, 27a | *Home Again*
Handscroll; ink and color on paper. L. 42"; H. 10 1/4". Inscription, signature, and 2 seals of the artist. Colophons; among seals are those of Hsiang Yüan-pien (1525–1590), Emperor Ch'ien-lung. The picture illustrates the famous rhymed prose by T'ao Ch'ien (365–427). PUBL: Bibl. 33, p. 147; 119, Cat. no. 12; 91, VII, list 109. The Metropolitan Museum of Art, New York.

Chao Mêng-fu
Tzu-ang, Sung-hsüeh
1254–1322, Chekiang.

28 | *Landscape with Twin Pine Trees*
Handscroll; ink on paper. L. 42 1/4"; W. 10 1/2". Two inscriptions and seals of the artist:

Ever since my youthful days, I have often played with painting on the time I spared from the learning of calligraphy. Landscape painting is a genre I am not skilled in. The fact is, of the wonderful works of the T'ang masters such as Wang Yu-

ch'eng(wei), General Li père, General Li fils, Cheng Kuang-wen(ch'ien), there aren't more than one or two to be seen these days. The Five Dynasties masters such as Ching Hao, Kuan T'ung, Tung Yüan, and Fan K'uan are absolutely different from the works of recent times. I dare not claim that my paintings are comparable to those of the ancients; contrasted with those of recent times I dare say they are a bit different. Since Yeh-yun has asked me for a painting, I write this at the end of it. Chao Mêng-fu.

EX. COLL: Yang Tsai (Yüan); T'ung Hsuan (Ming); Liang Ch'ing-piao (1620–1691); An Ch'i (1683–ca.1742); Emperor Ch'ien-lung and later Imperial collections. PUBL: Bibl. 16, I, 96; 91, VI, pl. 23; 65, no. 29. C. C. Wang, The Bamboo Studio, New York.

Chao Yung
Chung-mu
born 1289, Chekiang.

29 | Landscape with Scholar Fishermen
Hanging scroll; ink and color on silk. H. 34 1/16"; W. 16 3/4". One seal of the artist at lower right (Chung-mu), C. & W., p. 527, no. 3. 3 Collectors' seals, 3 seals of Chang Ts'ung-yü (20th c.). PUBL: Bibl. 43; 104; 91, VII, list 105; Sogen meiga-shu (Selected Masterpieces of Sung and Yuan Dynasties from Public and Private Collections in Japan), Tōkyō, 1930–39, I, 34. Mr. and Mrs. A. Dean Perry, Cleveland.

Li Shih-hsing
Tsun-tao
1282–1328, Kweichou.

30 | The Guardians of the Valley
Hanging scroll; ink on silk. H. 67 1/2"; W. 38 3/8". Signed, 2 seals of the artist with possibly 1 other. 1 seal of Yin Hsiang (Prince I); 1 unidentified seal. RECORDED: Shih-chü pao-chi, I/115. PUBL: Bibl. 65, no. 30; 91, VII, list 122. Fogg Art Museum, Harvard University, Cambridge, Massachusetts.

Huang Kung-wang
Tzu-chiu, I-fêng, Ta-ch'ih
1269–ca. 1354, Kiangsu.

31 | Dwelling in the Fu-Ch'un Mountains
Handscroll; ink on paper. L. 19' 8"; H. 13". Artist's inscription dated 1350. Six colophons: Shen Chou dated 1488; Wên Peng dated 1570; Wang Chih-teng dated 1571; Tsou Chih-lin (ca. 1585–ca. 1651); Tung

Ch'i-ch'ang (1555–1636) and Emperor Ch'ien-lung (1736–1795). EX. COLL: Shen Chou (1427–1509); Tung Chi-ch'ang; Wu Chi-chu; Chi Yü-yung (1st half of 17th c.); Kao Shih-ch'i (1645–1704); Wang Hung-hsü (1645–1723); and Emperor Ch'ien-lung (1736–1795); An Ch'i (1683–ca.1742). RECORDED: Shih-chü pao-chi; Wu Li, Mo-cheng-hua-pa; Yün Shou-p'ing, Ou-hsiang-kuan-chi; An Ch'i, Mo-yüan-hui-kuan; and others. PUBL: Bibl. 5, p. 110; 85, XVI, pl. 16–22; 105, IV, no. 161; 91, VI, pl. 67–72, VII, list 114. National Palace Museum, Taichung, Formosa.

Wu Chên
Chung-kuei, Mei-hua Tao-jen
1280–1354, Chekiang.

32 | Fisherman
Album leaf mounted as handscroll; ink on paper. L. 21 1/2"; H. 12 7/16". Inscription and seals of the artist, 1 seal, C. & W., p. 515, no. 1. EX. COLL: Kêng Chao-chung (1640–1686); Chang Tâ-ch'ien, collector and painter. PUBL: Bibl. 6, I, pl. 13; 65, no. 30a (not ill.); 91, VII, list 143. John M. Crawford, Jr., New York.

Wang Mêng
Shu-ming, Huang-hê-shan-jen
1308–1385, Chekiang.

33 | Fishing in the Green Depths
Hanging scroll; ink and color on smooth paper; damaged and repaired, clearly visible. H. 34 5/8"; W. 17 1/2". Signed with a poem on the right:

Your home is over the clean flood
And you drop your hook under the green shades;
Dew dampens the hibiscus moon
And fragrance dissolves in the lotus wind.
The drifting boat enters misty isles,
And in the press of flowers sits your flute;
Knowing only him who lives forgetting,
No thought for the Old Man of the Frontier.*
 Huang-hê-shan-chung-jen [The-man-from-
 the-heart-of-Yellow-Crane-Mountain],
 Wang Shu-ming painted and inscribed.

* "Old Man of the Frontier" refers to a figure in the old Chinese text, Huai-nan-tzu, whose good fortune turns to bad and whose bad fortune later becomes good. His experiences stand as a symbol of the unpredictable quality of change and inspire the cultivation of a tranquility of mind which always happily accepts the will of heaven.

2 other poems by contemporaries of the artist; 3 old but unidentified collectors' seals; 2 unidentified seals on the probably-Yüan inscription at left. RECORDED: *Shan-hu-wang* XI/5, 1643 (full description); *Shih-ku-t'ang* XXI/6, 1682; *P'ei-wên-chai* LXXXVI/12, 1708. Stephen Junkunc, Chicago.

Ni Tsan
Yüan-chen, Yün-lin
1301–1374, Kiangsu.

34 | Rocks, Trees and Bamboo in the Rain
Hanging scroll; ink on paper. H. 26 1/4"; W. 14 5/8". Seal and inscription of the artist. Five other inscriptions including a poem by Ts'ao Chih-po (1272–1355). EX. COLL: Liang Ch'ing-piao (1620–1691); Ku Wên-pin (1811–1889). PUBL: Bibl. 65, no. 39; 91, VII, list 128. C. C. Wang, The Bamboo Studio, New York.

Ts'ao Chih-po
Yün-hsi
1272–1355, Kiangsu.

35 | A Pavilion near Old Pines
Album leaf mounted as a hanging scroll; ink on paper; small damages and repairs. H. 18 7/8"; W. 14 3/8". Inscription:

> The Balcony of the Over-flowing Swamp [Wa-ying hsien; a retreat]; did this for the Liang-ch'ang grass-hall [a retreat]; seal of the artist: Yün-hsi.

6 Ch'ien-lung seals; 2 Hsüan-t'ung seals. PUBL: Bibl. 33, opp. p. 148; 17, I, 125; 91, VII, list 135. Musée Guimet, Paris.

Chao Yüan
Tan-lin
act. ca. 1360–1372, Shantung-Kiangsu.

36 | Saying Farewell to a Guest on a Fine Day
Hanging scroll; ink on paper. H. 37 1/4"; W. 13 13/16". Inscription and seal of the artist, C. & W., p. 526, no. 2. Seal of An Ch'i (1683–ca. 1742), seals of Ch'ien-lung (1736–1795); seals of Chang Ts'ung-yü (20th c.). RECORDED: An Ch'i catalogue, *Mo-yüan-hui-kuan*, V/29. PUBL: Bibl. 27, p. 526; 109; 91, VII, list 116. C. C. Wang, The Bamboo Studio, New York.

Yao T'ing-mei
14th c., Chekiang.

37 | The Scholar's Leisure
Handscroll; ink on paper. L. 33 1/16"; H. 9 1/16". Inscription:

140

1360, spring, first month. I did this and added my humble words at the end, followed by a poem signed Yao T'ing-mei of Wu-hsing.

Collectors' seals: Liang Ch'ing-piao (1620–1691), Emperors Ch'ien-lung, Chia-ch'ing, and Hsüan-t'ung. The poem on the painting by Emperor Ch'ien-lung is dated 1755. EX. COLL: Liang Ch'ing-piao (1620–1691); Emperors Ch'ien-lung (1736–1795), Chia-ch'ing (1796–1820), and Hsüan-t'ung (1908–1912); Chang Ts'ung-yu (20th c.). PUBL: Bibl. 109. The Cleveland Museum of Art, John L. Severance Fund.

Ch'en Ju-yen
Wei-yin
ca. 1341–1368, Kiangsu (Suchou).

38 | Lo-fou Shan's Woodcutter
Hanging scroll; ink on somewhat darkened silk. H. 41 3/4"; W. 21". Text written by the artist on top left of the painting:

> 1366, 1st moon, 16th day, Lu Shan Ch'en Ju-yen painted for Magistrate Szu-ch'i, the painting of Lo-fou Shan's wood-cutter.

EX. COLL: Magistrate Szu-ch'i family, 2 seals of Lu P'eng-sheng; 4 seals of Wang Shih-min (1592–1680); 1 seal of Kung Heng-p'u; 4 seals of Chang Ts'ung-yü (20th c.). RECORDED: *Li-tai chu-lu hua-mo*, III, 296; *Jan-li-kuan kuo-yen-hsü-lu*, IV, 7. PUBL: Bibl. 65, no. 40a; 109. Mr. and Mrs. A. Dean Perry, Cleveland.

Hsü Pên
Yu-wên
act. ca. 1372–1397, Szechuan-Kiangsu (Suchou).

39 | Streams and Mountains
Hanging scroll; ink on paper. H. 26 3/4"; W. 10 1/4". One poem and inscription of the artist:

> Green trees, yellow orioles,
> everywhere are mountains;
> Incidently I have just returned from the stream,
> where I watched the clouds.
> Man's life does not allow unbroken ease,
> But to be able to be high up in the mountain,
> this is leisure.
> 1372 on the 10th day of the 7th month, Hsü Pên did this painting and then added the poem above it for Mr. Chi-fu.

4 other poems with 3 seals by contemporaries of Hsü Pên: Hsieh Hui, Kao Ch'i, Lu Chen, and Huang Tsai. Hsieh Hui writes: "When Hsü Pên was visiting Wu-hsing (Chekiang) he did the painting *Streams and*

Mountains, and added a poem to present to Chi-fu, and I have written this." 2 unidentified collectors' seals on the painting; 3 seals on the mounting, including 2 of Liang Ch'ing-piao (1620–1691), and 1 title with a seal, possibly the writing and seal of Liang Ch'ing-piao. EX. COLL: Liang Ch'ing-piao (1620–1691). PUBL: Bibl. 65, no. 40; 91, VII, list 194. Mr. and Mrs. A. Dean Perry, Cleveland.

Chin Wen-chin
Yün-shih
act. 1400–1450, Kiangsu.

40 | *Ten Thousand Bamboo*

Handscroll; ink on paper. L. 29' 9 1/2"; H. 13 3/4". Dated 1438; 14 colophons including the artist's inscription, all on the painting. 44 seals not counting mounting seals; 4 seals of Hsiang Yüan-pien (1525–1590). PUBL: as by Kuan Tao-sheng in O. Siren, *Kinas Konst*, II, 423. Bibl. 91, VII, list 173. Fogg Art Museum, Harvard University, Cambridge, Massachusetts.

Hsia Ch'ang
Chung-chao
1388–1470, Kiangsu.

41 | *Bamboo Bordered Stream in the Spring Rain*

Handscroll, ink on paper. L. 50'; H. 16 1/4". Artist's inscription dated 1441. Several colophons; numerous collectors' seals including Emperor Ch'ien-lung (1735–1796). PUBL: Bibl. 91, VI, pl. 134, VII, list 186. The Art Institute of Chicago, Kate S. Buckingham Collection.

Liu Chüeh
T'ing-mei
1410–1472, Kiangsu (Suchou).

42 | *Landscape in the Style of Ni Tsan*

Hanging scroll; ink on paper. H. 58 5/8"; W. 21 5/8". Inscription and 1 seal of the artist. Colophon by Shen Chou. EX. COLL: Kao Shih-ch'i (1695–1704). PUBL: *Mostra di Pitture Cinese Ming e Ch'ing*, Rome, April, 1950, no. 3. Bibl. 65, no. 51. Musée Guimet, Paris.

Tai Chin
Wên-chin
1388–1462, Chekiang (Hangchou).

43 | *Ten Thousand Li of the Yangtze*

Handscroll; ink and color on paper. L. 38' 5 1/2"; H.

13 1/2". 2 seals of the artist: Tai Chin, Wên-chin; 1 colophon:

In my old family collection of paintings, there is a Sung scroll titled Ch'ang-chiang-wan-li [literally, Long River of ten thousand miles, referring to the Yangtze River]. The brushwork is quiet and graceful; the depicted objects are elegant and expressive. It is indeed a masterpiece. The other day, at my "classmate" Chiu-fan's place, I saw a painting with same title done by Chou Tung-ts'un [Chou Ch'en]. This is the painting recorded in the *Chiang-ts'un-hsiao-hsia-lu* [1693, Kao Shih-ch'i's catalog]. In view of the rendering of the mountains, waters, pavilions, boats, and carriages, the latter painting is of a different interest than that of my Sung painting, whose brush is strong and well-blended, enlivened by a note of elegance, a quality that could never be attained by the Yüan and Ming artists. The technique of Tung-ts'un is derived from various schools of Sung and Yüan. Although it has kept its own individuality, it lags far behind a Sung painting in spirit and fascination. This seems to be conditioned by its lateness in time, and the deficiency seems rather inevitable. Today, I have just looked over this Tai Wên-chin scroll. The brush is aged and forceful. Often there are strange poses and gestures. Obviously, it was created with such a smooth play between the heart and the hands, and a harmonious movement with the ancient methods, that they were qualities which Tung-ts'un could not possibly match. Tung Hsiang-kuang (Tung Ch'i-ch'ang), in commenting on Li Po-shih's copy of Tung Yüan's *Hsiao-hsiang-tu*, has remarked that in spite of his fame, Li Po-shih lacks this "aged and forceful" in his work. From this, we know that Wên-chin's "aged and forceful" would have been greatly praised by Tung Hsiang-kuang. Anyone who understands this will back me on this point.

Ch'ien Lung, Cha Ying [1794], autumn, 8th month, at Yang-chou, Wang Wên-chih [Mêng-lu] has written this.

1 colophon by Tieh P'ing-tzu, written in 1927. EX. COLL: Wang Wên-chih; Ch'ang Ching; Fei Ching-fu, and Tieh P'ing-tzu. PUBL: Bibl. 91, VII, list 235. The Cleveland Museum of Art, Purchase from the J. H. Wade Fund.

Tu Chin
Ku-k'uang
1465–1587, Hopei-Kiangsu.

44 | *The Poet Lin P'u Wandering in the Moonlight*

Hanging scroll; ink and slight color on paper. H.

61 5/8"; W. 28 1/2". Signed, titled, and sealed by the artist. 1 old unidentified seal; 1 seal of Chang Ts'ung-yü (20th c.); 1 seal of C. C. Wang (20th c.). EX. COLL: Chang Ts'ung-yü (20th c.); C. C. Wang (20th c.). PUBL: Bibl. 65, no. 42; 64, pl. 138. The Cleveland Museum of Art, John L. Severance Fund.

Shih Chung

Hsü Tuan-pên
b. 1438–ca. 1506, Kiangsu (Nanking).

45 | *Winter Landscape*

Handscroll; ink on paper. L. 10' 5 1/2"; H. 9 3/4". Dated 1504; poem by the artist:

> The Sky is clear; snow covers mountain and river,
> The Myriad Trees tower high; this is nature's work.
> Alone and always happy to suffer poverty,
> This old man, moved to tears, records the divine pine.
>
> In the spring of the chia-tzu year, during the reign of Hung-chih [1504], when snow fell heavily, The Fool made this picture and added the poem to accompany it. Shih Chung – [Tr. by K. Tomita].

2 seals of the artist, C. & W., p. 83, no. 10, unrecorded. 1 seal of P'ang Yüan-ch'i (contemporary collector). PUBL: Bibl. 115; 91, VI, pl. 194, VII, list 231. Museum of Fine Arts, Boston.

Kuo Hsü

Ch'ing-k'uang
1456–after 1528, Kiangsi (T'ai-ho).

46 | *Landscape: Pavilions and Water*

Handscroll; ink on paper. L. 62"; H. 8 1/2". Two paintings, mounted together, signed: Written and painted by Ch'ing-k'uang with running brush. 5 seals of the artist, C. & W., p. 318, nos. 2, 3; 1 unrecorded. EX. COLL: P'ang Yüan-ch'i, Shanghai. The Detroit Institute of Art, Detroit.

Chou Ch'ên

Tung-ts'un
act. ca. 1472–ca. 1535, Kiangsu (Suchou).

47 | *The Haven of Tao Yüan-ming*

Album leaf; ink and slight color on very finely woven silk. H. 9 11/16"; W. 8 11/16". PUBL: Bibl. 91, VII, list 178. The Cleveland Museum of Art, John L. Severance Fund.

Ch'iu Ying

Shih-fu, Shih-chou
act. 1506–1522, Kiangsu (Suchou).

48 | *Emperor Kuang-wu of the Eastern Han Dynasty Fording a River*

Hanging scroll; ink and full color on silk. H. 67 1/4"; W. 25 3/4". The artist's inscription is on the lower right and is followed by the seal, "shih-fu." EX. COLL: Liang Ch'ing-piao (1620–1691); Chou Hsiao-k'un; Ch'en Te-hsiang. PUBL: Bibl. 119, no. 17; 65, no. 50. The National Gallery of Canada, Ontario.

T'ang Yin

Po-fu, Liu-ju
1470–1523, Kiangsu (Suchou).

49 | *Strolling across a Summer Stream*

Hanging scroll; ink and slight color on satin-silk. H. 53 1/2"; W. 21 3/8". Seven character line poem by the artist for Sung Ch'eng-ch'i; 3 seals of the artist (C. & W., p. 226, nos. 10, 11, 15); 10 seals of Hsiang Yüan-pian (1525–1590); at least 3 seals of Li Tsung-wan (1705–1759), C. & W., p. 621; 1 seal of C. C. Wang (20th c.). 5 unidentified seals. PUBL. Bibl. 119, no. 18; 65, no. 46; 91, VII, list 241. The Royal Ontario Museum of Archaeology, Toronto, Canada.

Shên Chou

Shih-t'ien, Pai-shih-weng
1427–1509, Kiangsu (Suchou).

50 | *Album of Landscape and Poems*

Album paintings; ink on paper. H. 14 7/8"; W. 25 3/4". Each of the eight leaves is signed and sealed by the artist (similar to C. & W., p. 167, no. 15). EX. COLL: Wên Cheng-ming (1470–1559); Wên Chia (1500–1582); Teng Ju-kao; Lu Hsin-yüan (?) 1834–1894; Lu Shu-sheng; Tuan Fang. PUBL: Bibl. 116; 91, VII, list 228. Museum of Fine Arts, Boston.

51 | *Traveling in Wu*

Handscroll; ink on paper. L. 65"; H. 12 1/4". Inscription:

> I did this painting. Yüeh-ch'uang does not find fault with its easy quality, but says it has the flavor of Tung Yüan and Chü-jan. Yüeh-ch'uang has big eyes; most people believe what he says. I myself, of course, cannot know what it is actually like.
>
> Just for a laugh. Chia-wu [1474], Shên Chou [signed].

4 seals of the artist, 3 rather faded (C. & W., p. 167, nos. 3, 20), 1 unrecorded. Colophon signed by Shên Chou's friend, Wu K'uan, the first and the larger part of which appears to be replaced. At the end it relates that when Yüeh-ch'uang went South this painting was given to him. The picture is like traveling in Wu. 2 seals of Wu K'uan. 20 other seals; at least 5 are those of Li Chao-hang (17th c.); 3 seals of An Ch'i (1683–after 1742); 2 seals of Ch'en K'uei-lin (late 19th c.). RECORDED: Ch'en's catalog, *Pao-yü-ko shu-hua-lu*, Shanghai. PUBL: Bibl. 91, VII, list 224. C. C. Wang, The Bamboo Studio, New York.

52 | Four Scenes at Tiger Hill

Album paintings; ink on paper. H. 12 1/8"; W. 15 3/4". Tiger Hill, see 65 where the covered bridge is to be seen. Each leaf with 1 seal of the artist (C. & W., p. 167, no. 3):

 1. Chasm with Pavilion and Three Figures
 2. Rocky Ledges.
 3. A Street with Two Figures.
 4. Oak and Hummocks with Three Figures at a Well.

PUBL: Bibl. 55; 65, no. 52; 91, VII, list 229. Richard B. Hobart, Cambridge, Massachusetts.

53 | Landscape in the Style of Ni Tsan

Hanging scroll; ink on paper. H. 54 1/2"; W. 24 3/4". Poem, signature, and 1 seal of the artist (C. & W., p. 167, no. 24) dated in the 20th year of the Reign of Ch'êng Hua (1484), a Winter Day. EX. COLL: T. Yamamoto. RECORDED: *Chōkaidō shoga mokuroku*, 1932, II/99. PUBL: Bibl. 91, VI, pl. 174, VII, list 225. Nelson Gallery of Art and Atkins Museum, Kansas City.

54 | Landscape with Poems

Album paintings mounted as a handscroll; ink on paper and ink with color on paper. H. 15 1/4"; W. 23 3/4". 2 seals of the artist (C. & W., p. 167, nos. 3, 20). 2 colophons: 1 by Wên Chêng-ming, dated 1516; 1 by Hsieh Lan-sheng, dated 1824. Each leaf with poem and signature of the artist:

 1. Three Gardeners in a Fenced Enclosure
 (with slight color)
 2. The Artist-Poet on a Mountain (with slight color)
 3. The Painter with His Crane in a Boat (with color)
 5. Mountain Trail with Village Grove and a Stream
 (ink only).

RECORDED: P'ang Cheng-wei *T'ing-fan-lou shu-hua-chi* (Mei-shu-tsung-shu edition), supplement, 2nd part, 1a–2b, 1843 or later. PUBL: L. Sickman, "The Unsung Ming," *Art News*, November, 1946. Bibl. 91, VII, list 229. See 54a for leaf no. 6 by Wên Chêng-ming. Nelson Gallery of Art and Atkins Museum, Kansas City.

Wên Chêng-ming

Wên Pi, Heng-shan
1470–1559, Kiangsu (Suchou).

54a | Storm over a Lake

Album painting; ink and slight color on paper. H. 15 1/4"; W. 23 3/4". Dated 1516; 2 seals of the artist (C. & W., p. 19, nos. 3, 6). 2 colophons (see 54). Last section of the scroll containing five pictures by Shên Chou (see 54). The picture illustrates two lines of Wei Ying-wu's T'ang Dynasty poem:

> On the spring flood of last night's rain
> The ferry boat moves as if someone were poling.
> —tr. by Wytter Bynner.

PUBL: Bibl. 91, VII, list 257. Nelson Gallery of Art and Atkins Museum, Kansas City.

55 | Ancient Tree and a Cool Spring

Hanging scroll; ink wash and color on paper. H. 21 3/8". W. 9 5/8". 1 colophon and 2 seals of the artist (similar to C. & W., p. 19, nos. 10–20; 2nd seal is double):

> Sitting all by myself under the rainy window,
> I fell lonely for the longing of a friend. So
> I took up my brush and painted these ancient trees
> and cool springs, and offered them to the pine
> valley as companions.
> Signed and dated in accordance with 1531,
> 7th month, 24th day.

5 seals of Emperor Ch'ien-lung. 3 unidentified seals. PUBL: *Mostra di Pittura Cinese Ming e Ch'ing*, Rome, April, 1950. Los Angeles County Museum, Los Angeles.

56 | Seven Juniper Trees

Handscroll; ink on paper. L. 11' 10 1/2"; H. 11 1/4". Signed and dated:

> 1532, Summer, Chêng-ming imitated Sung-hsüeh's
> (Chao Mêng-fu's) brush [see 28].

Colophon by the artist is given in large part on pp. 74–75. 2 seals of the artist (similar to C. & W., p. 19, nos. 20, 30). Colophon dated 1538, by Ch'en Shun (see 63) with 2 seals:

> In the spring of 1532, Mr. Wang Shih-men came
> from Hai-yü (i. e., where the ancient junipers were
> standing), visited me at the Lake, stayed over night
> and left. 1538, in Autumn, Mr. Wang again visited
> me. He showed me the scroll with the Seven Juni-

pers of my teacher, Master Heng-shan. He told me that after he had seen me last time, he visited Master Heng and begged him to let him have the scroll. And now he wants from me a few words of comment. I carefully studied the scroll and could not leave my hand from it. This is indeed my teacher's masterpiece. In his lines and washes, delicate and lush, he attained the essence of Chao Mêng-fu's genius. Such a painting is not easily given away. Mr. Wang was certainly not afraid to ask and was lucky enough to get it. If it had not been for Mr. Wang's noble bearing and classical refinement, so appealing to the Master's taste, how could he have given it to him. So much the more Shih-men should treasure it.

Tao-fu inscribed
—tr. by Gustav Ecke.

3 collector's seals. PUBL: Bibl 122; 65, no. 55; 91, VI, pl. 210B, VII, list 258. Honolulu Academy of Art, Honolulu, Hawaii.

57 | *Cypress and Old Rocks*

Handscroll; ink on paper. L. 19 1/4"; H. 10 1/4". Inscription, signature and 1 seal of the artist (similar to C. & W., p. 19, no. 40). 12 colophons including: Wang Ku-hsiang, painter and poet, 1501–1568; Chou T'ien-ch'iu, calligrapher and painter, 1514–1595; Lu Shih-ta, painter and pupil of Wên Chêng-ming, act. ca. 1522 to 1566; Yüan Tsun-ni, 1523–1574; Huang Chi-sui, calligrapher, 1509–1574; Yüan Chung, poet, contemporary of Wên Chêng-ming; Lu Añ-tao, calligrapher, brother of Lu Shih-ta; Wên P'eng, eldest son of the artist, 1498–1573; Wên Chia, second son of the artist and himself a painter of note, 1501–1566; P'eng Nien, calligrapher, 1505–1566, colophon dated in the 29th year of Ming Chia-ching (1550) (this is the last colophon written at the time the picture was painted); Chang Feng-i, poet and calligrapher (his colophon, written in 1612, mentions that the picture was painted for him and presented when he was 23 years old). EX. COLL: Chang Feng-i (1527–1613); Liu Shu (1759–1816); Ku Wên-pin (1811–1889). Nelson Gallery of Art and Atkins Museum, Kansas City.

Wên Po-jên

Wu-fêng
1502–1575, Kiangsu (Suchou).

58 | *Landscape*

Hanging scroll; ink and color on paper. H. 50 5/8"; W. 14 1/4". Signed and dated 1561; 2 artist's seals (1 in

144

C. & W., p. 10, no. 14). 5 unidentified seals. EX. COLL: Emperor Ch'ien-lung (4 seals); Emperor Chia-ch'ing (1 seal); T. Yamamoto, Tōkyō. PUBL: Bibl. 65, no. 56; 91, VII, list 265. Seattle Art Museum, Seattle.

59 | *The Lute Song: Saying Farewell at Hsün-yang*

Handscroll; ink and slight color on paper. L. 23 5/16"; W. 8 1/8". Inscription signed by the artist: painted at "The Chamber of Lingering Cloud," 2 seals of the artist (similar to C. & W., p. 10, nos. 5, 6). 10 collectors' seals on painting and colophons; the 1st colophon is a transcription of the *Lute Song* (*Pi–p'a hsing*) by Po Chü-i (772–846) from which the title is taken. See A. Waley, *The Life and Times of Po Chü-i*, London, 1949, p. 117. EX. COLL: T. Yamamoto, Tōkyō. PUBL: *Chōkaidō shoga mokuroku*, 1932, III/94 (Catalog of Yamamoto Coll.), Bibl. 91, VII, list 266. The Cleveland Museum of Art, John L. Severance Fund.

Chü Chieh

Shang-ku
act. ca. 1531–ca. 1585, Kiangsu (Suchou).

60 | *Watching the Stream*

Hanging scroll; ink on paper. H. 43 1/2"; W. 9 7/8". Inscription and 1 seal of the artist (C. & W., p. 188, no. 4):

In the i-wei year of the Chia-ching reign [1559] on a day of the Little Cold season [approximately January 6–20] Hsüan-chin dropped by to pay a call and produced this paper, pressing me for a painting by my clumsy brush. At that time I had been ill and had long neglected brush and ink-stone. In a disorderly way I daubed and rubbed; surely one must find it awful. May Hsüan-chin not be offended with my soiling his beautiful paper.

Inscribed by Chü Chieh.
— tr. by A. Lippe.

2 seals of Liang Ch'ing-piao (1620–1691); 6 seals of the Ch'ien-lung Emperor including an Imperial gift seal. PUBL: Bibl. 59. The Metropolitan Museum of Art, New York.

Lu Chih

Pao-shan
1496–1576, Kiangsu (Suchou).

61 | *Rocky Landscape*

Handscroll; ink and color on paper. L. 44 3/4"; H. 9 1/2". Inscribed and signed by the artist:

Painted by Pao-shan Lu Chih, at the end of the

full moon in March, the *chi-yu* year of Chia-ching [1549].

Seal of the artist (C. & W., p. 343, no. 5) at the beginning and at the end of scroll; poem by the artist on the 1st colophon. First commentary colophon by Tung Ch'i-ch'ang, 1632. PUBL: Bibl. 30; 91, VII, list 213. Nelson Gallery of Art and Atkins Museum, Kansas City.

62 | *Landscape with Clear Distance*

Hanging scroll; ink and color on paper. H. 41 5/8"; W. 12 1/4". Poem by the artist and 3 artist's seals (C. & W., p. 343, nos. 3, 10, 18). 5 seals of Hsiang Yüan-pien (1525–1590); 1 unidentified seal. PUBL: Bibl. 91, VII, list 215. The Art Institute of Chicago, Chicago.

Ch'en Shun
Tao-fu, Pai-yang
1483–1544, Kiangsu (Suchou).

63 | *Landscape and Poems*

Handscroll; ink and slight color on paper. L. 65 3/4"; H. 10 3/8". Signature and 2 seals of the artist (1 similar to C. & W., p. 327, no. 3); 3 poems by the artist, signed. EX. COLL: Lo Chen-yü, scholar, archaeologist and writer (1866–1940). PUBL: Bibl. 91, VII, list 167. Nelson Gallery of Art and Atkins Museum, Kansas City.

Chou Yung
Po-ch'uan, Hsing-chih
1476–1548, Kiangsu (Suchou).

64 | *Winter Mountains and Lonely Temple,
after Li T'ang*

Handscroll; ink on paper. L. 61 1/2"; H. 11 3/8". Inscription and signature of the artist:

In 1548 of the Chia-ching reign, in the autumn during chrysanthemum time, painted at "Love the Sun Hall," signed, Chou Yung of Sungling.

2 seals of the artist. 2 colophons, the 2nd by Shen Shih (Ch'ing-men), a painter of the 16th c. PUBL: Bibl. 85, XV, pl. 17; 91, VII, list 181. The Toledo Museum of Art, Toledo.

Hsieh Shih-ch'ên
Ch'u-hsien
1488–ca. 1567 (?), Kiangsu (Suchou).

65 | *Tiger Hill, Suchou*

Handscroll; ink and color on paper. L. 81 7/8"; H. 7 1/2".

Signed and dated, Fall, 1536; 2 artist's seals (1 unrecorded, 1 similar to C. & W., p. 398, no. 4). 3 colophons with 4 seals, 1 colophon by Wu Hu-fan, the 20th c. collector, tentatively identifies the subject as Tiger Hill. PUBL: Bibl. 91, VII, list 191. Museum of Fine Arts, Boston.

Tung Ch'i-ch'ang
Hsiang-kuang, Hsüan-tsai, Ssŭ-weng
1555–1636, Kiangsu (Sung-chiang).

66 | *Autumn Mountains*

Handscroll; ink on Korean paper, a dated tribute-memorial from the Korean King to the throne of Ming Emperor Shêng-tsung. L. 53 7/8"; H. 15 1/8". 1 colophon on painting proper by the artist. Other 6 colophons: 2 on painting by Emperor Ch'ien-lung; 2 after painting by K'ao Shih-ch'i with seals; 1 after painting by Sung Lo with seal; 1 after painting by Shao Ch'ang-heng with 2 seals. EX. COLL: Kao Shih-ch'i (1645–1704); Sung Lo (1634–1713); Emperor Ch'ien-lung (1735–1796); Ch'ing imperial; Wang Chi-ch'ien. PUBL: Bibl. 65, no. 64. RECORDED: *Shih-chü pao-chi*, part II, XI/53. The Cleveland Museum of Art, Purchase from the J. H. Wade Fund.

67 | *Ch'ing Pien Mountain*

Hanging scroll; ink on paper. H. 90"; W. 26 3/4". Dated 1617; 2 inscriptions of the artist, 2 seals of the artist. RECORDED: Bibl. 32, III, 361. PUBL: Bibl. 65, no. 63; 91, VII, list 247. *Five Centuries of Chinese Painting, Ming and Ch'ing Dynasties*, Dallas Museum of Fine Arts, Texas, 1954, no. 16. Wango Weng, New York.

Li Liu-fang
T'an-yüan
1575–1629, Anhui-Kiangsu.

68 | *Thin Forest and Distant Mountains*

Hanging scroll; ink on paper. H.45"; W.15 7/8". Signed, 2 seals of the artist (C. & W., p. 151, nos. 11, 15):

Sparse wood and distant mountains have always attracted me;
As if they were from the brush and ink of Ni Tsan, left behind by the master in this mortal world.
Now that the quiet recluse has chosen to live in the South of the City,
He paints the spring breeze—over a curve of the river.

PUBL: Bibl. 41, p. 674; 91, VII, list 208; 65, no. 71. The Cleveland Museum of Art, John L. Severance Fund.

Shêng Mao-yeh

Nien-an

act. ca. 1607–1637, Kiangsu (Suchou).

69 | Lonely Retreat beneath Tall Trees

Hanging scroll; ink and slight color on silk. H. 71";
W. 36 1/2". Inscription and 2 seals of the artist (C. &
W., p. 369, nos. 1, 3); dated 1630, "Small spring" (10th
month). 3 seals at lower left of Liu Shu (1759–1816),
C. & W., p. 617, nos. 15, 31, 23. PUBL: Bibl. 65, no. 73;
91, VII, list 231. The Cleveland Museum of Art,
Purchase, Mr. and Mrs. William H. Marlatt Fund.

Ch'êng Cheng-kuei

Ch'ing-ch'i

act. ca. 1630–ca. 1674, Hupei-Kiangsu.

70 | Mountainous Landscape

Handscroll; ink on paper. L. 9' 3"; H. 7 3/4". Dated
1646. Colophon by Wang Ch'en. PUBL: Bibl. 91, VI,
pl. 349B, VII, list 302. The Art Institute of Chicago,
Chicago.

71 | Dream Journey among Rivers and Mountains

Handscroll; ink and color on paper. L. 135 1/2"; H.
10 1/4". Dated 1674, inscription and seal of the artist.
1 colophon. PUBL: Bibl. 65, no. 88; 91, VII, list 302.
The Cleveland Museum of Art, Mr. and Mrs. William
H. Marlatt Fund.

Lan Ying

T'ien-shu

1585–after 1664, Chekiang (Hangchou).

**72 | River Landscape in the Style of Four Early
Masters**

Handscroll; ink and color on gold-flecked paper. L. 21';
H. 10 1/2 ". Artist's inscription:

> When Chi-ho, my senior in literary pursuits, is not
> occupied in his research of the Six Classics, he is
> absorbed in the study of the Six Canons in a man-
> ner which transcended the limit of ink and brush.
> Once when I returned from a trip to Pei-yo
> mountains, I stayed with Chi-ho at his house. As
> the rainy season of the month of plum started then,
> I was unable to leave for my home. While I was
> spending quiet days as a guest, he produced this
> paper and asked me to paint for him in the dif-
> ferent manners of the four masters: Tung Yüan,
> Huang Kung-wang, Wang Mêng and Wu Chên. In
> ten days I completed his picture. I did it so as to

146

beg for Chi-ho's correction of my imperfections. It
didn't mean that I dared to sell water in front of a
river [i. e. to show off before a learned expert].

> Done in the year of Chia-tzu [1624].

5 collectors' seals; 6 19th c. colophons. EX. COLL:
M. Kato, Tōkyō. PUBL: Bibl. 89, II, pl. 131; 91, VI,
pl. 287, VII, list 203; 43, p. 705. Seattle Art Museum,
Seattle.

73 | Old Trees by the Water

Hanging scroll; ink and color on paper. H. 50 5/8";
W. 15 1/2". Inscription and 2 seals of the artist (C. &
W., p. 490, nos. 10, 5—similar); dated 1652. PUBL:
Bibl. 91, VII, 204. Eli Lilly, Indianapolis.

Ting Yün-p'êng

Nan-yü

act. ca. 1580–ca. 1621, Anhui.

74 | The Lute Song: Saying Farewell at Hsün-Yang

Hanging scroll; ink and color on paper. H. 55 5/8";
W. 18 1/8". Signature and 2 seals of the artist (C. & W.,
p. 1, nos. 5, 6); dated 1585. The picture illustrates the
Lute Song of Po Chü-i (see 59) written above the
painting, with 2 seals. 1 collector's seal on the paint-
ing. PUBL: Bibl. 91, VII, list 204. The Metropolitan
Museum of Art, New York.

Wu Pin

Wên-chung

act. ca. 1567–ca. 1617, Fukien-Nanking.

75 | Greeting the Spring

Handscroll; ink and color on paper. L. 2' 27 11/16";
W. 13 3/4". Signed and dated 1600; 1 seal of the artist.
EX. COLL: Imperial Manchu Collection. RECORDED:
Shih-chü pao-chi, part III, Ch'ien-ch'ing kung. PUBL:
Bibl. 65, no. 70; 91, VII, list 269. The Cleveland Mu-
seum of Art, Purchase from the J. H. Wade Fund.

Ku I-têh

Act. ca. 1620–died 1685, Kiangsu.

**76 | Enjoying the Moon from the Bridge over the
Brook**

Hanging scroll, ink and color on paper. H. 60 3/4"; W.
19 1/4". Inscription of the artist with 2 seals; dated
1628; copied "after Wang Mêng" (see 33). Colophon
by Tung Ch'i-ch'ang with 2 seals; 2 seals of Liang
Ch'ing-piao (1620–1691), possibly added later. PUBL:
Bibl. 57. The Metropolitan Museum of Art, New York.

Wang Shih-min

Hsün-chih, Yen-k'o

1592–1680, Kiangsu (T'ai-ts'ang).

77 | Landscape in the Style of Huang Kung-wang

Hanging scroll; ink on paper. H. 53″; W. 22″. Inscription dated 1666 by the artist. 3 seals of the artist. EX. COLL: Wang Po-yüan, Chang Tâ-ch'ien (20th c.). RECORDED: Bibl. 27, p. 51. C. C. Wang, The Bamboo Studio, New York.

Wang Chien

Yüan-chao, Lien-chou

1598–1677, Kiangsu (T'ai-ts'ang).

78 | Pine Shades in a Cloudy Valley at I-ya-ko

Hanging scroll; ink on paper. H. 34 3/4″; W. 14 3/4″. Inscription of the artist:

Imitation of Wang Mêng's Pine Shades in a Cloudy Valley at I-ya-ko, in the Ch'ing-ming Festival of 1660.
Wang Chien [signature].

1 seal of the artist; 1 seal of Pi Lung (18th c.), C. & W., p. 601; 1 unidentified seal. PUBL: Bibl. 65, no. 90; 91, VII, list 421. C. C. Wang, The Bamboo Studio, New York.

Wang Hui

Shih-ku, Kêng-yen-shan-jên

1632–1717, Kiangsu (Ch'ang-shu).

79 | Bamboo Grove and Distant Mountains

Hanging scroll; ink on paper. H. 31 1/4″; W. 15 1/2″. Inscription and 2 seals of the artist (C. & W., p. 67, nos. 25, 54):

Previously, Wên Hu-chou (Wên T'ung, 1018–1079) painted a scroll called "A Horizontal View of the Evening Mist," with an inscription by Emperor Kao-tsung (Ssŭ-ling) of the Sung Dynasty, later added on its beginning. The strength of its brush is not inferior to Kuo Hsi; and the bamboos between the trees and rocks are beyond the usual criteria of brush and ink since they are the direct overflow of the artist's feelings. Professor [i. e., Kuang-wên] Tzu-wên has asked me for a painting of tall bamboos and distant mountains. It is a pity that my brush cannot be compared with Kuo [Hsi], nor is it anywhere near that of Hu-chou. These few scribbles of rough and clumsy brush can only be taken as an expression of a moment's interest painted for gratifying Kuang-wên's graciousness.

—Huang-hê-shan-chung-jên, Wang Mêng [d. 1385]. Chia-hsü [1694], ninth month, copied for I-wêng at Ch'ang-an, Wang-Hui.

EX. COLL: P'ang Yüan-ch'i (20th c.). PUBL: Bibl. 68, III, no. 11 as "Distant Ravines and Tall Bamboos"; 91, VII, list 427. The Cleveland Museum of Art, John L. Severance Fund.

Wang Yüan-ch'i

Lu-t'ai

1642–1715, Kiangsu (T'ai-ts'ang).

80 | Landscape after "Ni Tsan in Color"

Hanging scroll; ink and color on paper. H. 31 5/8″; W. 17 1/8″. Inscription and 4 seals of the artist (C. & W., p. 40, nos. 37, 39, 63):

Painted while attending the Emperor on a trip and returning by boat. Painted after "Ni Tsan in Color," 4th month, 1707. Signed Lu-t'ai.

EX. COLL: P'ang Yüan-ch'i (20th c.), Shanghai, 1 seal. PUBL: Bibl. 68, I, no. 14; 65, no. 95; 91, VII, list 441. The Cleveland Museum of Art, John L. Severance Fund.

Huang Ting

Tsun-ku

1660–1730, Kiangsu.

81 | Mountain in Fall, after Wang Mêng

Hanging scroll; ink and slight color on paper. H. 63 1/4″; W. 26″. 2 seals of the artist and inscription:

1697, summer, painted after Wang Shu-ming's "Mountain in Fall" in the studio named Ch'ing-yün-shu-wu, by Huang Ting of Yü-shan.

4 colophons with 8 seals; 2 collectors' seals. Honolulu Academy of Arts, Honolulu, Hawaii.

Chang Tsung-ts'ang

Lu-shan

1686–1756, Kiangsu (Suchou).

82 | Landscape

Hanging scroll; ink and color on paper. H. 16 7/8″; W. 12 3/4″. 2 seals of the artist ("respectfully" and "paint") and inscription:

Your humble subject Chang Tsung-ts'ang has respectfully painted.

Poem by Ch'ien-lung Emperor, dated Fall, 1768; 8 seals of Ch'ien-lung; 1 seal of Chia-ch'ing. EX. COLL:

147

T. Tomioka. PUBL: Naitō Torajirō, *Shina kaigashi*, opp. p. 170; Bibl. 91, VII, list 292. Howard Hollis and Company, Cleveland.

Yüan Chiang

Wên-t'ao

act. ca. 1698–after 1724, Kiangsu.

83 | *Carts on a Winding Mountain Road, after Kuo Hsi*

Hanging scroll; ink and color on silk. H. 71 1/4"; W. 36 3/4". Signature and 2 seals of the artist (C. & W., p. 250, nos. 4, 5). Dated 1754. PUBL: Bibl. 91, VI, pl. 334B; VII, list 460. Nelson Gallery of Art and Atkins Museum, Kansas City.

Wu Li

Yü-shan, Mo-ching-tao-jên

1632–1718, Kiangsu (Ch'ang-shu; Shanghai).

84 | *Composing Poetry before the Yellowing of Autumn*

Hanging scroll; ink on paper. H. 53 3/8"; W 25". 2 artist's seals (C. & W., p. 131, nos. 3, 12) and inscription signed:

Your disciple from Yü-shan, Wu Li.

The poem and the painting were executed as a present to "the old master of T'ai-yuan." 1 collector's seal. Los Angeles County Museum, Los Angeles.

85 | *Pine Wind from Myriad Valleys*

Hanging scroll; ink on paper. H. 43 1/8"; W. 10 3/16". Title: "Wan-ho-sung-fêng-tu" written by the artist. Signed Mo-ching-tao-jên with 1 of the artist's seals; 1 seal of the artist at lower right (C. & W., p. 131, nos. 2, 17). 5 unidentified seals, possibly one of these at lower left belongs to Po-erh-tu (Bordu), d. 1697. At one time the painting had 5 presumably false Imperial Ch'ien-lung seals, since removed. PUBL: Bibl. 65, no. 99; 91, VII, list 449. The Cleveland Museum of Art, John L. Severance Fund.

Yün Shou-p'ing

Yün-Ko, Nan-t'ien

1633–1690, Kiangsu (Wu-chin).

86 | *Old Trees and Bamboo in a Rockery, after K'o Chiu-ssŭ*

Hanging scroll; ink and slight color on paper. H. 40"; W. 14 5/8". Signed and 2 seals of the artist. Numerous collectors' seals including those of Emperor Ch'ien-lung. RECORDED: *Shih-ch'ü pao-chi*. PUBL:

148

Bibl. 46, no. 154; 91, VI, pl. 415; 49, XIII, no. 15. National Palace Museum, Taichung, Formosa.

K'un-ts'an

Shih-ch'i

act. ca. 1657–1686, Hunan-Nanking.

87 | *The Pao-en Temple*

Hanging scroll; ink and color on paper. H. 52 1/2"; W. 29 9/16". Dated 1663; inscription and 3 seals of the artist (C. & W., p. 392, no. 12 and similar to nos. 11, 4). One unidentified collector's seal (?) at lower left. PUBL: Bibl. 5, p. 170; 100, p. 143; *Shih-ch'i shih-t'ao chien-chiang*, Tōkyō, 1954. Kanichi Sumitomo, Oiso.

Tao Chi

Shih-t'ao

born ca. 1630–after 1707, Kwangsi-kiangsu.

88 | *Min River Landscape*

Hanging scroll; ink and slight color on paper. H. 15 3/8"; W. 20 7/16". Poem by the artist, slightly garbled and incomplete, recorded in: *Colophons of Ch'ing-hsiang-lao-jen*, by Wang Yen-shan (18th c.); *Chronology of Shih-t'ao Shang-jen*, by Fu Pao-shih, Shanghai, 1948. The poem reads:

Under the Yangtzu Bridge, where the river overflows,
The willow tendrils show forth their hue, insensitive to man's grey hair.
Throughout Spring, rain and snow have kept away the scenery lovers;
Yet throughout Ch'ing-ming season, the plum blossoms will preserve and flourish.
Aging and being useless, I have grown attached to my friends;
But year after year, my friends have scattered like stars and seagulls.
Suddenly Master Wang turns to me with an astonishing exclamation from his mind,
"I am about to leave for Fukien to exploit its scenic beauties,
Before then, would you please put me in a picture for a preview?"
Before your eyes, you will see hills and valleys in one sweep.
Thousands and ten-thousands of miles are shown at the tip of my brush;
They are not ink, nor mist, but rather a presumptuous message:
Your respected father is a great man of a hundred eras,

One word of his spoken to the Emperor resulted
in storm and thunder.
The Emperor has bestowed on him much
extraordinary kindness;
And he is now coming south by the grace of the
throne.
[Would he remember] how many poor scholars
are awaiting him for recognition?
We are all counting on his efforts as the
"inducer of dragons [talents]."
Ting-ch'ou [1697], Spring, write the colophon on
the painting to give it to Master Wang Mu-t'ing,
who is to leave for Min-hai, also presenting this
to his Excellency the Commissioner of Examina-
tion, Mr. Ssŭ-po. [signed] Ch'ing-hsiang-lao-jên,
Chi, at Ta-ti-t'ang.

1 seal of the artist following the inscription. 2 un-
identified seals. PUBL: Bibl. 91, VII, list 406. The Cleve-
land Museum of Art, John L. Severance Fund.

89 | Landscape Album with Scenes of Travel

Album painting; ink and color on paper. H. 8"; W.
13 1/2". From an album of seven leaves (originally
over thirty). They were painted for Huang Yen-lü who
apparently composed or selected the accompanying
poems written by the artist with additional comment,
signature, and seals (C. & W., p. 425, nos. 4, 5, 9, 13, 16).
The original leaves as a group are reported to be re-
corded in Pi-hsiao-hsüan-shu-hua-lu, a record book by
Hu Chi-t'ang of the K'ang-hsi reign. Additional colo-
phons were added in 1790 by Wang Wên-chih. RE-
CORDED: Bibl. 34, IV, 371; 34. PUBL: Bibl. 65, no. 113.
Walter Hochstadter, Zurich.

90 | Landscape Album with Poems and Essays

2 album paintings; ink and color on paper (leaf no. 9),
ink on paper (leaf no. 12). H. 18 3/4"; W. 12 5/16".
Inscription and seals of the artist (C. & W., p. 425,
nos. 9, 14, 16). Leaf no. 9, "Retreat under a Cliff":
Before the ancients established the models, we
know not what kind of model they followed. Once
the ancients had established the models, the later
people let themselves become the slaves of the an-
cient models. Then for hundred and thousands of
years the later people have been unable to rise above
the ordinary. Because they try to imitate the foot-
marks, rather than the spirit of the ancients, they
can never rise above the ordinary. It is indeed sad.
Leaf no. 12, "Mountain Path":
The way [of painting] requires penetration. By means

of free brushwork in sweeping manner the thou-
sand peaks and the ten thousand valleys may be
seen at a glance. As one looks at [the painting]
fearsome lightning and driving cloud seem to come
from it. With which [of these great names] Ching
or Kuan, Tung or Chü, Ni or Huang, Shên or Chao,
could such a picture be associated? I have seen
works of very famous masters, but they all follow
certain models or certain schools. How can I ex-
plain that in both writing and painting nature
endows each individual with peculiarity and each
generation with its own responsibility?
Ta-ti-tzu [Tao-chi] presents this to Hsiao-weng
that he may laugh at my work. In the second
month of the year of kuei-wei [corresponding to
1703] at Ch'ing-lien thatched-pavilion.
—Tr. by K. Tomita.

EX. COLL: Ma Yueh-lu (18th c.); Ch'en Teh-yeh and
Wang Chi-ch'uan (20th c.). PUBL: Bibl. 117, from which
translations are taken. Museum of Fine Arts, Boston.

91 | Landscape Album

Album paintings; ink and slight color on paper. H.
9 1/2"; W. 11". Signed: Ku-kua-ho-shang, Ch'i; 2 seals
of the artist (C. & W., p. 425, nos. 2, 3). PUBL: Bibl. 24,
where 4 other leaves are reproduced; Ausstellung
Chinesische Malerei 15-20 Jahrhundert, Kunstsamm-
lungen der Stadt Dusseldorf, 1950, no. 100. Nu Wa
Chai Collection.

Chu Ta
Pa-ta-shan-jên
1624–ca. 1705, Kiangsi (Nanch'ang).

92 | Landscape after Kuo Chung-shu

Hanging scroll; ink on paper. H. 43 1/4"; W. 22 3/16".
Inscription of the artist, signed Pa-ta-shan-jên; 3 seals
of the artist (C. & W., p. 106, nos. 1, 6, 12). 3 collectors'
seals at lower right; 4 seals of Chang Tâ-chien (20th c.).
EX. COLL: Chang Tâ-chien (20th c.). PUBL: Bibl. 91,
VII, list 325. The Cleveland Museum of Art, John
L. Severance Fund.

93 | Landscape

Hanging scroll; ink and color on paper. H. 69 3/4";
W. 36 5/8". Signed Pa-ta-shan-jên; 3 seals of the artist
(C. & W., p. 106, nos. 14, 15, 16). PUBL: Chinesische
Gemälde der Ming- und Ch'ing-Zeit, Greven Verlag,
Koln, 1950; Ausstellung Chinesische Malerei der letz-
ten vier Jahrhunderte, Hamburg, 1949–1950, no. 88.
Nu Wa Chai Collection.

Kung Hsien
Pan-ch'ien
act. ca. 1655–d. 1689, Kiangsu (Nanking).

94 | *Mountain Landscape*
Handscroll; ink on paper. L. 31' 10"; W. 10 1/2". EX. COLL: Lo Chen-yü, scholar and collector (1866–1940). PUBL: Bibl. 5, p. 14; 91, VII, list 369. Nelson Gallery of Art and Atkins Museum, Kansas City.

Hsiao Yün-ts'ung
Ch'ih-mu
1596–1673, Anhui.

95 | *Clear Sounds among Hills and Waters*
Handscroll; ink and color on paper. L. 25' 7 3/4"; W. 12 1/8". Title: "Shan-shui-ch'ing-yin" written by Shen Fêng, dated 1744; Poem, inscription, signature, and 1 seal of the artist, dated 1664. 1st colophon after title by Chiang Pu-lo with 2 seals (C. & W., p. 173); 2nd colophon after title by Wang Ching-wei, dated 1943; 1st colophon after the painting mentions "brush of Ni [Tsan] and Huang [Kung-wang]," dated Winter, 1811. Signed Hsin-an Hsiang Chih-fan; 2nd colophon dated 1858. Seals of Chang Yün-chung (19th–20th c.). PUBL: Bibl. 55; 65, no. 105. The Cleveland Museum of Art, John L. Severance Fund.

96 | *Album of Seasonal Landscapes*
Album painting, ink and color on paper. H. 8 1/4"; W. 6 3/16". Last leaf from the set of Eight leaves; each leaf accompanied by artist's seal and inscription; last leaf (no. 8) signed and dated "Wu-shêng, 10th month [1668], 73 years old, Yün-ts'ung." 9 collectors' seals. PUBL: Sherman E. Lee "An Album of Landscapes by Hsiao Yün-ts'ung." *The Bulletin of Cleveland Museum of Art*, June, 1957. Bibl. 91, VII, list 338. The Cleveland Museum of Art, John L. Severance Fund.

Hung-jên
Chien-chiang
1610–1663, Anhui.

97 | *The Coming of Autumn*
Hanging scroll; ink on paper. H. 48"; W. 24 3/4". Poem, signature, and seal of the artist:

In season comes the time for desolation;
A wooden hut is simple peace;
A mountain wind is off the mountain stream,
And in cold consonance are heard the stalks
and branches.
Chien-chiang, Hung-jên.

2 unidentified collectors' seals. PUBL: C. C. Wang, "Introduction to Chinese Painting," *Archives of the Chinese Art Society of America*, II, 1947, fig. 11. Bibl. 65, no. 109; 91, VII, list 352. Honolulu Academy of Arts, Honolulu, Hawaii.

Ch'a Shih-piao
Erh-chan, Mei-ho
1615–1698, Anhui.

98 | *Landscape*
Hanging scroll; ink on paper. H. 69"; W. 26 3/4". Inscription and 2 seals of the artist. PUBL: Bibl. 65, no. 106. Richard B. Hobart, Cambridge, Massachusetts.

99 | *A Pleasure Excursion in the Stream after the Style of Wang Fu*
Album paintings; ink, ink and color on paper. H. 9 7/16"; W. 12 3/4" (average—vary in size). Dated 1684. Leaf no. 5: "Inspired by Huang Kung-wang's Grand Panorama of Yangtze Valley," leaf no. 6: "Ch'a Shih-piao Learning from Wu Chên." 2 colophons. The Cleveland Museum of Art, Gift of Mr. and Mrs. Severance A. Millikin.

Mei Ch'ing
Ch'ü-shan
1623–1697, Anhui.

100 | *Landscape Album*
Album painting; ink, ink and color on paper. H. 11 1/4"; W. 17 1/4". 8 different seals of the artist (C. & W., p. 306, nos. 1, 2, 22, 26, 27), 3 unrecorded. PUBL: Bibl. 65, no. 110. RECORDED: Bibl. 34, III/285. Richard B. Hobart, Cambridge, Massachusetts.

Hua Yên
Ch'iu-yo, Hsin-lo-shan-jên
b. 1682–ca. 1762, Fukien-Kiangsu (Yangchou), Chekiang (Hangchou).

101 | *Conversation in Autumn*
Hanging scroll; ink and color on paper. H. 45 3/8"; W. 15 5/8". Inscription of the artist:

Inspired by the idea of Yüan masters.
Hsin-lo-shan-jên.

Dated Winter, 1732; 2 seals of the artist: Hua Yên; Ch'iu Yüeh (C. & W., p. 381, nos. 5, 4). 1 of the three colophons on the mounting is dated 1825. PUBL: Bibl. 83, X, pl 137. The Cleveland Museum of Art, John L. Severance Fund.

102 | *Enjoyment of the Chrysanthemum Flowers*
Hanging scroll; ink and color on paper. H. 25 3/8";
W. 45 3/16". Inscription and 2 seals of the artist (C. &
W., p. 381, nos. 5, 15). Dated 1753. City Art Museum
of St. Louis, Missouri.

Chin Nung
Tung-hsin, Shou-men
1687–1764, Chekiang (Hangchou)—
Kiangsu (Yangchou).

103 | *Ink Play*
Album paintings; ink and color on paper. H. 11 1/4";
W. 9 1/2". 12 leaves; one leaf with inscription, dated
1754. PUBL: *Five Centuries of Chinese Painting, Ming
and Ch'ing Dynasties*, Dallas Museum of Fine Arts,
Texas, 1954, no. 44. Bibl. 5, p. 190; 65, no. 138a.
Wango Weng, New York.

Huang Shên
Ying-piao
1687–after 1768, Fukien-Kiangsu.

104 | *Album of Four Landscapes
and Four Figure Subjects*
Album paintings; ink and color on silk. H. 12 7/16";
W. 16 1/4". Dated Summer month, 15th year of Ch'ien-
lung (1750); inscription and 2 seals of the artist on
each page. PUBL: Bibl. 91, VII, list 348. Richard B. Ho-
bart, Cambridge, Massachusetts.

Li Shih-cho
Ku-chai
act. ca. 1741–ca. 1765, Korea-Manchuria.

105 | *Landscape with Waterfall*
Hanging scroll; ink on paper. H. 35 7/8"; W. 16 1/8".
Inscription by the artist:

Ching Hao called himself Hung-ku-tzu and wrote
an essay titled *Shan-shui-chüeh*. He had once boast-
fully criticized that Wu T'ao-tzu has brush but no
ink, and Hsiang Yung has ink but no brush. There-
fore, Hung-ku [Ching Hao] has mastered both ink
and brush, and later Kuan T'ung followed him.
They are the tops of the T'ang and Sung Masters.
I am here imitating the merits of Ching Hao, and
have discarded his weakness.
Li Shih-cho.

3 seals of the artist (C. & W., p. 144, no. 25), 2 un-
recorded. 6 collectors' seals. PUBL: Bibl. 91, VI, pl. 442.
The Cleveland Museum of Art, John L. Severance Fund.

Chang Tao-wu
Shui-wu, Feng-tzŭ
18th c., Shansi.

106 | *Landscape in Blossom Time*
Handscroll; ink and color on paper. L. 4' 6"; H. 13 3/8".
2 poems by the artist; 1 of them:

The lights in the water join the light above the hill.
I have painted your old thatched huts by the river
bank.
The houses lean closely to your plum trees,
I vaguely see my beloved one reflected in the
waters.
Who in this world whose desire for power and
position can be diluted as the "soul of ice"
[i. e., plum blossom].
Therefore the dream of a lonely traveler can only
linger on the fragrance of the "bones of jade"
[i. e., plum blossom].
I have a home, but cannot go back there;
Instead I painted for your Excellency a picture of
your home—what a shame.

Dated 1793; 4 artist's seals. Collectors' seals. PUBL:
Sekai bijutsu zenshū, XX, 118; Bibl. 91, VII, list 291.
Seattle Art Museum, Gift of Mr. and Mrs. Frank S.
Bayley, Jr.

Ch'ien Tu
Shu-mei
1764–1845, Chekiang.

107 | *Longings to Travel: T'ien T'ai*
Handscroll; ink on paper. L. 43 7/16"; H. 8 7/16". In-
scription of the artist:

Done for Mr. Chieh-hang at his request.

Dated 15th day, 1st month, 1826; 3 artist's seals (C. &
W., p. 464, nos. 30, 13, 28). 7 other seals; 13 colophons,
the 2nd dated 2nd month, 1827. T'ien-t'ai is a sacred
mountain in Chekiang province. This is no. 5 in a series
of paintings called "Longings to Travel" commissioned
by Chieh-hang. PUBL: Bibl. 65, no. 146; 91, VII, list 311.
Frank Caro, successor to C. T. Loo, New York.

108 | *The Bamboo Pavilion at Huang-kang*
Album leaf mounted as a hanging scroll; ink and slight
color on paper. H. 9 1/4"; W. 10 1/2". Signed and dated
1828 in the artist's colophon mounted above the pic-
ture; 2 seals of the artist (C. & W., p. 464, nos. 13, 21).
EX. COLL: T. Tomioka. PUBL: Naitō, *Shina kaigashi*,
opp. p. 176; Bibl. 89, II, 242. Howard Hollis and Com-
pany, Cleveland.

EUROPEAN AND AMERICAN DRAWINGS AND WATER COLORS

A | *Landscape with Figures*

By Claude Gellée (Claude Lorrain); French; 1600–1682, Pen and bistre, with bistre wash over black chalk; drawing. H. 10 1/8"; W. 15 3/4". PUBL: *The Bulletin of the Cleveland Museum of Art, June, 1928.* The Cleveland Museum of Art, Gift of Mr. and Mrs. Edward B. Green.

B | *The Rapids of the Danube Near Grein*

By Wolf Huber; German; ca. 1490–1553. Pen and gray ink, drawing. H. 6 1/2"; W. 8 3/4". Dated 1531. EX. COLL: Prince Lichtenstein. National Gallery of Art, Washington, Rosenwald Collection.

C | *A Winter Landscape*

By Rembrandt van Rijn; Dutch; 1606–1669. Reed pen and bistre wash; drawing. H. 2 5/8"; W. 6 5/16". PUBL: A. M. Hind, *Rembrandt*, Cambridge, 1932, p. 111; F. Lugt, *Mit Rembrandt in Amsterdam*, Berlin, 1920, p. 113, Abb. 71. Fogg Art Museum, Harvard University, Cambridge, Massachusetts.

D | *View of Arles*

By Vincent van Gogh; Dutch; 1853–1890. India ink and reed pen; drawing. H. 17"; W. 21 1/2". EX. COLL: Danforth. Museum of Art, Rhode Island School of Design, Providence.

E | *Waltersburg*

By Pieter Brueghel the Elder; Flemish; 1525–1569. Pen and brown ink; drawing. H. 12 5/8"; W. 10 5/8". EX. COLL: James Bowdoin, III. Bowdoin College Museum of Fine Arts, Brunswick, Maine.

F | *View of Stream Between Cliffs*

By Paul Cézanne; French; 1839–1906. Ink and water color on paper. H. 12"; W. 18 1/2". EX. COLL: A. Vollard. Formerly Rosenberg and Stiebel, New York, now in a private collection.

G | *Rocky Cliff at Tivoli*

By a follower of Paul Bril; Flemish; late 16th c. Pen with brown ink and blue and gray wash on paper; drawing. H. 15"; W. 10 7/8". The Cleveland Museum of Art, John L. Severance Fund.

H | *Metamorphic Landscape*

By Pavel Tchelitchew; Russian; 1898–. Pen and India ink and wash on white paper; drawing. H. 14 1/2";

W. 11 3/8". Signed and dated lower right, 1942. Durlacher Brothers, New York.

I | *Marin Island, Maine, 1914*

By John Marin; American; 1870–1953. Water color on paper. H. 16"; W. 14 3/8". The Cleveland Museum of Art, Norman O. Stone and Ella A. Stone Collection.

J | *Ship in a Tempest*

By Claude Gellée (Claude Lorrain); French; 1600–1682, Ink and wash; drawing. H. 7 1/16"; W. 9 7/16". EX. COLL: Spencer; Northwick; Bateson, Oliver; Harris; Bareiss. PUBL: *Liber Veritatis*, III, no. 44; Vasari Society, 2nd series, IX, 14. The Dudley Peter Allen Memorial Art Museum, Oberlin College, Oberlin, Ohio.

K | *Scene in a Park*

By Jean Honoré Fragonard; French; 1732–1806. Pen and water color; drawing. H. 7 5/8"; W. 9 7/8". PUBL: *The Bulletin of the Cleveland Museum of Art*, January, 1926. The Cleveland Museum of Art, Dudley P. Allen Collection.

PHOTOGRAPHS

L | *Mountains between Kuei-lin and Yang-so*
From *The Face of Ancient China*, Spring Books, London

M | *Mountains in Shensi*
Courtesy Walter Hochstadter

N | *Pine on T'aishan (Shantung)*
Courtesy Walter Hochstadter

O | *New Summer Palace Garden (Hopei)*
Courtesy Osvald Siren

P | *T'ai Hu Stone (Suchou)*
Courtesy Osvald Siren

Q | *Junipers at T'ai Shan (Shantung)*
Courtesy Walter Hochstadter

R | *The Min River (Fukien)*
Courtesy Walter Hochstadter

S | *Mountain Pines Near Peking*
Courtesy Osvald Siren

A SELECTED BIBLIOGRAPHY

1 Acker, W. R. B. *Some T'ang and Pre-T'ang Texts on Chinese Painting*, Leyden, 1954.

2 Bachhofer, Ludwig. *A Short History of Chinese Art*, New York, 1946.

3 Bachhofer, Ludwig. "Chinese Landscape Painting in the Eighth Century," *Burlington Magazine*, November, 1935.

4 Cahill, James. *Chinese Paintings, XI–XIV Centuries* (Series on Far Eastern Art and Artists), New York, n. d.

5 Cahill, James. *Chinese Painting*, New York, 1960.

6 Chang, Yüan (Ta-ch'ien). *Ta-feng-t'ang ming-chi* (Famous Paintings in the Great Wind Hall Collection), 4 Vols., Kyōto, 1955–56.

7 Ch'ang, Jên-hsia. *Han-hua-i-shu yen-chiu* (Studies on the Pictorial Art of Han Dynasty), Shanghai, 1955.

8 Chen, Jên-t'ao. *Chin-kuei ts'ang-hua-chi* (Chinese Paintings in the King Kwei Collection), 2 Vols., Kyoto, 1956.

9 Ch'en, Yüan. "Wu Yü-shan," *Monumenta Serica*, III (1937–38).

10 Cheng, Chen-to. *The Great Heritage of Chinese Art*, 2 Vols., Shanghai, 1952.

11 Cheng, Chen-to. *Yü-wai-so-ts'ang-chung-kuo-ku-hua-chi* (Chinese Paintings in Foreign Collections), 22 Vols., Shanghai, 1947.

12 Chiang, Yee. *The Chinese Eye*, London, 1936.

13 Chiang, Yee. *Chinese Calligraphy*, London, 1938.

14 Chou, Ling. "Introduction au paysage chinois," *Phoebus*, II (1949), no. 3.

15 *Chūgoku no meiga* (Chinese Famous Paintings), 10 Vols., Tōkyō, 1957.

16 *Chung-kuo hua-chia-tsung-shu* (Chinese Painters Series), 14 Vols., Shanghai, 1958–59.

17 *Chung-kuo ming-hua* (Collected Famous Chinese Paintings), 40 Vols., Shanghai, 1904–1925.

18 Clark, Sir Kenneth. "An Englishman looks at Chinese Painting," *The Architectural Review* (July, 1947).

19 Cohn, William. *Chinese Painting*, 2nd ed. London, 1951.

20 Contag, Victoria. "Tung Ch'i-ch'ang's *Hua-ch'an-shih-sui-pi* und das *Hua-shuo* des Mo shih-lung," *Ostasiatische Zeitschrift* (1933).

21 Contag, Victoria. *Die Sechs Berühmten Maler der Ch'ing-Dynastie*, Leipzig, 1940.

22 Contag, Victoria. "Schriftcharakteristiken in der Malerei dargestellt an Bildern Wang Mengs und anderen Maler der Sudschule," *Ostasiatische Zeitschrift*, 1941, 27. Jahrgang, Heft 1/2.

23 Contag, Victoria. *Chinesische Malerei der letzten vier Jahrhunderte*, Ausstellung im Museum für Kunst und Gewerbe, Hamburg, 1949–1950.

24 Contag, Victoria. *Die Beiden Steine*, Braunschweig, 1950.

25 Contag, Victoria. "The Unique Characteristics of Chinese Landscape Pictures," *Archives of the Chinese Art Society of America*, VI (1952).

26 Contag, Victoria. *Zwei Meister Chinesischer Landschaftmalerei: Shih-t'ao und Shih-ch'i*, Baden-Baden, 1955.

27 Contag, Victoria, and Wang, Ch'i-ch'uan. *Maler- und Sammler-Stempel aus der Ming- und Ch'ing-Zeit*, Shanghai, 1940.

28 Diez, Ernst. *Shan Shui, Die Chinesische Landschaftmalerei*, Vienna, 1943.

29 Driscoll, Lucy, and Toda, Kenji. *Chinese Calligraphy*, Chicago, 1935.

30 Dubosc, J. J., and Sickman, Laurence. *Great Chinese Painters of the Ming and Ch'ing Dynasties*, New York, 1949, Wildenstein Exhibition Catalogue.

31 Ecke, Gustave. "Comments on Calligraphies and Paintings," *Monumenta Serica*, III (1937–38).

32 Ferguson, John C. "Chinese Landscapists," *Asia Major*: Hirth Anniversary Volume, London, 1923.

33 Ferguson, John C. *Chinese Painting*, Chicago, 1927.

34 Ferguson, John C. *Li-tai chu-lu-hua-mu* (Index of Recorded Chinese Paintings in all periods), 6 Vols., Nanking, 1933.

35 Fischer, Otto. "Die Entwicklung der Raumdarstellung in der Chinesischen Kunst," *Ostasiatische Zeitschrift*, II (1913–14).

36 Fischer, Otto. *Chinesische Landschaftsmalerei*, München, 1921.

37 Fischer, Otto. *Die Chinesische Malerei der Han-Dynastie*, Berlin, 1931.

38 Giles, H. A. *A Short Biographical Dictionary*, London, 1898.

39 Giles, H. A. *An Introduction to the History of Chinese Pictorial Art*, rev. ed., London, 1918.

40 *Gems of Chinese Paintings*, 3 Vols., Shanghai, 1955.

41 Grosse, Ernst. *Die Ostasiatische Tuschmalerei*, Berlin, 1923.

42 Hackney, Louis W. and Yau, Chang-foo. *A Study of Chinese Paintings in the Collection of Ada Small Moore*, London, New York, Toronto, 1940.

43 Harada, Kinjiro. *Shina meiga hōkan* (A Pageant of Chinese Painting), Tōkyō, 1936.

44 Harada, Kinjiro. *Nihon genzai shina meiga mokuroku* (Catalogue of Chinese Paintings now in Japanese Collections), Tōkyō, 1938.

45 Hsieh, Chih-liu. *T'ang wu-tai sung yüan ming-chi* (Famous Paintings of the T'ang, Five Dynasties, Sung and Yüan periods), Shanghai, 1957.

46 *Illustrated Catalogue of Chinese Government Exhibits for the International Exposition of Chinese Art in London*, III, Shanghai, 1936.

47 Jenyns, Soame. *A Background to Chinese Painting*, London, 1935.

48 *Ku-kung Monthly*, Palace Museum, 44 Vols., Peking, 1929–1938.

49 *Ku-kung shu-hua-chi* (Collection of Calligraphies and Paintings in the Palace Museum), 45 Vols., Peking, 1929–1935.

50 *Ku-kung Weekly*, 21 Vols., Peking, 1930–1934.

51 *Ku-kung Weekly Special Issues*, 5 Vols., Peking, 1930–34.

52 Kuo, Hsi. *An Essay on Landscape Painting*, tr. by S. Sakanishi: Wisdom of the East Series, London, 1936.

53 Laufer, Berthold. "The Wang-chüan t'u, a Landscape of Wang Wei," *Ostasiatische Zeitschrift*, 1931.

54 Lee, Sherman E. "The Story of Chinese Painting," *Art Quarterly* (Winter 1948).

55 Lee, Sherman E. "Some Problems in Ming and Ch'ing Landscape Painting," *Ars Orientalis*, II (1957).

56 Lee, Sherman E. and Fong, Wen. *Streams and Mountains Without End*, Ascona, 1955.

57 Lippe, Aschwin. "Enjoying the Moon," *Metropolitan Museum of Art Bulletin*, May, 1951.

58 Lippe, Aschwin. "A Christian Chinese Painter," *Metropolitan Museum of Art Bulletin*, December, 1952.

59 Lippe, Aschwin. "Waterfall by Chü Chieh," *Metropolitan Museum of Art Bulletin*, November, 1953.

60 Lippe, Aschwin. "Kung Hsien and the Nanking School," *Oriental Art*, New Series, II (Spring, 1956), no. 1 and IV (Winter, 1958), no. 4.

61 March, Benjamin. "Linear Perspective in Chinese Painting," *Eastern Art*, III, 1931.

62 March, Benjamin. *Some Technical Terms of Chinese Painting*, Baltimore, 1935.

63 Matsumoto, E. "On the Eastward Propagation of the Indian Method of Mountain Portrayal," *Kokka*, No. 618.

64 Ministry of Education, Second National Exhibition of Chinese Art, *Painting and Calligraphy of Tsin, T'ang, Five Dynasties, Sung, Yüan, Ming and Ch'ing Periods*, Chungking, 1942.

65 München, Haus der Kunst. *1000 Jahre Chinesische Malerei*, München, 1959.

66 Myer, Prudence. *Landscape Elements in the Earlier Caves of Tun-huang*, A thesis accepted by the Institute of Fine Arts of New York University, 1947–48. Digest published in *Marsyas*, V (1947–49).

67 Naitō, Torajirō. *Shinchō shogafu*, (Painting and Calligraphy album of Ch'ing Dynasty), Ōsaka, 1916.

68 P'ang, Yüan-chi. *Ming-pi-chi-sheng*, (Selected Paintings from the P'ang Hsü-chai Collection), Shanghai, 1940.

69 Peking, Palace Museum. *Chung-kuo li-tai ming-hua chi* (Collection of famous Chinese Paintings of all periods), 4 parts in 2 Vols., published 2 parts as Vol. 1, Peking, 1959—present.

70 Pelliot, Paul. *Les Grottes de Touen Houang*, 6 parts, Paris, 1914–24.

71 Petrucci, Raphael. *La Philosophie de la nature dans l'arte d'Extreme-Orient*, Paris, 1910.

72 Petrucci, Raphael. *Encyclopedie de la peinture chinoise: Kiai-tseu-yuan houa echouan*, Paris, 1918.

73 Priest, Alan. "Southern Sung Landscapes: The Horizontal Scrolls," *Metropolitan Museum of Art Bulletin*, March, 1950.

74 Priest, Alan. "Southern Sung Landscapes: The Album leaves," *Metropolitan Museum of Art Bulletin*, April, 1950.

75 Priest, Alan. "Southern Sung Landscapes: The Hanging Scrolls," *Metropolitan Museum of Art Bulletin*, February, 1950.

76 Priest, Alan. "Landscapes: Green and Blue," *Metropolitan Museum of Art Bulletin*, March, 1951.

77 Rowland, Benjamin. "The Problem of Hui Ts'ung," *Archives of the Chinese Art Society of America*, V, 1951.

78 Rowley, George. *Principles of Chinese Painting*, Princeton, 1947.

79 Rudolph, Richard and Wen, Yu. *Han Tomb Art of West China*, Berkeley and Los Angeles, 1951.

80 *Shanghai po-wu-kuan tsang-hua* (Shanghai Museum Collection of Chinese Painting), Shanghai, 1959.

81 Sakanishi, Shio. *The Spirit of the Brush*, London, 1939.

82 *Shen-chou kuo-kuang-chi*, 21 Vols., Shanghai, 1908–12.

83 *Shen-chou-ta-kuan*, 16 Vols., Shanghai, 1912–22.

84 Shimada, S and Yonezawa, Y. *Painting of Sung and Yüan Dynasties*, Tōkyō, 1952.

85 *Shina nanga taisei*, 2nd ed., 23 Vols., Tōkyō, 1937.

86 Siren, Osvald. *Chinese Painting in American Collections*, 2 portfolios, London, 1927–28.

87 Siren, Osvald. *A History of Early Chinese Painting*, 2 Vols., London, 1933.

88 Siren, Osvald. *The Chinese on the Art of Painting*, Peiping, 1936.

89 Siren, Osvald. *A History of Later Chinese Painting*, 2 Vols., London, 1938.

90 Siren, Osvald. "Shih-t'ao, painter, poet, and theoretician," *Bulletin of the Museum of Far Eastern Antiquities*, No. 21, Stockholm, 1949.

91 Siren, Osvald. *Chinese Painting: Leading Masters and Principles*, 7 Vols., London, 1956–58.

92 Sickman, Laurence and Soper, Alexander C. *The Art and Architecture of China*, Baltimore, 1956, and 2nd ed., 1960.

93 *Sōgen minshin meiga taikan* (Collection of Famous Paintings of the Sung, Yüan, Ming and Ch'ing Dynasties), Tōkyō, 1931.

94 Soper, Alexander C. "Early Chinese Landscape Painting," *Art Bulletin*, XXIII, 1941.

95 Soper, Alexander C. "The First Two Laws of Hsieh Ho," *The Far Eastern Quarterly*, August, 1949.

96 Soper, Alexander C. *Kuo Jo-hsü's Experiences in Painting*, Washington, 1951.

97 *Sōraikan kinshō:* (Chinese Paintings in the Collection of Abe Fusajirō), 6 Vols., 2 pts., Ōsaka, 1930 ff.

98 Speiser, Werner. "Die Yüan-Klassik der Landschaftsmalerei," *Ostasiatische Zeitschrift*, 1931.

99 Speiser, Werner. "T'ang Yin," *Ostasiatische Zeitschrift*, 1935.

100 Speiser, Werner. *Meisterwerke Chinesischer Malerei*, Berlin, 1947.

101 Sullivan, Michael. "On the Origin of Landscape Representation in Chinese Art," *Archives of the Chinese Art Society of America*, VII, 1953.

102 Sullivan, Michael. "Pictorial Art and the Attitude Toward Nature in Ancient China," *Art Bulletin*, March, 1954.

103 Swann, Peter C. *Chinese Painting*, Paris, 1958.

104 Taichung, National Central Museum. *Chung-hua wen-wu chi-ch'eng* (Collection of Chinese paintings, calligraphies and art objects in the collection of National Central Museum, National Central Library and Peking Palace Museum), 5 Vols., Taiwan, 1954.

105 Taichung, National Palace Museum. *Three Hundred Masterpieces of Chinese Painting in the Palace Museum*, 6 Vols., Tōkyō, 1959.

106 Taki, Sei-ichi. *Three Essays on Oriental Painting*, London, 1910.

107 Tanaka, G. *Chūkoku meigashu* (Chinese Famous Paintings), 8 Vols., Tōkyō, 1947.

108 Tamura, J. and Kobayashi, Y. *Tomb and Mural Paintings of Ching-ling*, Kyōto, 1952.

109 *T'ang Sung i-lai ming-hua-chi* (Catalogue of the Chang Ts'ung-yü Collection), 2 Vols.

110 Teng, Ku. "Tuschespiele," *Ostasiatische Zeitschrift*, 1932.

111 Teng, Ku. "Einführung in die Geschichte der Malerei Chinas," *Sinica*, X (1935).

112 T'ien-tsin, T'ien-tsin Art Museum. *I-yüan chi-chin* (Selection of Fine Painting from T'ien-tsin Art Museum Collection), T'ien-tsin, 1959.

113 T'ien-tsin, T'ien-tsin Art Museum. *T'ien-tsin-shih i-shu-po-wu-kuan ts'ang-hua-chi* (Chinese paintings in the Collection of T'ien-tsin Municipal Museum of Art), Peking, 1959.

114 Tomita, Kojirō. *Portfolio of Chinese Paintings in the Boston Museum of Fine Arts*, (Han to Sung), 2nd rev. ed., Cambridge (Mass.), 1938.

115 Tomita, Kojiro. "Snowscape by Shih Chung," *Bulletin of the Museum of Fine Arts*, April, 1940.

116 Tomita, Kojiro and Chiu, Kaiming. "An Album of Landscapes and Poems by Shen Chou (1427–1509)," *Bulletin of the Museum of Fine Arts*, October, 1948.

117 Tomita, Kojiro and Chiu, Kiaming. "Album of Twelve Landscapes by T'ao-chi (Shih-t'ao)," *Bulletin of the Museum of Fine Arts*, October, 1949.

118 Tomita, Kojiro and Chiu, Kiaming. "Album of Six Chinese Paintings dated 1618, by Li Liu-fang (1575–1629)," *Bulletin of the Museum of Fine Arts*, June, 1950.

119 Toronto, Royal Ontario Museum of Archaeology. *Loan Exhibition of Chinese Paintings*, Toronto, 1956.

120 *Tō-sō gen-min meiga tai-kan* (Catalogue of Exhibition of Chinese Paintings of the T'ang, Sung, Yüan and Ming periods, Tōkyō Imperial Museum, 1928), 2 Vols., Tōkyō, 1930.

121 Trubner, Henry. "A Chinese Landscape by Hsiao Yün-ts'ung," *Oriental Art*, New Series, I (Autumn 1955), no. 3.

122 Tseng, Yu-ho. "The Seven Junipers of Wên Cheng-ming," *Archives of the Chinese Art Society of America*, VII, 1953.

123 Tun-huang Research Institute. *Tun-huang pi-hua-chi* (Wall Paintings at Tun-huang), Peking, 1955.

124 Vanderstappen, Harrie. "Painters at the early Ming Court and the Problem of a Ming Painting Academy," *Monumenta Serica*, XV, 1956, no. 2 and XVI, 1957, Nos. 1–2.

125 Van Gulik, R. H. *Chinese Pictorial Art as Viewed by the Connoisseur*, Rome, 1958.

126 Citta de Venezia. *Mostra d'arte cinese catalogo*, Venezia, 1954.

127 Vincent, Irene. *The Sacred Oasis; Caves of the Thousand Buddhas, Tun-huang*, with a preface by Pearl Buck, Chicago, 1953.

128 Waley, Arthur. *An Index of Chinese Artists*, London, 1922. ("Ergänzungen zu Waley's Index," by Werner Speiser, *Ostasiatische Zeitschrift*, 1931 and 1938; "Notice sur *An Index of Chinese Artists*" represented in the Sub-Department of Oriental prints and drawings in the British Museum par A. Waley," by Paul Pelliot, *T'oung Pao*, XXI, 322–362).

129 Waley, Arthur. *An Introduction to the Study of Chinese Painting*, London, 1923.

130 Wang, Po-min. *Che-chiang ku-tai-hua-chia tsop'in hsüan-chi* (Selected works of early Painters of the Che-chiang Province), Hanchou, 1958.

131 Wenley, A. G. "The Question of the Po-shan Hsiang-lu," *Archives of the Chinese Art Society of America*, III, 1948–49.

132 Wells, Wilfried H. *Perspective in Early Chinese Painting*, London, 1935.

133 Yonezawa, Yoshio. *Painting in the Ming Dynasty*, Tōkyō, 1956.

INDEX OF ARTISTS

158

Icon Editions